Sadakichi Hartmann

Sadakichi Hartmann
Alien Son

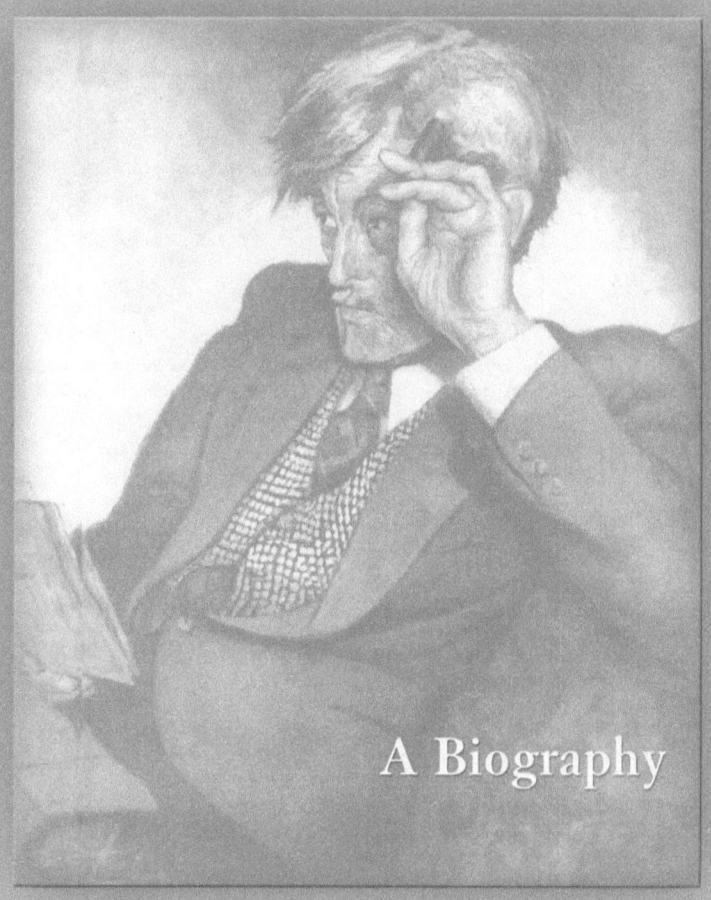

A Biography

James S. Peters

SUNSTONE PRESS
SANTA FE

© 2017 by James S. Peters
All Rights Reserved.
No part of this book may be reproduced in any form or by any electronic or mechanical means including information storage and retrieval systems without permission in writing from the publisher, except by a reviewer who may quote brief passages in a review.

Sunstone books may be purchased for educational, business, or sales promotional use.
For information please write: Special Markets Department, Sunstone Press,
P.O. Box 2321, Santa Fe, New Mexico 87504-2321.
Body typeface › Granjon LT Std
Printed on acid-free paper

Library of Congress Cataloging-in-Publication Data

Names: Peters, James Stephen, author.
Title: Sadakichi Hartmann : alien son : a biography / by James S. Peters.
Description: Santa Fe : Sunstone Press, 2017.
Identifiers: LCCN 2016046708 | ISBN 9781632931603 (softcover : alk. paper)
Subjects: LCSH: Hartmann, Sadakichi, 1867-1944. | Authors--United
 States--Biography. | Art critics--United States--Biography. | Photographic
 critics--United States--Biography. | Intellectuals--United
 States--Biography. | Racially mixed people--United States--Biography.
Classification: LCC PS3515.A797 Z85 2017 | DDC 818/.5209--dc23
LC record available at https://lccn.loc.gov/2016046708

SUNSTONE PRESS IS COMMITTED TO MINIMIZING OUR ENVIRONMENTAL IMPACT ON THE PLANET. THE PAPER USED IN THIS BOOK IS FROM RESPONSIBLY MANAGED FORESTS. OUR PRINTER HAS RECEIVED CHAIN OF CUSTODY (COC) CERTIFICATION FROM: THE FOREST STEWARDSHIP COUNCIL™ (FSC®), PROGRAMME FOR THE ENDORSEMENT OF FOREST CERTIFICATION™ (PEFC™), AND THE SUSTAINABLE FORESTRY INITIATIVE® (SFI®). THE FSC® COUNCIL IS A NON-PROFIT ORGANIZATION, PROMOTING THE ENVIRONMENTALLY APPROPRIATE, SOCIALLY BENEFICIAL AND ECONOMICALLY VIABLE MANAGEMENT OF THE WORLD'S FORESTS. FSC® CERTIFICATION IS RECOGNIZED INTERNATIONALLY AS A RIGOROUS ENVIRONMENTAL AND SOCIAL STANDARD FOR RESPONSIBLE FOREST MANAGEMENT.

WWW.SUNSTONEPRESS.COM
SUNSTONE PRESS / POST OFFICE BOX 2321 / SANTA FE, NM 87504-2321 /USA
(505) 988-4418 / ORDERS ONLY (800) 243-5644 / FAX (505) 988-1025

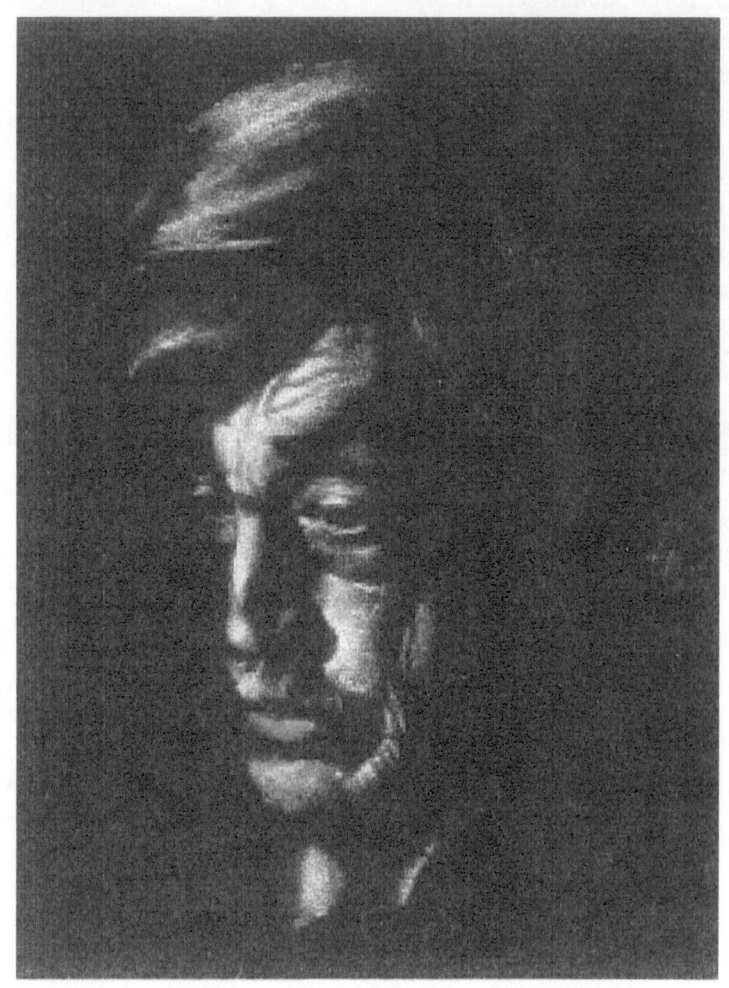

Sadakichi Hartmann by John Decker, 1940.

Dedication:
Rae Redbird

Preface

Japanese German Sadakichi Hartmann's journey through life was a long trek of pummeling conflicts and ironies. Following his mother's death in Japan shortly after his birth, his father, after shipping him to Germany for a European education, tried to erase him into oblivion by his lack of attention and continued absence. Hartmann's acetic quote from his *White Chrysanthemums* echoes the complaint, "I knew Jean Valjean much better than my father who seldom honored my childhood with his presence." Throughout Hartmann's unfinished and unpublished autobiography he constantly addressed his father as "venerable," but it was more in contempt than respect. He also had to come to terms with his illegitimacy, a rood which weighed heavily upon him. As a young student in Germany he would suffer racial harassment, then later in the United States the same echoes of embarrassment followed him. During the Second World War his dual racial inheritance was reason enough for the FBI to continuously track him as a security threat, with the intent of shipping him to an internment camp, although an American citizen since 1894. And to boot, and the symbolism may not have been lost on him, he was born on the *artificial* man-made island of Dejima, Japan.

In executing this work, Sadakichi Hartmann's unpublished autobiography was used as a framework; sometimes cherry-picked, other times somewhat generously transcribing much of the text. The decision for the latter was to give Sadakichi his voice, and by so doing, attempt to gain an insight as to his tone, temperament and character. Since more had been written of his professional life than his personal, that too played a part in exploring his autobiographical manuscript, it being an excellent primary source. A few corrections in spelling and sentence structure was done to better clarify rather than alter any meaning, but minimally and with discretion. Accompanying his brilliance and intelligence we view at times his flaws and clay feet, for no man is perfect.

Sadakichi Hartmann began writing his autobiography in 1892 when he was about 25, and completed the first section, Volume One, in 1933 when he was around 56. Volume One concludes after he met his future first wife, Elizabeth Blanche Walsh, who was a nurse at the hospital where he turned himself in following an attempted suicide in 1890. He ends on page 298 with, "...and thus closes the first volume of my auto-biography." It remained incomplete. It also contains an occasional time shift, he looking back at an incident or two which may give it a momentary lack of sequence. But they are few.

He set aside the work until about 1940 when, in California, author Gene Fowler agreed to help him complete it. Sadakichi was then about 73, and had not touched the manuscript for 17 years. As a result, naturally, there were contradictions when his mid-70s memory was called into play relating events written years before in his original pages. This may have been one of the aggravations which grated on the two, Fowler attempting to correct Hartmann on nagging discrepancies. Although Gene Fowler's *Minutes of the Last Meeting* displays an occasional passing view of Sadakichi's life and work, he appears more in cameos as the court jester of their parties, and dwells little on Hartmann's serious literary and creative prominence during the early 1900s. Although he and Fowler had sincere plans of co-partnering the completion of Sadakichi's work, in 1942 Hartmann requested the return of his manuscript, they having a parting of the way. By this time septuagenarian Sadakichi was a very ill man; his asthma attacks were more frequent, he was hounded by an untreated hernia, and was by then an overenthusiastic advocate of the grape. So it is possible the ancient wanderer's growing irascible unreliability dampened Fowler's ardor. By this time too, Hartmann had deled patience from his vocabulary and had become a deeply devoted cynic.

Sadakichi's last years in southern California was spent traveling between his shack in Banning and artist John Decker's Bundy Drive studio in Brentwood, a district in west Los Angeles. Fowler labeled Decker's abode, an "artist's Alamo," where for years many actors of film and stage met to drink, dine, recount escapades and try each other's egos. Others may have likened it to Custer's Last Stand.

Sadakichi Hartmann died in Florida in 1944 at 77.

—James S. Peters

In this torn sea of arabesques,
Looms there no isle of peace?
 —Sadakichi Hartmann

1

> A woman's death created me.
> Rest with my thanks,
> Rest softly under the hills of Kobe;
> While wind and birds sing everlasting
> Funeral rites to thee, my mother.
> —Sadakichi Hartmann.

Carl Sadakichi Hartmann, writer, playwright, poet, actor, artist, art critic, lecturer and intellectual of the early 1900s, was a soul adrift. He was one of those driven human beings who spend their lives wandering the earth in a consuming quest, yet fail to find whatever it is they seek. George Knox wrote, "Hartmann's entire life seems to have been an impassioned search for identity."[1]

Knox's perceptive assessment certainly earns him a merited tip of the hat, but there was infinitely more to the somber saga of Sadakichi's run; additional shades yet to the variegated tale of his erratic odyssey. Intelligent, brilliant and multi-talented, the years from 1890 to 1910 were his crucial period of creative exploration; his time for delving into a myriad of art forms, his time for searching for his place in the many expressive creative fields he espoused. It was also his time to choose from his extensive expertise and focus seriously on a career specialty, to expand and flourish. But his aim was blunted by the Albatross of psychological imperative, a fatal flaw which he could not resolve so as to be fully free in order to proceed unhampered with his life. As a result he remained the hyperactive horseman unable to maintain his bearings, frantically galloping through the art world on his winged Pegasus, powerless against his millstone.

Carl Sadakichi Hartmann was born 8 November 1867[2] on Dejima (Artificial Island), Nagasaki Bay, Japan.[3] His father, Carl Hermann Oscar Hartmann, was a German citizen born in early Prussia, multi-lingual, a successful businessman, and said to have been a member of the German consulate.[4]

Sadakichi's mother Osada was Japanese[5], and died two months following his birth. Soon after her death Sadakichi and an older brother by two years, Oscar Taru, were delivered by their father to Hamburg, Germany to be cared for by Carl's brother Ernst and their mother. It was to fulfill a vow made to Osada as she lay dying, to give her sons a European education.[6] While Sadakichi naturally never knew his mother he yet felt a deep loss, and carried with him a small photographic portrait of her the rest of his life.

In time, Sadakichi learned that following the birth of his older brother in 1865, their mother's parents disowned Osada for marrying a foreigner.[7] After Osada died from a pulmonary disorder, she was denied burial in Nagasaki's cemetery.[8] "Her body was cremated in Kobe...her relatives, still scandalized by her marriage to an occidental, strewed her ashes along a dusty road for donkeys to walk over," were her son's bitter words of condemnation.[9]

Sometime in the 1860s, the senior Hartmann was said to have been sent from Shanghai, China to Nagasaki as a representative of the Jardine-Matheson & Co. trading offices to search out new opportunities for them.[10] Scotsman-surgeon-businessman William Jardine founded the company with Scotsman businessman James Matheson in Canton, China on 1 July 1832. The firm remains active today. Although a successful entrepreneur, Jardine's main source of income appears to have been the opium trade, after discovering the enormous profit of dealing in illegal narcotics. He is credited with engineering the First Opium War of 1840–1842,"...fought as a result of the Chinese officials attempt to suppress the opium trade within their borders."[11] Jardine died in 1843.

While in Japan, Carl Hartmann (and later with his family), resided on Dejima Island, an old Dutch trading post. It was a late attachment in 1866 to the main Oura Foreign Settlement District, which was built along the Oura River mud flats as residences for the growing foreign population.[12] The Settlement opened 1 July 1859, and became a growing, thriving community of six districts. Hartmann is found on the Settlement roster (undated) employed by Walsh & Company, along with a V. Hartmann, the latter employed by Lehman & Co, who may have been a brother.[13]

In Kenneth Richard's psychological interpretations of a collection of "The Early Literary Works" of Sadakichi Hartmann, he conveys the intriguing thought that Carl Hartmann may have met Osada, "In the licensed pleasure quarters of Maruyama in Nagasaki..."[14] Numerous brothels had been concentrated in the

district for years, some combined with opulent restaurants. Located in the center of Nagasaki about twelve blocks south of Hartmann's residence, a short rickshaw ride away, the section burned to the ground in 1867, the year of Sadakichi's birth.[15]

Hartmann's first son, Oscar Taru, was born in 1865 in Kobe, 300-some miles N.E. of Dejima-Nagasaki. It was probably Osada's home, and she may have desired to give birth at her parents' domicile. But they held a strong bias against her consorting with a Westerner, with the result of her being unceremoniously cashiered from the family. It was undoubtedly an unpleasant experience for her. She, with her new-born, Taru, rejoined Hartmann in Dejima.

Many Westerners at the time would make arrangements for a Japanese woman as a mistress, while others married. In both instances they lived together as spouses for years, some having children. While Kenneth Richard gives no source for his ruminating on a Hartmann-Osada meeting, it is probable Hartmann looked about for a permanent sexual companion, realizing he would be in Dejima several years, and with venereal disease being rife then, it was a risky gamble if one freelanced about for sexual pleasure. Geishas would probably have been the natural choice for the intellectual, educated Hartmann, for the women were not only trained in the arts of singing, dancing, playing musical instruments (mainly the shamisen, a three-string guitar), and social graces, but painting, poetry, literature and more importantly, the art of conversation.[16] Yet, although possible it was highly unlikely, for geishas were a class of professional entertainers who took their trade seriously, and prostitution was rarely embraced. So whatever arrangement Hartmann arrived at with young Osada, probably a free-lance prostitute of the Maruyama District, in the final analysis it was certainly a pragmatic resolution to his thorny live-in dilemma.

Whatever the outcome of Carl Hartmann's search in Nagasaki for business opportunities for Jardine-Matheson, if it were so, as mentioned earlier, Carl soon was in the armament business as a dealer, and although quite promising, in a short time it all turned sour. It was not over a lack of business ingenuity, but an unseen stroke of fate. The side he was dealing with suddenly lost political position because of a regime shift, and he found himself on the wrong side, isolated. Following this business disaster, Hartmann decamped to Hamburg to join his family, surrendering forever any further career thoughts in Nagasaki.[17]

2

In young Sadakichi's new environment of luxury and economic comfort in Hamburg, his material needs were far from wanting. In fact, he confessed later to becoming quite spoiled. Speaking of his early years, the opening notes on one of several roughly planned outlines of his intermittently attended autobiography were, "Date of arrival in Germany unknown to author. Baptized as Lutheran. Went to private schools in Hamburg and Kiel. Read Schiller and Goethe at the age of nine." Of his belated baptism he remembered "old Lutheran Pastor Detmar" of St. George's Church, and "pulling frantically at my white kid gloves, (and) it sometimes seems as if I could feel the sensation of drops of water on my head."

Everything before his seventh year seems a blank. The first thing he recalled was nestling in the arms of an English nurse in the cabin of the sailing vessel which brought them from Japan to Hamburg, and the sight of a vermilion tam-o'-shanter nearby. Next, he is lying sick at his grandmother's near Hamburg, with old women peering down at him in his cradle. Then, a seashore resort on the Baltic, the bathing carts, a fat laughing *badefrau* (woman bather), making him jump up and down in the breakers. Next, a clean and bare bedroom, his brother afraid of bathing (swimming), creeping under the bed.

Then his first recollection of his father, at eight or nine. It was a sunny day at a market place in Rostock, with his father gripping his hand and pulling him along as he resisted while asking for more beer. He presumed they had just left a restaurant. His father then angrily boxed his ears. He remembered screaming as they trotted along. This is all he recalled of his father until he was eleven years old.

His next recollection is more vivid, their house, with a row of trees before it. It was a three-story structure with rooms painted in white and gold. It sat on the edge of a large lake dotted with small red and green steamers. Nearby at one of the landing piers was a boathouse with dozens of anchored, colorful rowing and sailing boats.

Inside the house, their governess, "...a buxom German maid sitting melancholy in white underwear at her toilet table, her hair all loose, I playing around her. Crawling upon her lap I dived (sic) my hand into her bosom and begged 'I only want to warm myself.' 'Yes,' she answered, 'but only for that reason.' I did that repeatedly. Of the lessons she gave me I recall one when being very naughty I was put in a corner, and there counted the droppings of the little rabbit we had in the nursery. On a similar occasion ready to go to bed I lifted my shirt and displayed my naked behind at her, and took great glee to expose my posterior anatomy."

Then came another memorable recall, a slight more dramatic.

"Of the playing during all these years I only remember smashing doll's heads with a hammer, in particular one, a shining one of glazed porcelin (sic) with very black hair painted on it."[18]

Then, "A year or so later came the wedding celebration of my father marrying my stepmother, her kneeling in her bridal robe and wreathed with myrtle in a crowded parlor in the ramshackle building of her well-to-do parents. At dinner we ate at a separate table, I drinking much wine, and Carl Meyer, who was now our uncle, advising me that I should not drink so much, which I ignored."

Among their toys was a red tam-o'-shanter which was his favorite. "My brother had appropriated it to his 'playthings' and I was not allowed to wear it. It was made out of one piece. I often gazed at it in wonder, trying to solve the mystery of how it was made. Peculiar fascination had the little topelip to me.

"Other Japanese relics were few, now and then two little yellow shirts, and two pairs of zori (sandals held by leather straps between the big and second toe), appeared somehow on the surface of the nursery. There also stood a lacquer tray with crows, in the dining room, which we thought our mother had made (very likely that she didn't). There was a brown earthen teapot with a few ornamentations, said to be painted by our mother, which did not attract much attention until one day our grandmother said, 'What a pity the teapot is broken.'

"Pictures of our mother were scarce. We had one photograph not larger than a stamp of a seated figure in a checkered Japanese gown, with cross-cut *décolleté,* and large boxwood pins in her hair. Later on in life we came across a larger copy of the same picture, also a large full-face bust portrait, and one of a group of women, which showed that our mother was almost a head taller than

the average Japanese woman. Her face in these photographs looked extremely pale and flat, almost like an outline drawing of peculiar linear beauty, and there was something wistful, sad, suffering, (perhaps) helplessness in her face. Grandmother told me repeatedly that my father had not treated her rightly, that somebody had told her that he had in a quarrel beaten her.

"During childhood the vision of my mother did not often appear to me; many years later I realized the romance and mystery and strange fascination that was woven around my birth."

Sadakichi's grandmother "was a tall, large built, unusually well-preserved woman for her age, of a soft stately deportment with few gestures. I was always fond of her and almost worshiped her during my youth. I have never known a father's nor a mother's love, but this woman's kindness repaid fully for the other shortcomings. What I know of her life is easily told. She came from one of the old well-established families of Parchim, Rueter's birthplace,[19] was married to the burgomaster, and later came driving into Hamburg in a private coach with six white horses. He was grandmaster of the lodge, in which uniform he was familiar to us through photographs. They had thirteen children. All died young except four sons, of which one, apparently her favorite, died at the threshold of manhood. She had no grandchildren, and when suddenly two curious looking little babies were sent to her, her maternal instinct was reawakened and flowed out generously towards us two for many years.

"It was as if she could have given birth to innumerable children yet, and as if now in her second period of motherhood she was as young and strong. I see her still, how in the evenings when we lay in our little cots, just before going to bed herself, she came into our room, a large stately figure with slow step, seeing if we were well-covered, adjusting a pillow or tugging at the blanket here or there. In every movement there was infinite love. This vision expressed her whole nobility of character, her womanly grandeur that is always maternal. Only an action like Mme. Janaushek[20] could give the reflection of such affection. How many hours of her life, often sleepless nights, did she devote to thoughts of our welfare? How often might she have troubled herself about what would become of us when we were taken away from her loving care? And she knew that it would happen, though she never foresaw the cruelty of fate that fell upon us. And can such kindness be wasted? No, every thought of her imperishable love was a

new stimulant towards the mission of my life. I who have little affection for my fellow beings, and have loved so sparingly, loved this woman with all my soul, so that maybe she absorbed too large a part (of my affection), and little was left.

"And yet she was in no way demonstrative in her display of her feelings towards us; kisses were very rare, they could easily be counted. But it showed itself in every detail in life. For instance, one morning we could not leave for school before she had seen if we had our rubbers on, or if we had our shawls around our neck, or our coats buttoned against the wind. But we disliked these (shawls) because they looked so effeminate, so we tore them off as soon as we left the house.

"Little did I appreciate it at the time, often grumbling, 'Go away,' and tossing angrily when she bent over our bed. We did not see overmuch of her, except at meals and in the evening when she was sitting in the parlor and listening to the Fraulein reading some novel or periodical to her. In the afternoon Grandma was usually taking a nap in her white peignoir and cap and her white Himmelbelt.

"Then she dressed and we often came running in, talking to her, or asking for our pocket money which consisted of twenty pfennigs a week. I often wondered at the peculiar shape of her chamber which she had to use standing. Our education being well taken care of, she took like most people no special care of our moral development, but guided and advised us by the natural expression of her dignified character. One afternoon I quarreled with Taru and shouted, 'You lie! You lie!'[21]

"'You must not say you lie,' she softly admonished me. 'Say, you must be mistaken, Taru.'"

"For my uncle I have always entertained the highest feelings of reverence, even admiration, not love, simply because one could not love him—the Hartmanns were all of a reticent, stoical nature. I admired him for his very haughtiness of manner and deportment, when he entered the dining room like a prince and kissed Grandmother on her forehead. How he moved a cup of coffee to his lips, how he held the newspaper, how he opened a novel with an ivory paper cutter, or toyed with some biscuits before him, everything revealed the perfect gentleman of the world, who is at home everywhere. He was exceedingly reticent, and there were meals at which he said hardly a word. Only at parties and on Sundays his speech became a little more animated, and when he took part in our games.

"Uncle Ernst was traveling a good deal, and during his absence or when he was invited out to dinner, he lived in a more bourgeois style, dining at four and indulging in a more plebeian bill of fare such as sweet soups, cherry soup, pancakes and dumplings and rollfleish, etc.

"Uncle Ernst had a wine cellar which contained claret and burgundy as expensive as eighteen marks per bottle; port wine older than himself; Chateau d' Yquem, Rhine wine, Madeira, sherry, and different brands of champagne, not only for special occasions, for hardly a Sunday passed without champagne. I had a taste of and for all of them, and ever since a liking for a real dinner with a special wine for each course, and a longing to have my own wine cellar, the first I indulged during my short bachelor days when funds were high. The latter is still a dream as my storage of liquor hardly ever succeeded a gallon of wine and a bottle of whiskey."[22]

"Poor Taru! His whole childhood was saddened by severe attacks of asthma to which he was subjected at regular intervals since his fourth year. How many hours were embittered by this not dangerous but obstinate and torturing ailment, how many of his pleasures were spoiled. It sometimes left him for months, once even for a year, but always returned with renewed force. Entire nights he sat up gasping for breath, groaning and coughing, sometimes screaming so loud people on the street stopped in front of the house. Every amusement he had to pay with a few days torment. Once he went on a picnic and was very sportive, and somehow he exposed himself and had to suffer the next few days for it.

"One Christmas Eve I remember distinctly when he was unable to walk from the nursery into the dining room where the tree was lit, and the printing press he so longed for was brought into our room. He got up to examine it, but had to abstain from the pleasure. What remedies were tried all proved unsuccessful, with the exception perhaps of stramonian cigars[23] and the burning of salt peter paper that gave him relief for a short while.

"And how impatient I was with him. At night when the noises woke me up and I could not fall asleep again, I would mimic his pains, little wretch that I was. He was the pet of Grandmother while was liked better by the rest of the household, particularly by the maids and visitors. In him the Japanese traits were much more pronounced, and there was a certain fierceness in him. Taru was in every way more active and clever of us two. I was a stout lad called *'Der Dicke'*

(fatty), of more dreamy disposition, although I amused people by a comical trait running parallel with the other in my character.

"Taru was a great collector in his childhood, and he managed his affairs with sincerity and a certain connoisseurship, rare at that age, and patience acquired by sedentary habits which he developed during his sick spells, still too unwell to go out. He had a stamp collection of almost two thousand. Not a single one was torn, and each one was pasted in a book with gum arabic in the corners. His knowledge of collecting was considerable, and the latest album was one of his stock-in-trade wishes for Christmas. He also had a coin collection of about two hundred, and a shell collection. He played chess continuously, invented puzzles for the aunts, and once invented a new war game that was quite ingenious, and really the most interesting and thoughtful for a boy that I ever saw. He also had about 2,300 tin soldiers, all of a certain Humenberg make; tiny feet, little figures one inch high artistically designed and painted. They represented quite a value, as they cost fifteen cents a box, containing thirty infantrymen with general pieces; a flag bearer and drummer, or twelve cavalrymen. They embraced nearly all the regiments of Europe in exact uniform that we became acquainted with; the Bashir Bazoakes(?), as well as the Scotch Highlander, Cossacks, Spanish Zouaves and Russian infantry. Playthings like these are a great means of education. Sometimes Taru would take a whole day to compose a battle or hold a review of his soldiers. He spent all his pocket money for this sort of thing, while I spent most of mine for cake, fruit and candy. Now and then I also bought soldiers or started a stamp collection, but generally sold them to Taru.

"In school Taru was very industrious. In many subjects he was the first, and the certificates at the end of a term generally contained the *gut* (best), while I generally was never higher than *ziemlich gut* (almost good).

"He also took an interest in growing plants, and our room was always lined with flower pots. In the garden in the summer he grew radishes, carrots and parsley. We each planted a little chestnut tree, both of which blossomed and grew for years.

"The most particular trait in Taru's character was a certain commercial instinct, the interest he took in the rise and fall of stocks and all the transactions of the stock exchange. On afternoons before dinner he would study the *borsenzeitung* (stock market report).

"We two got along very well together, that is we loved each other, and my

brother defended me like a lion when the boys would attack, coming on to tease me at school. One day Carl Meyer's mother gave him some money to treat us at a confectionary store. He, as 'uncle', wanted to carry on airs, insisting I should say 'dear uncle' before I could get any sweets. I refused and my brother took my part and threatened to lick uncle Meyer until he gave in. We (Taru and I) hardly ever played together, our interests being so different. Besides, he preferred to play alone, even to walk by himself. We often had quarrels, and pushed each other with fists, tearing each other's hair, and once fighting we rolled down the stairs together. But as soon as the fight was over everything was alright again. We never sulked for hours, or ever refused to talk to each other."

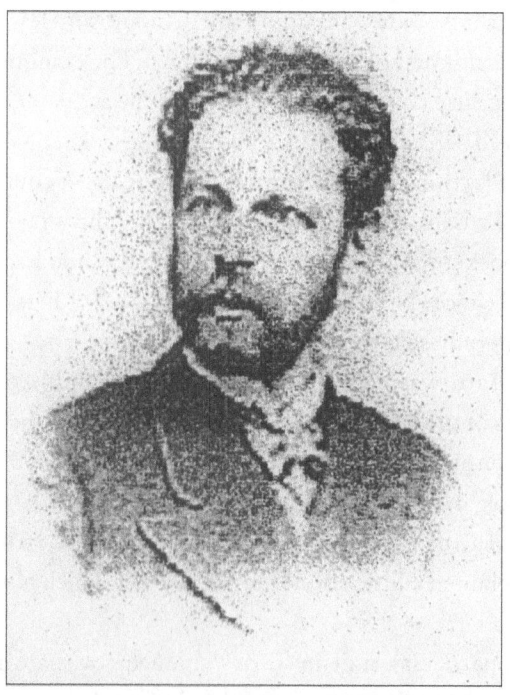

Oscar Hartman Sadakichi's Father.

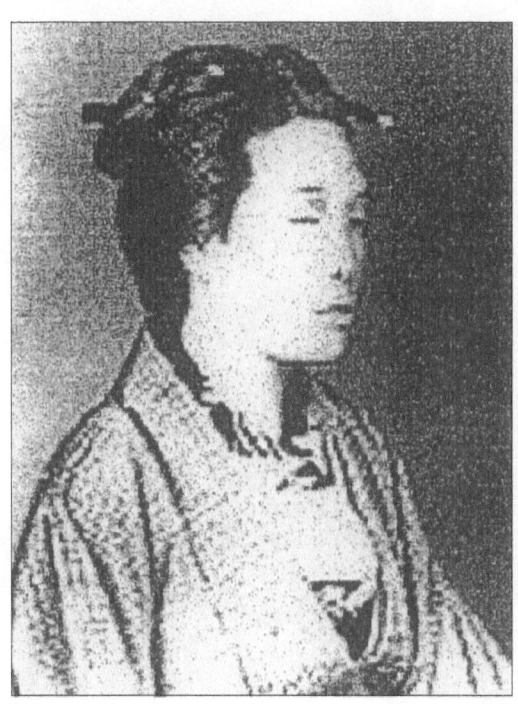

Oscar Hartman Sadakichi's Mother.

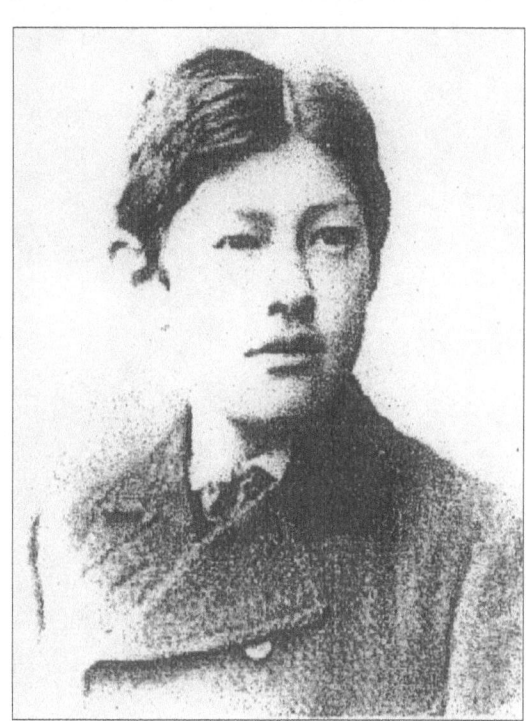

Sadakichi Hartman, age 13.

Sister of Oscar and Ernst Hartman; grandmother of Sadakichi and Taru.

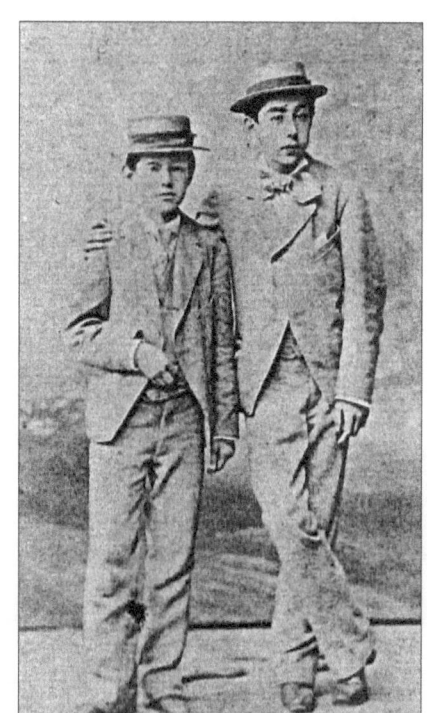

Sadakichi and Taru.

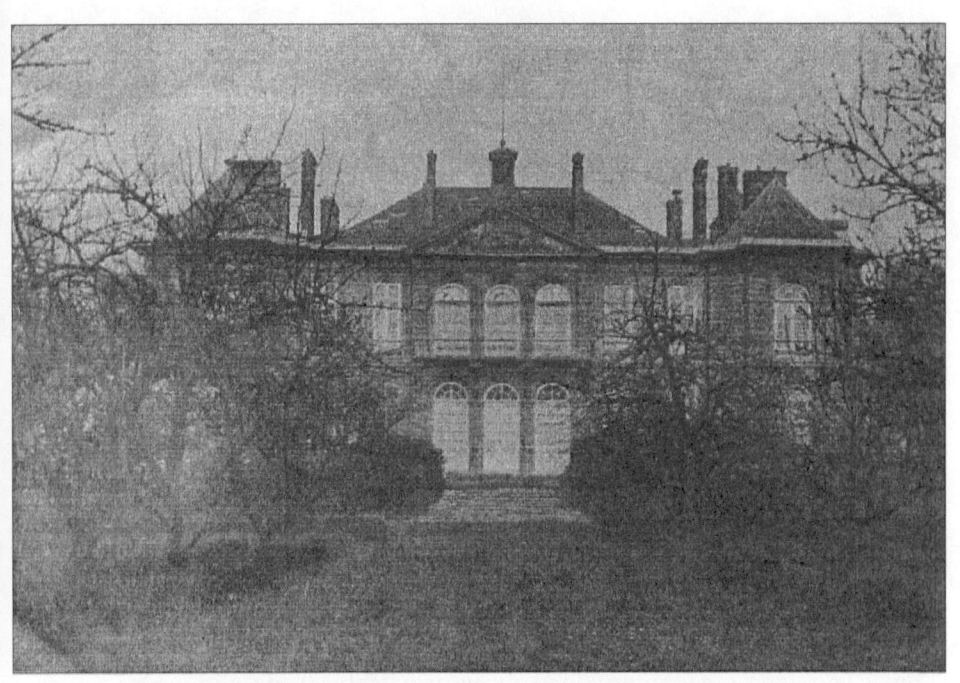

Ernst Hartman villa, "Mon Repos" (My Repose or Resting Place).

3

"Creeping like a snail unwillingly to school," opens Sadakichi in his chapter, School Days. "I was a stout little boy of seven, almost as short as wide, which secured me the nickname Fatty, *'der Dicke,'* when I began studying French: *ma maison, de la maison, a ma maison, ma maison.* I thought all this school business dismally tiresome and attended home lessons in a most superficial manner. Why bother a tiny boy who would be ever so good otherwise in such a stubborn fashion! As soon as the school gate lay behind me I forgot all until the next day. I never was a truant, it never occurred to me, I did not play much with other boys. Still, I had the reputation of being a little rogue and good-for-nothing. I had always inevitably a book with me and it lay on the open shelf of my desk, and whenever a lesson bored me, I put it on my knee and read a page or two. Thus the elders thought me strangely inattentive, and as I seldom knew my lessons also of being lazy. When my uncle chided me I pleaded: you forget what a wee little fellow I am. Much of the blame ought to be shouldered by Cooper and Marryat.[24] I was engaged on adventurous expeditions with *Peter Simple* and Leather Stocking, so what did I care for *ma maison, de ma maison,* etc.! This was the case from the start, and I behaved rather worse than better in later years.

"In arithmetic I was alert, and in composition frequently the best in the class, also in recitation I scored whenever I took pains of memorizing the selection. Ancient Greek and Roman history was to my taste, botany and geography occasionally, but the remainder I hated heartily. By fits and starts I became interested in one or another branch for a week or so. I once memorized all the dates from the Peloponnesian wars to the beginning of the Byzantine Empire, and still remember them from those days.

"I was exempt from gymnasium exercises and singing lessons. Some accident had happened which resulted in a mild attack of hemorrhage, and I made use of this to avoid any jumping bar and pole exercises. As for singing, although

I was interested in music I could not repeat a melody correctly to save my life. I simply bawled away at the top of my voice, spoiling any ensemble effort. After meticulous examination proved unavoidable atavistic projection, I was excused. I considered this clever on my part as it gave me additional hours of freedom.

"Still, my education started early, and with a governess and private tutor at beck and call. So with somebody always ready to coach me, I went along in a makeshift manner. I missed a few promotions but did not fall back to any alarming extent. When I was thirteen and a half I was in high school and had only four more classes to go to make the Abiturienten Examen which would have entitled me to only one year's service in the army, and I could have made them in four years. Of course I would not have done so—hardly any of the boys do, eighteen being considered an exceeding good record. Thus if my venerable father considered me backward and concluded that I could just as well stop, he labored under an illusion unwilling to confess to himself that his main object was to get rid of me, and that any excuse would do.[25]

"I went to five different schools; four private schools in Hamburg, and one public school (with moderate tuition fee), in Kiel. They were excellent. At the age of twelve I knew as much as any boy who goes through an American high school. The courses of instruction were wonderfully varied. I started French at seven, English at nine, Latin at twelve, and Greek at thirteen. The history course, according to German practice, taking one country after the other, I covered fairly well, except the history of Germany reserved for the higher classes. Botany was taught with flowers and leaves that each pupil had to bring, and Natural History with models from the natural history museum. Then we had geography with an extensive use of charts and pictorial illustrations. (Historical Geography being taken up in the higher classes.) And then of course, grammar, writing from dictation, recitation, arithmetic, geometry and algebra, freehand drawing which I considered a joke, and always getting the worst markings possible, and bible instruction without any sectarian reference.

"Each class was in charge of an *Oberlehrer* (head instructor), while each department was in the hands of a special teacher. In this fashion we had every hour a welcome change, a different teacher, a new face—an excellent method for teachers as well as pupils. School hours in Hamburg were so arranged that there was only one session, 9 to 2 or 3, with several short recesses and one longer one for luncheon. A baker and fruit vendor were allowed to come to the playground and

were sure of ready sales, as we were all boys of well-to-do families. I had always plenty of pocket money and practiced the treating system.

"As for the educational standards of the schools—there is no comparison between the schools I went to and the average public school in an American town. I was simply aghast at the lack of knowledge of my children when at the age of fourteen they graduated from a New York grammar school. Sure, they could add and subtract, read and write tolerable well, and had a smattering knowledge of United States history and the capitals of each state, but ignorant of all subjects that hold a deeper cultural insight. The criticism that too much is taught in Germany does not hold. It is impossible to teach too much. Something sticks anyway. And slight knowledge is preferable to utter ignorance in certain directions. Much is forgotten but also much remains. Without what I had learned in school I could never have continued my studies. Only one thing I objected to, the length of the school days, and that applies to most countries. It seems to be everywhere the same. There is something wrong with keeping children in school until late in the afternoon, and then overburdening them with home lessons, so that the whole day is devoted to the acquirement of knowledge which could be decimated just as easily in a shorter span of time.

"The shortcoming of the better German schools is that they exist only for the privileged classes who can pay. There is supposed to be compulsory school attendance, but in some places there is no school at all. The little red schoolhouse with one teacher and one pupil, or of a school shack for the privilege of two families who each send six 'off-sprinkles' (children), as I have seen in some remote parts of the States, does not exist. There is not the same opportunity for all.

"Corporeal punishment was in practice in all the schools I attended. We had to hold out the palms of our hands upon which descended with more or less severity the elastic end of a Spanish cane, as used in rug beating. It hurt considerably. Only in rare instances were other parts of our anatomy used for sadistic exercises. Other punishments were to stand in a corner during lessons, or for an hour or more after school was over.

"In public school the pupil is easier controlled. The threat that he will be dismissed curbs some of his mischievous spirit. Besides, there is a truant officer, the children's court, and what not. In a private school more leeway is given, as institutions naturally cater to as many pupils as they can get. Of course, we boys

did not argue this out, but we were fully aware that maximum punishment was a letter of complaint to our parents or guardians.

"The first few years I was rather well-behaved. I found many ways to amuse myself in my own whimsical way. I was a regular little Jew doing traffic with my luncheon, coins and postage stamps. We each had a special compartment for storing books. I put a sign on mine, 'To Let,' and carted my books home each day in order to make some deal which would put me in possession of something on which my heart was set on at the moment. Perchance some new kind of candy—for the other boys—as I did not care for that sort of thing.

"In later years I became a sort of a gangster, not so much because I had any special influence, over the boys, but because I was inventive and at the crucial moment would suggest to worry the teacher. I had several new tricks to my credit. One was to roll a marble against the teacher's desk—click! It came to the platform, then another and another—and it was always difficult to discover the culprit. Another maneuver was to move our desks forward, slowly, imperceptibly, until we were quite near to the teacher and our desks stood no longer in straight rows, but pell-mell across the room. Or we would throw moist paper balls against the blackboard where they would stick. At one time we put a cat in the teacher's desk and locked the drawer! Sometimes on mornings when it was dark and the teacher came in saying it would be nice to have some light, we would all jump up, light matches and strips and papers and run about like gnomes in the last act of the Merry Wives of Windsor.

"It could be done successfully only with certain teachers who lacked the disciplinary gift. I recall one who could actually be induced by sneer and taunt to engage in a wrestling and fisticuff match with one of the bigger boys. While with other instructors we did not care to say boo! They knew how to quell the slightest disturbance at the start with a mere look. A new teacher was always made the subject of a new test. If he passed through the ordeal we admired him, but if he wavered or proceeded in an undecided fashion he had his hands full. Boys have an instinct that tends toward the right. One French teacher had some great sorrow or trouble about one of his children, and when he arrived in the classroom hardly able to hinder a copious flow of tears telling us about his calamity and asking us to excuse him, we decided collectively that we had no right to make fun of a weeping teacher, and made the resolution that we would be extremely well behaved, for awhile at least.

"I got my share of whippings and probably not half as many as I deserved. I was stubborn as a goat. I would take my punishment with absolute *sang-froid,* and disdain holding out my hand even when the punishment was over. There were times when I was so unruly that I was told to leave the classroom 'forever.' I went into the courtyard and ventured forth to the nearest grocery store, and returning, spent my time in munching some cake or fruit, looking at the class with a strange sensation of triumph and guilt combined.

"Sometimes we were punished without deserving it. In Kiel my attire bordered on shabbiness. One of my light pants had a big dark patch on the seat which mortified me. It was over-conspicuous, yet I hoped it would not be noticed by my classmates. When we were asked a question we had to rise, and very fidgety I would look back to see in the faces of the pupils behind me if they had discovered or commented on the 'mortification.' Then the teacher would pounce upon me and belabor me with his miserable instrument of torture.

"I was teased a good deal about being a foreigner, but bravely stood up for my half-Japanese ancestry. Still, it made me mad. There were some incidents, when people who should know better, questioned me as if I had just arrived from Tokyo. When the first tramcar was installed in Kiel, my history teacher, meeting me on the way to school said, 'Well, they haven't such things in Japan.' 'Oh, yes,' I answered in disgust. 'I have been told that they had street cars at the time I was born.'

"In one school we practiced the method, that whenever a pupil was asked a question and he could not answer correctly, the pupil next to him was asked, and so forth, until it was answered correctly. The correctly answered one would then occupy the seat of the first asked, and all the others would slide down the long benches, each losing one point. There was much wearing out of the pants, and I hopelessly glided down to the very end at various times. In composition however, (premonition of my authorship to come?), I was often the first, and I remember the suspense of all concerned after one examination when the teacher read the list of winners by numbers. ONE! Everybody expected to hear Carl Hartmann, but it was somebody else. I happened to be fourth. After all, not so bad, I consoled myself. Fourth is not so strange with thirty-five competitors. It seems that somehow, like Caesar, I was always ambitious.

"I made but few friends. Only in one school I took a great liking to a handsome boy, and for his sake (I wanted to look exceedingly bright and smart),

studied so hard that I scored for a few weeks the best markings in everything. But then the family moved to other quarters, and I fell again into my negligent ways and read more on the sly than ever. What pedagogies know of a child's soul is pitiful!

"At the time the school hours passed slowly enough. They maintained their share of early ennui, early sparks of enthusiasm, the eager expectancy of recess, and for the final bell ringing that school was over for the day, and then—the great joy when vacation came. Yes, surely schooldays had their joys and sorrows, disappointment and tiresome routine, and spurts of childhood freedom and adventure. And now, it is only a swift pleasant dream of the long ago."

4

In his brief self-cameo, "How a Tiny Gentleman Behaved," Sadakichi wrote, with a combination of nostalgia and dirge, a sort of farewell to his youth, with also a tinge of prescience, perhaps subtly sensing he was about to undergo a shift in his life.

"Yes, those were great days of awakening. I cannot say exactly how old I was, about eleven I suppose. I was a mere kid but strangely well versed in worldly ways, and with an exceptional understanding of what was beautiful and what was not—add to this a craving to do something exceptionally beautiful always uppermost in my mind, which was misunderstood by everybody. As I look back on those years I would critically put myself down as a precocious imp, stubbornly determined in as yet undefined qualities, an embryo poet bent upon living his own moods and predilections.

"Kreuznach. What a place. The whole fashionable world seemed there to congregate—the international upper crust of society—drinking some hot mineral water oozing out of the earth, large terraces (upon which) to dine, wide promenade to take constitutionals, with afternoon and evening concerts. And there we were: my multi-millionaire Paris uncle and his wife, a French-Jewish actress with a decided 'sex appeal', her mother, my father and stepmother as guests with their numerous off-sprinkles, five in all, and governess.

"A way of living that pleased me! Get up when you choose and take breakfast, dainty rolls and *cafe au lait* with one or the other of the family, mostly with my venerable father, and after that the whole day, a long stretch, just to play and to do just as you damned pleased. Paradise, yes, in a way—after all, time had to be filled continuously with new wiles and fancies.

"Strange to say, my playmates were mostly girls with the exception of one American boy, a very handsome kid. But his sister of my age, Alice O'Donnell, and two sisters from Jassy, Roumania, were my principal companions. To Alice I wrote a poem, "Morning Dreams," five or six years later. It was my first

acquaintance with Cupid. What did we do! Rather ask, what we didn't do? All that children of rich parents are allowed to do.

"There was always the opulent dinner of six or seven courses, the concerts, rambles in the park of the *Kurhaus* proper, the playgrounds for children, theatre performances, donkey rides, etc. But I was not satisfied with the routine of things; I made my lonely self pedestrian trips to the vineyards, an old ruined castle and other places within reach.

"My Paris uncle, a true sport, who liked to throw money around Croesus fashion, often arranged special excursions to fair Bingen on the Rhine, where we drank Rhine wine, real Rhine wine; and on one occasion only we two went to a singing festival at Oberstein on the Nahe and I had a glorious time, enjoying the crowd, the noise, the wonderful agates everywhere for sale, and a visit to some medieval church built into the rocks. And so childhood passes, and with a few radiant reminiscences like these are worth the rest of life!

"I was and acted like a full-fledged little gentleman with plenty of money in his pocket. I could go to any show and invite whomsoever I pleased. I also had my Tiberian moods. There were some peach trees at the bank of the river. Even though far from ripe they still fascinated me, and when I discovered that within the kernels was something which tasted like almonds, I decided to pick all of them. Caught in this procedure by the park watchman I just shifted about on my young legs listening to his severe reprimand knowing that it meant nothing. Anybody with my Paris uncle as sponsor could have uprooted all the trees and thrown them into the Nahe River without any serious consequence, except that the damages of this kind were added to his bill. It must have been some incident like this, a summons to give an account of myself for certain actions. Realizing that I might be punished I preferred to punish myself. I did not obey orders, and as it was a rule that whoever did not come on time for dinner and supper would get none. I went without dinner that day.

"I was very independent in all my actions; at dinner when I like a dish I helped myself twice. I mean when the waiter came around again and I took another portion, retarding service for our entire crew. This put my venerable father into a rage. He was always a stickler for commonsense proprieties. When on some holidays I shot off firecrackers in the corridors of the hotels, he boxed my ears—which was one of the incidents upon which I pondered all my life, whether

he was right, and I do not know to this very day. See, it is a case of off-sprinkle against venerable parentage!

"What I remember of those two and a half months in exceptional surroundings are the *mise en scene,* the Nahetal, a performance of Uncle Tom's Cabin, some *prestidigitateur* (magician), good food, and Alice O'Donnell. So much more than that: opulence—power to do as you think best and at least for me was the determination to do so all my life. Mentally I put myself two or three pegs higher and I surely—if I did nothing else—lived up to that philosophic dictum as the days came and dropped off into the past."

5

And so alas, in 1881 thirteen-year-old Sadakichi's good life among the posh was terminated. While his brother Taru was apprenticed to a large farm in Holstein, he was sent to a naval school in Kiel to train for a naval career. "Such was the verdict of my venerable father," entered Sadakichi in his autobiography-in-progress in 1915, "who like so many German fathers took it upon himself to decide for his children what professions they should pursue."

One reason for the sudden career move for Carl Hartmann's sons appears to have been the growing dissension between Sadakichi and his parents, culminating in Sadakichi's later claim of a disparity of economic and emotional attention between he and the step-sisters. Also, his ersatz mother may not have been well-received by the youth, perhaps feeling swindled at having lost his original co-creator. Whatever occurred, the elder Hartmann in his final solution dispatched his recalcitrant son off to a naval school.

But after three months the young student, seething at what he perceived as the injustice of his treatment, went further against his parents' wish to exile him, and rebelled against the rigid Teutonic establishment by skipping school.

There is a brief mention in Gene Fowler's *Minutes of the Last Meeting* of Sadakichi attending, then abruptly cutting, seaman's school. Once upon a family vacation, it seems young Hartmann set off some firecrackers in a Cologne lobby. The reckless act enraged his father, and perhaps now weary of his son's continuous and persistent misbehavior, used it to send him to the naval school in Kiel for not only needed lessons in discipline, but a sailor's profession.

In the chapter "At the Training School" in Sadakichi's unpublished autobiography he opens rebelliously, if not angrily, "In no way did I feel elated over the prospect of staying three years at the Seamannsschule (Seaman's School) in Steingwaerder, Hamburg, and being trained to become a third mate on some sailing vessel. I hated everything (about) discipline, but could not help admiring my Sunday uniform; the jaunty short jacket with brass buttons, and the sailor's

cap with flowing ribbons. It is no doubt due to them that I did not run away sooner..." He then goes on to describe the numerous rigid duties, watches, chores, and classes for the students, "about 75 ranging in the ages from twelve to eighteen."

"What I did not like was the hazing," he critiqued. They assigned every junior student with a senior of whom he had to be a servant, to "...brush their boots and clothes, shine brass buttons aside of our own, fix their hammocks..." which of course is routine in many military schools the world over, being actually part of the thankless grind of discipline. Hartmann went on. "...I rebelled to be a fag to older boys (refused to do another's drudgery). And then of course (with) so many boys together, also other things happened. My senior was a rather decent chap, but I was so enraged at what I saw, not necessarily 'youthful' levities, that I decided not to stay where such weird and silly practices could occur. So one Sunday I simply did not return."

Abandoning the school he borrowed some money and ran off to Longjumeau, France, a town just south of Paris where his step-mother was visiting uncle Ernst.

His reception was not exactly warm nor sympathetic. In his explanation to Ernst as to why he had left he hinted at the "...acts of perversity I had witnessed." But his uncle replied "Pooh! That is nothing, even at St. Cyr (an early school of Ernst's) the same things happen."

"That may be true," replied Sadakichi, "but I would not stay at such a place. I will not go back to school."

His father wrote to send him back to Hamburg, so uncle Ernst took him to Paris and put him on a train. Upon his arrival in Hamburg his father told him he was disappointed in him, but that he did not have to return to school. Instead, he would send him to America. But Sadakichi did not care to go to America. His father then asked where would he like to go? Maybe Montevideo or New York? But the fractious youth was not interested in either city.

In exasperation, Herr Hartmann, probably more the uncompromising controller than commiserating guide, and whose level of tolerance was zero when it came to rebellion in the ranks, in anger disinherited him. Not stopping there, he immediately decided to shuck himself of Sadakichi by shipping him off to a granduncle in America. Both traveled to Paris by train, then Le Harve; father in first class, son in second.

"This sudden departure and subsequent events were brought about by my stepmother," wrote Sadakichi in 1933 in a chapter of his autobio called *'Erb-schleicheri'*, The Legacy Hunter, or more liberally translated, The Gold Digger. "She was the sole *deus ex machina*. Helen Mayer, the only daughter of a maritime owner, supposed to be wealthy but living in a shabby old fashioned house, was an ambitious woman, but only for her own children...she resembled (August) Strindberg's Laura. (She was an evil and petulant monster in his play, *The Father*.) There were so many rich relatives about, why should her children not profit, and my brother and I be deprived of privileges. What were we after all but *half-breeds and illegitimate!*[26] (Italics author). My father was quite irresponsible in such matters. So the road was clear, and little was needed but some 'unconscious' diplomacy and hypocrisy...And now she had scored her first decided triumph. I was steaming away on the *S. S. Lessing*,[27] to far away lands,"

Yet he strangely denied any dislike for her. She was an amiable woman, and never scolded him, even though his behavior was far from acceptable. He spent a few months with her during winter at her father's house in Charleroi, plus a summer at a resort in Kreuznach, and he claimed they got on wondrously. But her preferential treatment toward her daughters Elsa and Rosa aggravated him no end. He claimed she was one of the most fanatic mothers he had ever met. He described her manic concern over Elsa, how, when she vomited, mother Helen investigated the contents of her eruption by tasting it to see if she could determine the reason the girl threw up. Another time, Elsa briefly was sleep walking, and Sadakichi and Helen discussed and tried various experiments to break her of the affliction.

Too, Sadakichi admitted his behavior toward her daughters was quite rough at times. Once he dug a deep hole in the garden where he kept the girls imprisoned like Christian martyrs, not allowing them to climb out of the pit. Still, his stepmother reprimanded him but slightly. He ominously sensed, "the real reprimand no doubt was reserved for a more final settlement."

Yet he actually felt his stepmother Helen was quite a handsome woman and was easily comfortable in her elegant surroundings, and could hold her own in social gatherings without acting the flirt or coquette, "although she always pretended that it was wrong of me to peek in at her when she was dressing,

combing her hair or bathing. If I had made love to her would that have changed the run of events? Well, this was out of the question, I was a boob in such matters. In fact I never knew how to make love."

As Sadakichi surmised, if that were the case, calculating Helen proved successful in bringing about her "final settlement." Also, ecstatic at finally being surrounded by millionaires after her marriage, it gave her entrance to the Hartmann hearth and purse, and she was able in time to successfully marry off her daughters to men of cushy wealth and social standing.

And now here was 14-year-old Sadakichi with his father making their way along the docks toward the ship *S. S. Lessing* which would take him to Hoboken, New Jersey. "A clean, grey-white stretch of the jetty at La Havre," he waxed eloquently, "my venerable father and I promenading in the twilight on my last evening in Europe, leaving one civilization for another. How clearly I remember it all: steamers and sailing craft, the calm expanse of water, the particular limpid green atmosphere of the setting sun shining into my eyes. On the hill a huge mansion where my multimillionaire uncle once lived in the splendor of forty rooms, thirty servants, eighteen horses and twelve carriages, from buggies to coach.

"'And every servant got a generous portion of wine every day,' commented my venerable father. 'The butler, cook, gardener, three bottles a day, and the two chambermaids, one.'

"I was not much impressed by this opulence, being too used to that kind of thing, but I wondered how anybody could do away with three, as I was satisfied with one glass all these years. My venerable father no doubt gave me some excellent advice in his nonchalant manner, but I was not interested in the immediate future, I was going to some unknown place of adventure, that would take care of itself. Afterwards, that is a different matter, for I assured him that I would become a great writer, if not one of the greatest, surely an important one as, well, let us say Diderot, whose "Confessions of a Comedian" was one of the few books I had in my suitcase.[28]

"Anyway, I had it in for my father; he had escorted me from Hamburg to La Havre, and strange freebooter that he was, had thought it necessary to travel first class while I was ensconced in the second class cabin. I considered this in very bad taste, as if a father on such an exceptional occasion could not share

potluck with his son.²⁹ The trip through the North Sea and the Channel had been extremely rough. Everybody was seasick, to be on deck was prohibitive, and I stood all alone at the entrance of the stairway braving the inclemency of the weather. It blew and it rained and the cold made water run from my eyes and nose. One of those smart German Americans of low breed who, after making a little money in the U.S.A. revisited the old country, and ran everything down 'in the Fatherland' passed and growled, 'why don't you wipe your nose? They will teach you manners, my boy!' This infuriated me. To be found fault with by some bum socially beneath me, instead of appreciating my bravery, venturing forth, trying to be on deck in the terrible gale. I wish I could chuck him into the sea, the old ass!³⁰

"When it grew dark that day in June 1882, I no doubt bid goodbye to my venerable father, just a handshake, and returned to my cabin on the *Lessing,* which I shared with a pleasant middle aged man from Saxony or Baden. It was a delightful trip of fourteen days, the ocean at all times smooth. We passed a flotilla of icebergs in the distance, ran across a shoal of whales, and could see the dolphins gambol about in the sunlight. There were dances and deck games and card playing at which I won a bottle of champaign. The steerage folks formed a band and held concerts and parades, and the playing of an accordion made me weep, with pleasure.

"The fellow travelers were sadly middle class, an uninteresting but cheerful lot, and everything was so new to me that I got some real fun out of the trip. At the table I sat next to a cavalry officer who treated me to 'my glass of wine' at dinner... Being a mere boy I attracted considerable attention for the feat of traveling alone, and a bevy of young girls treated me with a condescending feeling of sympathy and pity. The tables turned when we finally reached Hoboken; the young dames all lost their heads and ran about in bewilderment and confusion, not unlike a stampede in a chicken yard, while I was quite self-possessed. Had I not traveled alone to Paris only a fortnight ago?

"It was a hot day, and the red brick pavement and the blue cloudless sky together with the heat had the effect of exhilaration. What a clash of colors, what a busy scene, of life running over with vitality! My first impression was: surely a marvelous place, I'll like this land of equal opportunities!

"I was supposed to wait for a business friend of my father's who would ship

me to my granduncle in Philadelphia. As nobody was in evidence and I was too excited to wait, I ventured forth on my own hook, checked my baggage, bought a ticket and was on my way to the City of Brotherly Love while most of the passengers were still in helpless commotion, which made me smile. I could have managed all their affairs.[31]

6

"So there I was, at the old pretentious Pennsylvania Station, Ninth and Green Street, Philadelphia," wrote Sadakichi of his arrival in the city on a torrid summer day of early June 1882. He was amazed at the passenger trains (trolley cars) in the streets, and delighted he had but to walk a few blocks to the Hartmann's. It was "A sweltering blaze that day, and I in my naval school pea jacket and shoes (only fit to be worn on deck of a sailing vessel, which my venerable father had not deemed necessary to change...).

"I rang the bell at 806 Buttonwood Street. The green slanting cellar door opened from below and a gaunt old lady arrayed in a Mother Hubbard soared into view as if raised on a trap and greeted me.

"'Is that you, Carl?'

"'Yes.'

"She disappeared, opened the front door, and gave me a welcome kiss, as chilly as the atmosphere of the interior, which with shutters closed was wrapped in semi-darkness. I delivered some messages, letters and jewelry, accepted in a matter-of-fact silence, and was installed in the garret of the two story brick house.

"My granduncle shuffled in after working hours, grey-bearded and stooping. My new relatives both looked as if life had not been overly kind to them. They were good-hearted old folks, not particularly overjoyed at the boarder which my venerable father had thrust upon them, but they tried to be as nice as a childless couple could be under the circumstances."

The first thing his granduncle did, upon considering Sadakichi's wardrobe a European "outrage," was immediately proceed to a tailor friend and purchase the youngster a suit, some ties and pair of shoes for $25.

Within a week his granduncle found the youth a job at a lithographic printing company that made labels and borders for cigar boxes. One of his unpleasant chores was the daily collection and cleaning of spittoons. The bronzing of labels was especially filthy, for as the label sheets were fed into a bronzer, finely-ground

dust of the mineral crept into his hair, underwear and shoes. But the delivery of packages was a pleasant break, allowing him thankfully to leave the building for the streets and some fresh air, where he took his time pushing a loaded handcart about. Being the youngest of the apprentices he was elected to take and pick up lunch orders, but at this he refused, explaining he did not speak English good enough to order the food. So an older youth was given the task. Too, he must have finally realized by now that his posh life of luxury was over.

"His first weekly salary of three dollars was a moment of great elation, until arriving home. His granduncle took it all, remarking, "You do not think you can keep it all, do you? You have one dollar for pocket money."

Sadakichi "...felt awfully sore about it. To work all week and then not to have use of the money earned," he wrote, ending philosophically, or perhaps fatalistically, "what a strange world this is!"

But he remained residing with the Hartmanns, the room and board lessening his economic worries. "Early in the morning I got a quart of milk and ten cents worth of cinnamon buns which with cocoa constituted my breakfast. We had dinner in the evenings with plenty of fruit, whatever was in season, with berries and peaches. There were many things I could not get used to. I had never seen false teeth up to that time, and when I saw my aunt's upper plate in a glass of water standing in the sink I almost fainted. And I was furious when my uncle made me help him. He was a secretary of the lodge and whenever a member died—and they seemed to die constantly—he had a lot of notifications to fold and put into envelopes. Then and there I got my first lessons in 'circularising'"

On Sunday afternoons the trio would visit his other granduncle, a watchmaker, or at times they would visit them. The six "...would sit on the redbrick patio backyard shooing flies and mosquitoes with palm leaf fans..." The garden had seemingly been abandoned to return to nature, along with a worn lawn. Sunflowers grew about the outhouse.

When the weather cooled Sadakichi was sent to night school, his English was so "... defective..." The teacher took an interest in the young lad, so kept him for extra lessons after class. Soon, during classes, "...Mongrel Americans..." began teasing him until one day he turned and punched one of the antagonists. The teacher reprimanded both, resulting a lull in hassling. But one night after class several students waylaid him. He had no knowledge of boxing, but in the ensuing fight Sadakichi grasped one of the assailants and locked onto him, both

ending up rolling in the dirt and mud. His attackers then became disgusted since he wouldn't stand and fight, but wrestle, so left. Sadakichi then slunk home down Chestnut Street muddied from head to toe. This ended his attending night school.

For the rest of the winter he insisted going to an art school, so attended the Spring Garden Institute, drawing from casts. He was determined on winning first prize, and labored over a bust of Pietro Aretino, the early Italian dramatist. He "...worked very hard on a life-size copy in charcoal... I was awarded the second prize. This disgusted me to the extent that I decided not to continue."

Around New Year's of 1883, the litho company he was employed at went bankrupt, so he cast about for another job. He answered an ad for a Gordon Press feeder, tried out, then was dismissed, "...mightily glad that I was still in possession of my fingers..." He then went on to Well & Hope, a firm that specialized in lithographic signs. He applied and was unexpectedly sent to the art department. The foreman there asked if he could draw and he answered confidently, "Yes, a little, I won second prize..." He was then sent to a lithostone to copy a design of pears and leaves. After several months an independent lithographic artist engaged him as an assistant for six dollars a week. A few months later at another lithographer shop where he worked as a stippler, he was paid nine dollars a week. "Only fifteen years old and making nine dollars!" he enthused.

Following the loss of this job he decided to learn negative retouching, and paid a $30 enrollment fee. After a month of training he felt confident enough to apply for a position in his new line of expertise. Hired, a photographer handed him a pile of negatives, "... which he did in a jiffy..." Afterwards he was handed ten dollars and let go. Near Christmas he was hired for another job in the vicinity of Eighth and Chestnut, working with two others, "...all three of us equally incompetent." But the holiday rush was on, and although the regular retoucher flung up his arms in despair, he kept them until after the holidays, then fired them. On Girard Avenue was another job that lasted less than a week, after which his career in negative retouching permanently terminated.

"Meanwhile, I had not neglected my self-education..." He had the pressing dream of becoming an artist, aiming as the equal of another "...Raphael or Titian..." He drew constantly in every medium to perfect his talent and technique, from pencil to ink, copying from photographs and designs.

Too, since he realized he had made few friends, except a young lithographer

who helped him with advice and books, Sadakichi felt he was ready to expand his intellectual affiliations. He desired not only ordinary contacts either, for he felt the best in town was what he wanted. In his journey in this direction, he was awed on his first meeting with the accomplished German painter, Carl Webber,[32] in his studio, who happened "to be a client of his granduncle." He next met a woodcarver who turned out Indian figures for cigar stores; and another artist from Munich who thought Sadakichi "showed considerable imitative talent." He often frequented the Pennsylvania Academy of Fine Arts admiring Eakin's Crucifixion, and the works of Schuessell and Kirkpatrick, the huge Bal Masque, and the Wests and Allstons, "and a canvas of some Italian painter depicting the murder of a Parisian woman in the Piloty style."[33]

One night while attending the performance of the great tragedian, John Edward McCullough, in "Virginus," he became stage struck, and his ambition next veered toward acting. Later, attending the performances of Keene in Macbeth and Richard III finally did it. He fell in love with the stage.

But this new amour he had to keep secret from his granduncle and grandaunt, they being of more practical mein, and more concerned with keeping their young boarder's nose to the grindstone. Yet, he was found out in due time after he purchased on credit a wagonload of books in German; the complete works of Goethe, Schiller, Heine, Kleist, Lenau, Lessing, etc., about a hundred volumes. He brought them home quietly in bags and rat-holed many of them in his large tin trunk. Having shelved his dreams of being an artist, instead of drawing he now read. Then one day his grandaunt appeared and inquired about the volumes of books.

"Oh, they are our great German authors. I want to become familiar with their writings."

"But they are nearly all dramas."

"Well, they happened to write dramas."

"I trust you have no foolish ideas in your head, Carl?"

"No, indeed not!"

His granduncle wanted him to return all the books immediately, he feeling it was wrong for the bookman to have sold so many to him. But Sadakichi demurred, and suggested perhaps it would be a good thing if he moved, that he couldn't stay with them forever. Since they did not object, he felt they were glad to be rid of him. But when he went room-hunting the next day, they argued why

be in such a hurry? Too late, he had found a place on Ninth and Poplar.

A week later, while in his new abode, Sadakichi was informed by the dairyman that his granduncle had passed away, and not an hour before. For two nights he held a wake at the coffin, listening to the melting ice drip into a bucket underneath the casket. He rode in the first carriage to the cemetery with his great-aunt, she leaning on his arm throughout the entire ceremony of speeches, and afterwards of Masons tossing tiny branches into the grave. Following the burial his great-aunt went to live with relatives and Sadakichi returned to his room. For a time once a week he attended dinner at his other granduncle's, the watchmaker.

7

The 15-year-old youth was now living on three-dollar checks still sent weekly from his grandmother in Hamburg. In computing his basic expenses, his weekly rent of $1.75 left him $1.25 for food, books and theater tickers. He was amazed at how he could manage on nothing. So he decided on a plan. He would abandon completely the idea of working and concentrate on his self-education. Another like-companion of Sadakichi's was the apprentice-friend of his print shop days who also decided to quit work and devote himself to study.

With the full-blown fervor of an idealistic adventurer that only a naive teenager could know, or a man possessed, or both, he plunged headlong into his own self-study course, setting no limits or borders, driven and determined. He wished to acquire an unlimited knowledge of literature, especially drama. And everything possible with the fine arts... "painting, sculpting, music, dance, Delsarte and mimicry, history and the history of costume, theatres, biographies of actors, anthropometry, artistic anatomy, foreign literature, etc."

He ravenously read twenty books a day, some thoroughly, others in selected parts for desired information. He learned to take in a whole page at a glance, probably developing a talent for speed-reading. The library had open shelves, so he could sate his orgy for knowledge in any department by checking out a dozen or more tomes at a time. This was quite the change from the lackadaisical student of Germany not too long before. By the time he was through he read nearly all the books of the Mercantile Library, and the entire volumes of the Universal Public Library.

Sadakichi was finally successful in his attempt to reach "upward" in his intellectual life, and it appears it was through the youth's interest in Shakespeare. Probably during his use of the library of the Philadelphia High School in his feverish boning up, he made the acquaintance of the librarian, Albert Henry Smyth, a graduate and valedictorian of the school in June 1882, the same month and year Sadakichi arrived in Philadelphia. The meeting of the two may have

been in 1884, when Smith was twenty-two and Hartmann sixteen. Smith was a contributor to a small publication, *Shakespeareana,* and both their interests in the Bard sparked a friendship, to the point where Smyth invited him as a member of a small discussion group which met daily afternoons in the library.

Besides Smyth, who in the future would become Professor of English Literature of the school, was a member who was studying medicine, and a third who was wealthy and had a great interest in Elizabethan Literature. Soon, Sadakichi was drawn to other notables which were friends of the group; the wealthy lawyer Joseph G. Rosengarten, who published historical articles of noted interest; Dr. Parker Norris, a Shakespearean scholar; Dr. Franklin Taylor, ditto; and Dr. H. H. Furness, fifty, also a Shakespearean scholar who was doing work on the *Othello Valorium.* Certainly no lightweights here, but an excellent collection of accomplished, serious and scholarly men.

On Sunday evenings Sadakichi and his trio of friends would meet at a Baptist church to hear Dr. Furness deliver his sermons, being an eloquent orator. His wide range of subjects included even the French Revolution.

He also became acquainted with a second-hand bookstore dealer (through whom he would in the future meet the poet, Walt Whitman); a Reverend Ames and his two college-aged daughters; and a Dr. Brotherton, an orthodox Quaker, who introduced the youth to the works of Scottish poet Robert Burns. Brotherton often also spoke of Whitman, whom Sadakichi vowed to meet. The Quaker's wife one Christmas presented the youth with the present of a fine hand-stitched linen handkerchief. But alas, in the author's words, in later years they soon lost interest in him as, "I was leading a life that would lead me to the very brink of iniquity."

His roughly two years of tenacious persistence in self-education gave him the results he strove for, a wide range of knowledge in literature and the arts. Fortunately he had the natural intelligence in the first place with which to put to work, and like a sponge he devoured and retained information obsessively. While the books filled him with the data desired, his social contacts gave him the working communication to expand and develop. In his own words, "They (books, people) all assisted to fill me brimful with knowledge. I astounded all with my methodic ways, my perseverance, and what was no doubt my trait to be most admired: my power of assimilation. Although only seventeen I behaved like a man of twenty-three." A touch of ego-polishing there, but he had the right

to feel proud. He had bitten deep of the apple of knowledge coming away more learned than ever, but assuredly with a heathy boost of genetic inheritance from Hartman Pere.

The daughters of Rev. Ames were impressed with Sadakichi's deep ambition of specializing in minor Shakespearean roles. But Sadakichi secretly dreamed of becoming another David Garrick, or at least a Kemble. Yet, he still was not absolutely certain of an acting career. The thought of being a painter was still pleasurable, although he neglected his studies there. Writing, too, was a possibility, but he couldn't yet express himself well enough there to move in that direction. But he yearned to make his mark in something sensational, "something above the ordinary!" His strongest yen for now was the stage. The home of the great Edwin Forrest sat on the corner of Broad and Poplar Streets. It was a striking white mansion reminiscent of an Italian villa. Passing it at times in the moonlight he fantasized of owning something similar to it one day.

A female elocutionist, a stickler for accurate pronunciation, elected to give Sadakichi free lessons. He, like the Greek orator Demosthenes, struggled mightily for clear articulation. But for his exercises the youth used a spoon instead of pebbles. He progressed well, and at one time spoke English with hardly an accent, but soon fell back on his German-Japanese articulation. He never completely overcame it. In a part on stage as the Earl of Shrewsbury, he made up as an old man and the audience "thought it quite a feat for a young German Jap."

Sir Henry Irving was his favorite player. "Faithful Smyth found a way I could attend every performance, and so I saw Irving as Mathias, Hamlet, Shylock, Benedict, etc. I tried hard to meet him. Rosengarten gave me an introduction. But I did not get to see him personally. Rosengarten then spoke to him about me, of my parentage, how I studied, and whether there would be any chance for me. Sir Henry replied: A young fellow as you describe, if he wants to succeed, he will succeed."

Again, Sadakichi was still amazed at how on his meager income he could manage so well. Of course, to stretch his finances, he gradually learned to make his calls at meal times whenever possible. He recalled one Thanksgiving Day when he made four visitations to four separate turkey dinners. But then there was a Christmas time when he had wrongly timed his foraging expeditions and missed them all! Well, nobody is perfect.

Sadakichi finally did make his desired acquaintance with the American

poet, Walt Whitman, who lived across the Delaware River from Philadelphia, in Camden. His terse and somewhat colorful description to Fowler of the meeting is worth repeating verbatim. It also appeared clear and precise in his memory after 56 years. It was on a wintry November day of the youth's birth month in 1884, that the 17-year-old struck out for the bard's home. He was so excited that he took the wrong ferry and debarked too far upstream, so had to backtrack to Whitman's domicile. It was a cold and windy trek as he trudged along the snow-covered landscape to the two-story house on Mickle Street.

"In reply to his knock the front door opened, and Sadakichi saw standing before him an old man with a long grey beard spread over his naked chest.

"'I would like to see Walt Whitman'

"'That's my name. And you are a Japanese boy, are you not?'

"'My father is German, but my mother is Japanese.'

"He led me into the small and humble two-windowed little parlor, with its chilly atmosphere, as no fire was lit, and everything in great disorder. The first color impression of the interior was a frugal gray.

"He sat down at the right-hand window, where he was generally to be seen by outsiders, and his face turned toward the street. Inside the parlor a visitor would sit on the opposite side of the room. Between host and guest stood a table covered with books, magazines, circulars and manuscripts piled in topsy-turvy fashion; here and there odd pieces of furniture and a trunk; and a large heap of his own publications loomed up like rocks.

"On the mantlepiece stood an old clock surrounded by photographs of celebrities and friends. At the time of my first visit apples and onions were scattered about on the mantel. At one side of it hung a portrait of his father, and on the other side that of his mother: two strong, highly interesting physiognomies.

"'I never forget that my ancestors were Dutch,'" Sadakichi quoted Whitman as having said to him."

Hartman "liked Whitman's face for its healthy manliness and said that the poet's complexion was as rosy as a baby's." 'Above all else,' Sadakichi continued, 'I was attracted by the free flow of his gray hair and beard and the distance between his heavy eyebrows and his bluish-gray eyes, calm and cold in their expression, denoting frankness, boldness, haughtiness. His forehead was broad and massive, not furrowed by Kantian meditation but vaulted by spontaneous prophecies. His broad nose with its dilated nostrils showed with what joy he had inhaled life."

Whitman had partially recovered from a paralytic stroke in 1873, and moved about with the aid of a yellow stick. Until his last years he would occasionally go to Philadelphia to see a play at Mrs. Drew's Arch Street Theatre; or, as Hartmann wrote in an article for the *Southwest Review* (1927), to walk slowly along the streets, his left foot dragging, and reply to all greetings in a cordial manner. Whitman was not a talkative person, however, Hartman reported, and had the habit of replying with an "Oy! Oy!" to most questions.

Sadakichi, with a touch of earned arrogance, may now have had a great desire to test and display his honed and keen intellect, to exhibit his new "self" as a proud kid with a new toy.

"I was three years now in the country. I had seen but little besides town life, except Fairmont Park, the Wissahickon Creek and Camden, but I had surely met the most representative intellects of Philadelphia. I had broadened my book knowledge to an almost alarming degree. I could converse brilliantly with anyone interested in art or literature or music, and easily hold my own. Of sex and business I knew absolutely nothing.

"It now entered my head to go to Europe. My love for painting decided on Munich for further activities. I decided to sell my books, not donate them to secondhand book dealers, but rather sell my accumulation to private persons for a more liberal exchange. Just to have enough to get abroad. The rest would come out all right."

8

In February 1885, seventeen-year-old Sadakichi Hartmann boarded the *SS Waesland* in New York for Antwerp, Belgium. Selling his library of approximately 150 used books, which brought in about 100 dollars, he paid off some debts, purchased a "stylish suit," a cowhide valise, and a ticket on the Red Star Line for Europe. At the time there was a price-war among steamship companies, and for only seven dollars he not only was able to purchase passage, but it also included a first class train ticket from Philadelphia to New York, his point of disembarkation. In added economic shrewdness, he chose steerage, the cheapest accommodation, to insure extra funds on hand in Antwerp.[34] Going further, he made haste to a money exchanger on the Bowery where he, "received an astonishing amount of coins for my few greenbacks." Feeling financially flush and secure after this, he exuberantly looked forward to a pleasant time in Europe at the end of his fifteen-day voyage where, filled with a mixture of hubris and chutzpah, "he would conquer the world—of art at least."

Following his Antwerp arrival he checked in at the Hotel Antoine, bathed, donned a fresh set of clothes, then went to dinner. Following his repast he secured a guide and asked to be taken to a theater, whereupon he was led to an opera house where *The Huguenots* was billed. As he paid his two five-franc coins for a box seat, the ticket-taker refused them while accepting some of his other change. Asking his guide about the problem, he found to his dismay the francs he had purchased at the Bowery were earlier discontinued and taken out of circulation.[35] So he ended paying for an open box from some legal currency he had left, and sat through the opera crushed, frantic, and wondering what to do, so worried he hardly remembered the show. In his hotel room he checked his finances. Depressingly, three quarters of his money was tied up in discontinued francs.

In the morning his guide explained the francs actually were not valueless, and could be redeemed at the mint. He asked Sadakichi where he wanted to go.

"Hamburg, as soon as possible," he answered.

"Well, that can be managed," replied the guide. At this point the guide morphed into his personal manager and took the youth in hand. He calculated to Sadakichi he had enough to pay for his hotel bill, a third-class ticket to Hamburg and a "small compensation" for him. Also, enough for Sadakichi to spend the afternoon touring Antwerp before his train left later that day.

The sympathetic "guide" probably got his pound of francs from Sadakichi without him realizing it, and went his way. So Sadakichi took his casual tour of the town, which included a cathedral and a museum. After a lunch, he returned to the museum to study the collection of amatory bas reliefs from the Indian book of love, after which he boarded his train to Hamburg.

Late in the night Sadakichi, who had fallen into a deep sleep in his chair, was suddenly wakened by the conductor announcing, "Dusseldorf! All out except first-class passengers. Express to Hamburg!" Third-class Sadakichi had to detrain at midnight in a strange town, penniless.

"Do you come from America?" asked a man on the walk next to him.

"Yes," answered the young traveler in desperation, as he told the stranger his plight. The man was an emigration agent, but could do nothing for him. He advised him to try the small hotel across the street.

Approaching the proprietor he said, "I would like to stay here over night."

Bowing profusely, he answered, "With pleasure."

"But I have no money."

Straightening, he replied, "Then I regret to say it will hardly be possible."

"But I have a rich uncle in Hamburg, and I could leave this valise."

"A rich uncle?" He eyed the valise. "I think it can be done," and he bowed again.

The next morning the proprietor lent him ten marks and accompanied him to the train.

Arriving without baggage at his grandmother's, she was taken aback at the impropriety. "What will the servants think?"[36]

"After a two-week stay in Hamburg and a visit to Kiel, necessary to recuperate my finances, I ventured forth to Munich.[37] There had been a slight change in the program of my studies, due to two incidents. Because of the exposure and hardships of the trip, I had contracted a catarrh of such fiendish vehemence that it almost knocked me off my feet, and ended with my first attack of asthma

which has made an invalid of me throughout my life. In this condition I paid in Hamburg visits to three local histrionic celebrities who were to sit in judgment of my abilities.

"The first was the stage manager of the Thalia Theater, a stout, bearded, good-humored person, no doubt a poly-appointed thespian himself to whom I recited the monologue of William Tell. That will do very well for domestic purposes, he said, but I would not advise you to go on the stage.

"Max (the second judge), the popular comedian who paid court to my stepmother at the time, in a dressing gown, could not on his life understand why a scion of a rich merchant's family should have the desire to go on the stage. Anything else rather than that, there is nothing in it. And (since) the shabby little house in which he lived was all he had gotten out of his amazing popularity, it seemed that he spoke the truth.

"The third was a character actor, one of those men brimful of talent but who lack something to become really prominent. He seemed very much embittered about the Hamburg audiences. The test he put me through was to say one sentence of Schiller's *Don Carlos* in a coaxing, commanding or indifferent manner, which was beyond my elocutionary power. On that particular day every word I uttered came out with a fatal nasal twang, my handkerchief was wringing wet and I felt all dazed. He did not realize that I had come over in steerage, and consequently this great connoisseur of human emotions pronounced me to members of my family as absolutely untalented."

But the judgments of the professional theatrical triumvirate slid off Sadakichi's armor of chutzpah as rain on a rock. He remained unconvinced, and as usual when blocked, or facing resistance, he stubbornly summoned his weary and tattered Pegasus to try another direction.

"I felt that it had been no test at all, and wondered after all that I should rather train myself to become a producer of plays than an actor, or a painter, or a poet. What does it matter as long as it is something out of the ordinary. I was only seventeen, so many roads lay open to me. I was sure to find the right one. Let me see where it will lead me." So with no hesitation he galloped to Munich to learn the craft and art of stage production.

His prime concern upon arriving, as usual, was to stretch what money he had in his lean and hungry purse. He had been "recommended to a distant relative, a protégé of my Hamburg uncle, a real professor of philology who had written,

con amore, A History of Commerce of the Venetian Republic in 30 volumes..." He was soon settled in a room in the flat of an old spinster for the low price of 20 marks; a month, assumedly. It included, "A breakfast of coffee, two rolls, butter, and occasionally an egg thrown in. The midday meal I took at a beer garden which consisted of a three-course dinner and one *seidel bier* (mug of beer) for twenty cents. In the evening I spent twenty cents for half a *seidel,* a few slices of bread, some radishes, sausage or cheese. So I managed to subsist on about 38 cents a day, or around twelve dollars a month. I used no tramway and did my own laundry." His earnest resolution at penny pinching is certainly to be commended, although he does add an important footnote to his boast, that, "Besides, I had a natural gift for borrowing—and my relatives."

He then spent several weeks in an orgy of serious sight-seeing, starting with a myriad of art galleries.[38] In his endless peregrinations he also visited Munich's varied architecture and statuary; its churches, factories, and parks. He even descended down a coal mine and took a tour of a slaughter-house of calves and sheep, then journeyed through a morgue. Nothing was alien to his insatiable curiosity.

"After absorbing all these various attractions I decided to settle down to regular work. I had determined to study stage art in all its various aspects and expressions. I became a "voluntary" apprentice to the famous stage machinist, Karl Lautenschlager of the Royal Theater.[39] This meant paying for the privilege, and by hook and crook I raised the inevitable three hundred marks. From that day on the National Theater and the adjoining Residenz Theater—famous for its Rococo auditorium, and revolving stage simplifying the change of scenery—became my constant abode from early morning till late at night."

So once again, teen-aged Sadakichi flung himself into studying, this time to learn all he could of stagecraft, from a to z for approximately eight months-surrendering his idea of becoming a "great" actor. The profession probably had hardly ever seen an apprentice who so sacrificed himself to art. His thirst for knowledge and ability to retain so much of what he learned was phenomenal. His drive could only be compared to his earlier years in Philly and his round-the-clock task at self-education, and the drive and results which so amazed those who knew him as a dynamo of energy in action.

"I on the other hand cared for little but study; I was worn out from overstudy. I burnt the candle not only at both ends but on all sides. The blood would

rush to my head when I mounted the stairs or stooped, and I had several fainting spells...

"I continued to work incessantly. It was largely a process of accumulation and absorption. Mentally I had rare digestive faculties and slowly developed some critical powers. Of course my main concern was to know the drama and the stage...

"After staying eight months I became restless. I still desired to see Vienna and the Burgtheater if possible, also Dresden and Leipzig, but there was a most palpable deficiency of funds, so there was nothing to do but to try to get back to America. But on the way back I would at least stay for a few weeks in Berlin, and meet Brandt,[40] a great rival of Lautenschlauger, who had the reputation of emphasizing atmospheric effects, making a moonlight scene in Italy blue, and in Denmark greenish brown.

"I now knew the German drama and stage fairly well, and I knew the ways a performance was launched. Strange that in all my after life I never made use of the accumulated knowledge ...but after a few feeble efforts I gave up the fight for practical results...I could have been of value as an impresario, but not as a reformer or propagandist-perchance if life had willed it so a great guiding genius of some magnificent enterprise as my dreams, but never as an ordinary stage craftsman fighting solely to please the public and personal advantages."

In the fall of 1885, the Royal Theater was closed for some special ordered performances for four weeks. The mystery was why, and who for? As a result many rumors and stories were floated about. The leaser-culprit was the King of Bavaria, 40-year-old Ludwig II.[41] He often did this at various times and places for the benefit of his private performances of the operas of his favorite composer, Richard Wagner. One thing he demanded; no audience to gawk at him. The locked theater was darkened, and within the shadowy interior Ludwig would be seated alone somewhere in the ebony murk, enthralled and lost in the music and arias and themes. He imagined himself as *Parsifal,* the hero of one of Wagner's operas. All his life Ludwig was more inclined toward his arty dispositions, and especially by the absorbing fantasies of building castles, palaces, and relishing Wagner's music.

Sadakichi, having a connection or two, was able to attend a performance. "Through some red tape mechanism and super influence of relatives and

connections, I was granted an audience with his majesty; that is, with a lot of stiff, dignified and decorated officials, and a screen behind which the king was supposed to be seated. I did not even know if he was present at the time. I had been led in great secrecy and haste from the Court Theater through the roof garden, catching a glimpse of the lake whereupon in a swan-boat the king played the part of Lohengrin to his gratification, (then) passed by some East Indian and Chinese pagoda-like structures, and was ushered into a huge, empty, audience chamber, where my case was mentioned: a young poet asks for the privilege of witnessing from the auditorium the dress rehearsals of his majesty's private performance, etc. I did not say a word, just trembled with excitement. Granted! My jubilation was boundless. I do not remember how I was returned to ordinary terra firma, and I was too inexperienced to realize what I had missed: not seeing the king in person.

"But I, especially favored, was allowed to be a spectator during the dress rehearsals, which were perfect replicas of the performances for the king. It caused no comment as everybody was too busy, and I wisely retreated to the remotest part of the auditorium. And so it came to pass that I witnessed what nobody else except the king was privileged to see, for instance *Parsifal*. The only times it was given outside of Bayreuth, before Conrad performed it at the New York Metropolitan Opera House many years later.[42] Leaning back in the darkness in the box seat, exalted, bewildered, yes, even imagining I was the king himself, the various stage pictures passed by like the visions of some other life."

But alas, Sadakichi records in disappointment, "The repertory his Majesty deigned to select was a capricious gallimaufry... I must confess that the plays conveyed little to me. The impression was strictly scenic." He then goes on to critique the works of the evening in quite a knowledgeable and professional manner; not as a neophyte, but a seasoned professional. His past months of studying stage production was certainly no waste of time.

"The theaters were closed, everybody was on vacation, and so I thought I would follow suit. How much I desired to see Nuremberg, Augsburg and Ratisbon! Alas, my funds were low, I could not make all three, so I decided on Ratisbon for no particular reason except that I had some letters of introduction to friends of relatives, and Ratisbon was the least invaded by the common tourist. Everybody goes to Nuremberg and Augsburg, while comparatively few to Ratisbon.

"There is really not much to see. It is a typical old German town, so ancient that if given to excavation one might discover pre-Roman ruins in ones backyard. It has played an important part in medieval history, but history rarely furnishes me with a theme of exploitation. I liked the crooked narrow streets, and gabled houses hundreds of years old, some picturesquely embellished with coat-of-arms, but aside of the town hall there are only the cathedral and the Walhalla nearby.[43] Master Ludovichio's[44] masterpiece is worth a special trip. Its expression is not overwhelming, yet as an example of pure German gothic without exaggeration, it is imposing.

"Of whimsical interest to me was the Inn of the Golden Cross, where they still show the room and the bed where Charles V condescended to be entertained by Barbara Blumenberg, a Ratisbon maiden of 'some selective faculty.' The hero of Lepanto: Juan of Austria,[45] was the result of this momentary affinity. It seems remarkable indeed to have preserved for posterity a place of non-immaculate conception, the true birthplace of a human being. For is not the moment of conception the most decisive though most neglected and least discussed procedure of all sex relations?

"Stopping at a humble *Gasthaus,* after breakfasting in the inevitable beer garden attached to it, and some tower climbing and general sightseeing, I set out to pay my visits.

"Nearly all folks were away, thus I caught only glimpses of German homes and gardens and German servant girls, who were lost in wonder how a young gentleman could ever come from so far a place as America. Finally I called on an old university professor who had courted my stepmother when she visited the town a few years previous.

"I told the servant to announce me as, 'the son of Helene Hartmann.' He apparently misunderstood my instructions, for the professor came rushing down, frowsy looking and grey hair flying, in ill-fitting clothes with a layer of dandruff on his shoulders, exclaiming, "Where, where?! I thought Helene Hartmann was here?" He looked very distracted.

"'No, only her son, that's me.'

"'Impossible!'

"'Not at all, she married my father'

"'She did? What sort of man is he?'

"'Oh, a rather indifferent type of man.'

"'Oh, the poor, poor woman!'

"As we proceeded in our conversation he put his services at my disposal—nothing too good for a son of Helene Hartmann—and he suggested a walk. And so we took a stroll into the country, drank coffee somewhere at a rustic table, rambled along hillsides with wonderful vistas on adjacent farmland in the setting sun, and all the while he gesticulated, raising his arms to heaven and tearfully shouted, 'Oh, Helene, my sweet little Helene!'

"...The next day he accompanied me to the ruins of castle Stauf, and thenceforth to the Walhalla, where we ascended noble flights of marble steps, and where we saw more marble busts (of celebrated Germans) than I have ever seen again, except in Jo Davidson's exhibitions.[46] I do not recall whether I wondered more at the quantity than quality of these productions. They looked a trifle cold and futile to me, these bearded stone faces, imitations of classic art at their best, and I enjoyed the superb view from the grounds more than anything else. The professor unrolled his knowledge about all these personalities with amazing glibness of tongue, and proved himself a most enthusiastic and self-sacrificing cicerone.

"The following morning I journeyed to the Befreiungshalle near Kehlheim on the Danube, alone, and as it happened I was the only tourist who strayed that way that day. After a short railroad trip I found myself in Weltenburg, a historical Benedictine convent, a part of which has been changed into a picnic ground. And there in the open, with gurgling water on three sides, alas! Will Bierwurst and Munchener ever taste as delicious again!?

"...Then the Befreiungshalle,[47] not especially attractive from the outside, was a surprise as I entered. Something finer than Napoleon's tomb. The high and spacious rotunda in colored marble, lined with thirty-four gigantic victories by Schwanthaler,[48] with the light streaming down from the dome is surely beautiful. (In) Architect Klenze I began to comprehend what freedom (in art creations) mean!

"Then I ventured forth outside the balustrade, gazed at the marvelous scenery, and thought of Ilka Seidl.[49] Am I in love with her? Does she mean anything to me? I wrote her name and date on one of the columns, bad habit that, but forgive me this one time, Aphrodite, for it was my intention to come here again years ago, and then I would know what Ilka Seidl meant to me.

(With) the professor shouting 'Helene!' and I whispering the name of my choice, (we) seemed to compete in sighing and calling up our beloved ones in *Manfred* fashion.⁵⁰

"Next afternoon I left Ratison, and as I said goodbye to the professor he pointed to the cathedral towers, exclaiming, 'See, the pigeons have come back. This has never happened before. Apparently they left when you came, and (now) return when you leave. A strange coincidence!'"

Sadakichi continued his touring, and during his sightseeing continued to meet, court and cultivate new acquaintances in his usual frank and candid manner. At a summer resort in Schliersee, near Munich, he came across a creative group of guests, practically an artist's colony, who welcomed him into their company. They included the orchestra conductor of the Stuttgart Opera House; a stout, jovial violoncellist named Menther; Cornelia Meysenheim, an opera singer; a Miss Devereux, an American actress and her sister, and an etcher and landscapist named Urban. Nearby lived Freiherr von Perfall, a popular novelist, and his wife Magna Irschick, a tragedienne. Among others, there was the painter Fritz Kaulbach. Sadakichi earlier had seen Magna Irschick in various roles while she was on tour in the U.S., as Medea, Mary Stuart, Joan of Arc and Jane Eyre, but to nearly empty houses. "Her star was on the decline," he keenly perceived.

One evening he was asked to recite some poetry in German. "I felt rather embarrassed, not as to the merit of my recitation, but because the actress (Magda) was not asked first. I did not realize then that married celebrities under contract were not allowed to perform privately. (Afterwards,) She said to me, 'You have a good deal of natural emotion, and a good voice, too. You should become an actor.' At last, what I wanted to hear. Too bad. If it had been before her trip, I might have acted Mortimer to her Mary."⁵¹

The group continued their social activities together, hiking into the mountains, trout fishing and swimming, with Sadakichi and the etcher/landscapist, Urban, pairing off as constant companions. Following a trout cookout one evening, the two young men sauntered off under the moonlight to a nearby waterfall with a pair of sisters with romance on their minds. While Urban was rewarded with a kiss, Sadakichi experienced nothing more than holding hands. The next day the seventeen-year-old Hartmann was unkindly informed further by his female companion that he, "was entirely too young for moonlight excursions."

And, short of funds as usual, the conductor and opera singer voluntarily contributed a small sum to enable Hartmann to stay with them until the end of vacation.

Before returning to the States, Sadakichi quenched his desire to meet with the German writer, playwright and poet, Paul Heyse.[52] Previous to his trip to Munich he had read Heyse's *"In Paradise,"* a novel of artists' life in Munich, plus several novelettes, and he was moved deeply, especially by the novel. "I was a good deal of a hero-worshiper those days, ever-anxious to get into personal touch with my favorites." So with an introductory note from Professor Sorgenloch, he made his way to Luisenstrasse 49, "a villa in the shadows of Glyltothek. I presented the letter and was asked to meet the poet in his study one flight up.

"My heart was beating, but I managed to say with nonchalant brusqueness acquired in America, 'I have read some of your stories, Herr Heyse, and I would like to make your acquaintence.'

"He asked me to be seated and I told him my antecedents, the reason of my stay in Munich, and above all else my admiration for his writings. My German-Japanese parentage was the best introduction I had at that time. It invariably interested people. Later on it became a curse, as it seemed that people were interested in nothing else but that."

One thing which struck him was Heyse's youthful appearance. At 54 he appeared 40, and his head of wavy hair and full beard betrayed not a single thread of grey.

Many of their afternoons were spent in a pleasant exchange of literary ideas and opinions over the works of various authors, playwrights and poets, and they took turns rating the actors who portrayed certain roles in a handful of plays. One afternoon he was invited to Heyse's group reading of his *"Death of Don Juan,"* after which he open heartedly presented to the youth a copy with all translation and producing rights. (Later, stateside, Hartmann presented it to Tree, Barrett, Mansfield and others, but it gathered no interest. In time it was lost.) Over their series of soirees, the 17-year-old intellectual neophyte appeared to have held his own with the seasoned, half-centurial author in their many give-and-takes, and they parted on a pleasant note. For a time he and Hartmann corresponded. When Sadakichi married for the first time five years later in 1891 to Elizabeth Blanche Walsh, he claimed Heyse sent him a wedding gift of fifty dollars.[53]

Years later, in 1910, Sadakichi in an article carelessly published Heyse's earlier unvarnished remarks concerning his dislikes of authors Ibsen and Possart, which caused the author some heavy embarrassment. Heyse of course denied making such comments, assuming his personal opinions of the various writers they discussed were in confidence, and no doubt he was highly upset at his young ward's candid revelations.

"Something similar happened to me with Whitman," Hartmann recalled. "Is it really possible that in old age one forgets what one has said in former years?" More to the point, is it really possible Sadakichi was so naive as to be unable to distinguish between confidential opinion and legitimate information? His recollection of Whitman brings the echo of an identical situation concerning them years earlier.

After befriending poet Whitman in 1884 and serving as his secretary for a time, Sadakichi, twenty, wrote an article which was published in the *New York Herald* in 1887. It embarrassed and angered Whitman (and those mentioned within), for it contained uncomplimentary comments of fellow writers and poets Whitman had made during his and Sadakichi's tete-a-tetes. Although known for his bluntness of opinion, to have them aired so publicly understandingly caused a furor. Some defenders of the poet labeled it a fantasy interview. Whitman heatedly claimed the youth's words "were absurdly warped...said things for me I didn't say for myself."[54] The old rhymster, finally in the end, more pacifistic than pugilistic, forgave him.

The following year young Hartmann attempted organizing a Whitman Society, but predictably it was a complete failure. After Whitman's death in 1892, Sadakichi, never giving up a chance for notoriety, expanded the article into a 13,000 word booklet, entitling it, "My conversations with Walt Whitman," earning him more brickbats.

Paul Johaun Ludwig von Heyse.
German playwright and writer (1830-1914)

Anna Shubart Heyse,
second wife of Paul Heyse

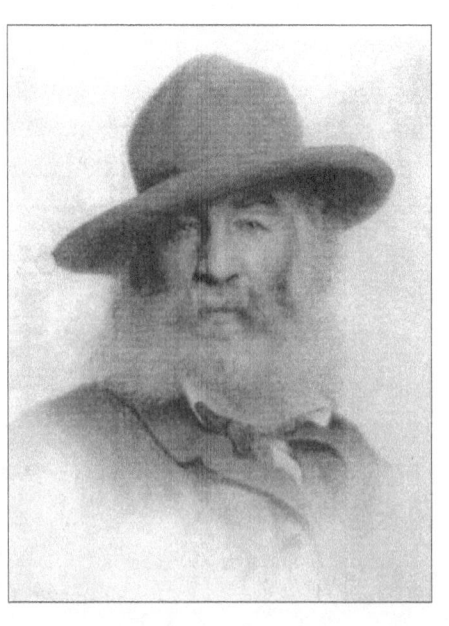

Walt Whitman, American poet, 1819-1892.
Portrait by Thomas Wilmer Dewing

9

In late September of 1885 Sadakichi Hartmann sailed back to the States—and fell in love. It was a six-month ordeal of storm and stress and angst, a siege of noir wretchedness only a 17-year-old could know. For his first experience in romantic upheaval, he was generously aided and abetted by the outlook, "I worshiped women as if they were supernatural creatures. My imagination freed them from all earthiness. They were more like spirits consisting of fire and dew than damsels with corsets and bustles. A spot on their undergarments would have been a great shock to me, like the false teeth of my aunt. Logically carried out, I must have seen them like winged heads with no body beneath their skirts."

The above observation was written by Hartmann in 1915, when he was 48, as he was putting together the pages of his autobiography.

"During my (earlier) three years in Philadelphia women had been as good as non-existent; love was not yet sprouting for me. I had not felt the slightest inclination to make the acquaintance of a young girl, if for nothing more than to ask her to take a walk with me. Flirtation was unknown to me. I lived like a young priest, buried in my studies, and without becoming conscious of any temptation.

"I remember one morning at daybreak of seeing just for a moment in the garret window opposite mine a white female vision, no doubt a servant girl in her nightgown, looking out to check the weather. But to me she seemed the most poetic apparition, something to worship from afar. For many a morning I tried to get another glimpse of her, but my vigilance was not rewarded, and it never entered my head to look for her going on errands or cleaning the front steps. At another time a young girl had stayed overnight, and I was asked to tell her it was time to get up. Instead of rapping at the door I opened it just a trifle, and with breathless trepidation, gazed through the chink. She was still asleep. Just an ordinary girl lying in bed all decorously covered up. But to me she seemed like

some sleeping beauty reclining in some castle hall. Oh, if only I had dared to be the Prince to waken her! My aunt called, 'Is she awake?' I answered, 'Not yet,' and closed the door.

"Then one New Year's Eve an older girl friend of the family, when we exchanged greetings, kissed me as she had done all the others. I thought that the heavens were opening. That was happiness. What a wonderful creature woman is! And that time may happen again next year!

"For a whole year I cherished the thought, but the following New Year she thought I had grown too big, and did not kiss me. It is difficult to imagine my angst. It kept me awake. Was I all alone in the world? Did nobody love me sufficiently even to show me a sign of affection? This worked upon my imagination. Anyway, one night I ran to the house on Logan Square where she was engaged as governess, and like a troubadour without a lute, on the ladder I looked in the windows. I had no idea where her room was, but I saw lights in one room and went into ecstasy. There behind the curtain she moved about! All in vain though, as she does not think of me, and I cannot see her."

"Of much harmless nature was my relations with the other sex until I met Clara. I had been introduced to her at some exhibition and concert at the Academy of Fine Arts. It was just before my departure to Europe when my head was filled with traveling plans, and she made no particular impression. When I came back I somehow recalled her. I had been a week in New York, living in a room without a window, having tried to find out what chances there were for any kind of a job in stage managing. I had become much discouraged, and Edwards of Wallacks stock company had assured us that there was no opportunity in the same sense as in Europe. Stage managing in America seemed to consist of scene shifting, carpentry, and a quick get out of town. The classic stars did not bother about ensemble or artistic scenery. So, I was much woebegone.

"In Philadelphia I made one more try by seeing Mrs. John Drew of the Arch Street Theatre. I called at her house and was ushered into a large and silent parlor, and from behind a screen, just as a scene from the *Rivais,* emerged a lady as it seemed to me hoop-petticoated and frilled as in a play of the Restoration, fan in hand, the actress I had admired so often from the gallery of her own theater."

Whatever audition or demonstration Sadakichi exhibited, Mrs. Drew expressed little interest in his presentation, commenting further that she had all

the help she needed. "I still believe the play's the thing," she added. As she made a curtsy, he bowed in return, and that ended the interview.

"I needed consolation. I was tired of living alone. I wanted to live with some family, so I thought since Clara was living with her mother and sister—they had a little dry goods store in Philadelphia—I could find accommodations there. She was a cousin of my young lithographer friend, and he arranged matters for me at some ridiculously low rate, four dollars per week, or something like that.

"I had not an idea what I would do next. Well, Clara and I got along with each other from the start. We liked each other, and I offered to read to her, which she graciously accepted and which I attended to with incomparable zest. I was willing to read at all times. A stroll into the park, yes, and then some more reading, why not? Reading after dinner, reading before supper, after supper, only not in the morning as she had to tidy up the rooms. But the rest of the time when she was sewing there was no objection. And we were never disturbed, for her mother was busy tending the store, and her sister who did not care for that sort of thing did the cooking. And so it was not strange that the same thing occurred to us as once to Paolo and Francesca.[55] But as she (Clara) was unmarried, no jealous male darkened the scene, only our progress in studying Whitman was severely hampered by frequent neglect of the finished page before us. Then I realized that this was love, at last the real love of which I had read so much, and my conscience at once became busy. Of course, we had to get married. The difference in our ages? She was twenty-eight and I seventeen. What does that matter? Love is love, and cannot be controlled by any such reasons. But if that was the case, I argued against my own wishes, for it was no longer proper for me to stay under the same roof with her. Why, she innocently asked, she being almost as unsophisticated as I. Why? Because a gentleman can not do such a thing. Obeying some atavistic code of conduct I had to move just when I found a homelike place. True, the food was not sumptuous, the carpets discolored and the sofa badly in need of upholstering. Still, everything was acceptable those days, for the last years had hardened me.

"With a great display of emotion I advised her to tell her mother. The mother said these were very honorable sentiments to which she could not help but agree. And so I summoned my friend from Flanders, who had become so attached to me that he would do any errand at my bidding, and we carried my

possessions away, per horsecar. A few kisses in secret as a last farewell until the next day, when I would call as behooved a gentleman who wooed a lady, was the only consolation, but when I got back to my old room in Poplar Street I collapsed. Why had I to live all alone? I just craved association with some member of the gentler sex, and Clara was sweetheart, sister and mother, all in one. I could not stand the separation! So I jumped on the next car, determined to have them take me back, as this argument about propriety was all foolishness. Why could not two people who loved each other in an honorable way live under the same roof? It had been done before, it could be done again. Besides, an exceptional case like this one needed first class treatment.

"But her mother shook her head, she thought it was after all better as I had decided, that I should not take it to heart so much, as I could call every day.

"Well, in one way, it was very apropos that it was settled that way, on account of my pecuniary vicissitudes, as it would have been rather embarrassing to owe my prospective mother-in-law, which would have been the case within a few weeks. As it was I could not stay at my old haunt and moved to North 13 Street. So poverty compelled me to write my first literary efforts. (First) a visit to Gabriel Max's studio, for which I received the munificent sum of two dollars from an American, and another from Carducci, much in the method of a foundation. I felt at the time I had hitherto done very little original thinking so I set forth to write an essay on the nude in art, and went especially to the park for a whole day, making myself think hard, knocking my forehead, tossing about on the grass, trying to seize upon something like a coherent utterance, until my head felt it would burst. The mind was stubborn and for a long time would not respond. With both hands clenched, pushing fists forward, I endeavored to jerk out some well-connected words-crack! crack! seemed to go my brain cells. Finally exhausted I managed to scribble down some sequence of thoughts, and felt proud and elated over the achievement.

"A few days later things came more easily and I penned quite a lengthy paper on German Literature up to Paul Heyse, which was much admired by my old friend, the second-hand bookdealer, and Dr. Brotherton.

"I still had stage aspirations and remember answering an advertisement where I met a number of crude young fellows who all wanted to act *Hamlet,* so I joined in reciting some of the soliloquies for their benefit (I knew *Hamlet* by heart

at the time). They decided that I would do, for what I never found out, for I never heard from these embryo thespians again.

"I still must have received occasional contributions from Germany, for I indulged in a few pleasure trips during the summer. Smyth was studying at John Hopkins, so I thought I would pay him a visit. I only knew the name of the street where he lived when I arrived in Baltimore, so with rare persistence I rang every doorbell until I finally was directed to the right rooming house for students. Smyth was delighted to see his prodigy, and showed me what was worth seeing in Baltimore. There seemed to be bronze statues of Barye everywhere;[56] on Mount Vernon Place, and also if I remember rightly, in the Sunken Gardens. Then we went to a classroom where they studied *Faust* in a way which I considered irritatingly dull. After spending the day with Smyth about the college grounds, I went for a day to Washington to visit the Corcoran Gallery and the Smithsonian Institute. Some time after I made my first trip to Boston, just a sightseeing tour, and faithfully visited the City Hall, Fanueil Hall, the Bunker Hill Monument, the Art Museum, the Public Gardens, the Black Bay, the Charles River Bridge and the Shakespearian Window at Harvard College, which had furnished the cover for our little magazine, *Shakespeareana*.

"The rest of the time I spent in West Philadelphia. I still studied, but preferred to study together with Clara, who had read little but an occasional novel and Rainer Maria Rilke's works, and no doubt wondered at the unlimited richness of my literary offerings. I still saw my old acquaintances, but not as frequently, as it amounted to the problem whether I would rather spend all afternoon or evening in somebody else's company or Clara's. The solution of course was self-evident. I frequently came for the whole day, but if I could not manage that I would come in the afternoon, and scarcely ever called to appear for supper and the rest of the evening. Whenever I could I tried to drag her along to Whitman or anybody else, but there were not many opportunities. As it was, since neither of us had any money, I was content with sitting in the parlor with its black horsehair sofa and atrocious crayon portraits, partaking of frugal meals that never varied in their monotony, and taking an occasional stroll in the park.

"I bought new books almost every day and never tired of reading aloud. I read to her in the parlor or the backyard, leaning against the door when she was on duty in the store, where she was sweeping or ironing. My intellect was carnivorous and constantly demanding food, and I made her share my indiscriminate

taste and hunger. I endeavored to fill the gaps that were left from former explorations. I left many fields of learning entirely unexplored; I never cared for mere facts or information. Knowledge had to be picturesque suggestively before it appealed to me.

"And there was of course a most ardent devotion to osculation, plain osculation without any fancy frills or mortifying caresses. Even the sadly neglected swell of her breasts yielded no sweet moments for me. At first we did in dead secret, but the second year we grew a little more audacious. We did not mind the boy boarder when he just happened to be around and stared at us with undisguised wonder. And one evening when Clara felt mischievous, we performed a regular kissing match before her sister who exclaimed, 'Gracious me, have you gone on that way all the time!'

"Yes, we were guilty to that extent. And to think that such an affair could last for six months, and that after a winter's absence in the siren city of the Seine we continued to express love in the same milk and water fashion. This proves that I was extremely backward in certain things. I was mentally over-balanced. There was no room for sensual expansion. Although erotically inclined in my literary taste, and even a student of sexual psychology, my own instincts were so overgrown, so choked with book knowledge, they operated unconsciously if in evidence at all. Of course there were moments when my caresses tried to roam astray, but she always rebuked me. And thus it could happen I know. I knew her for a year and a half, often spending days in constant company with her, the affair remained strictly platonic, or rather childish and amateurish.

"A rather cold blooded arrangement? No, indeed, it was all fire and flame, lambent vapor that transfigured all things for me. I recall one moonlit night in the park near the William Bent College, when I felt so exalted, that the earth actually seemed to sway about me, the light patches on the grass and the wavering shadows of the trees seemed to intermingle, and I was filled to overflowing with a jubilant sensation of happiness. Although ever eager to analyze my emotions like an entomologist, the transformations in an insect's life, I never experienced anything so spontaneous and exquisite again. It was love, but unstained by passion, love of the Laura and Beatrice kind,[57] the first effervescence of awakening, still undeveloped and unconscious, perhaps the best a young man can offer to a woman. What Clara, still virginal and unscathed by grosser sensations felt, I

can not tell. Intimate naturalism can not be applied to other persons, it hardly surfaces for self-analysis. One can not state what other people feel. Even in the greater writers it is little more than conjecture and surmise. And that is why I never attempted writing a novel.

"It all seems a trifle silly to me now. Still, it was genuine, and its fervor the trickling flow of a huge casket brimful with passion, perversion, brutality, as yet untapped. I feel as if I scattered before her the best I ever had to offer a woman. This may be vanity, and I do not know how far she appraised it, I feel more than I want to make myself believe from the events of her later life.

"After the humiliating experience in the park when we were discovered by a policeman in a rather precarious position, I felt that there was something struggling within me that threatened the serenity of our relationship. I had the idea that if nudity was the emblem of purity, than it would also possess that calming and cleansing influence in real life. So I proposed the rather preposterous proposition that I would like to see Clara naked, not unlike the unrobing incident of Hannah in my *Christ*, II, 2.[58] It was to me an abstract ideal. Clara could not quite see it that way. Well, what was the use then of reading Whitman on praising Greek sculpture, of the allegory of truth coming out of the well. We argued for days. Clara no doubt felt like Lady Godiva ready to make the sacrifice, but only with the consent of her mother. I threw up my arms in despair. What had a third person, a brainless mother, to do with such a delicate experiment! How could I ever deem it successfully? Still, it was put before her trinomial for decision. The denudation did not take place, and I remained unpurified. I suppose my theory was strictly pagan and not applicable to Christian practices. And might it not have worked as in the case of St. Anthony, like a temptation rather than a moral invigoration?

"One evening Clara was ironing some underwear. I wanted to take up one piece, quite innocently, and examine it as to the cut. But before I could reach it she hid it in the basket with the other clothes. As her sister was present nothing further was said. But afterwards I wanted to know the reason of her action. She answered she was afraid that I might make an improper remark. I felt furious and deeply hurt and ran out into the night, and sat actually crying with indignation on a bench near the Fairmont Avenue Bridge. I can still see the bridge in the bright moonlit night, and my sorrow at not being understood. People, apparently even those nearest to each other, always suspect each other of something mean.

Misunderstandings of this kind with endless explanations were plentiful, and kept us busy dodging the strokes of fate that seem to fall even into the most idyllic of existence.

"Another time we made an excursion to Salem, that once so prosperous and now so deteriorated looking harbor town. What the trip amounted to anybody can imagine who knows the Delaware of that region. Just a muddy flood and no banks of interest whatsoever in the distance. The apparent purpose of this sail I suppose was the enjoyment of the river breeze, as the boat was scheduled to make the return within half an hour after it reached Salem. We got on land and took a walk along a dismal array of fenced-in yards, I with the ardent desire that we would stroll too far so that we would miss the boat. Then there would be some adventure. Perhaps we may have to stay overnight in some hotel. Then she would not refuse my request. For what? Oh, to show herself naked to me. That crazy notion was still in my mind, and that is as far as my thoughts went. Even three years later in a similar case the idea of seduction would not have entered my mind. And we did not miss the boat.

"Clara had become more suspicious, and whenever I touched her body by accident she thought it was intentional. No doubt, true to female nature, she expected something wonderful which never happened, for the simple reason that she had accepted not a man but a young boy as a suitor, precocious in everything else but sexual feeling.

"We weathered the cape of the horned beast successfully, and even in the farewell night before my departure to Paris, when we stayed up until nearly dawn, I never took any liberties with her (with this one exception in the park), not even as much as opening her waist or fondling her knee. It was straight osculation throughout."

Sadakichi left, regretfully he claimed, for his second trip to Europe in October 1886, returning to Philadelphia in June the following year. He stayed but a short while in Philadelphia before moving to Boston in August, after finding his relationship with Clara pretty much the same. "I had grown considerably mentally," he evaluated, "and was more spiritual than ever." He went on to describe her as," ...tall and slender, with curly dark brown hair, rather keen features, and a big nose. The color of her eyes, even as I looked into them a thousand times, I have always failed to remember. Of her body," he somewhat groused, "I knew nothing."

"Time makes incidents hazy and vague, and our memory becomes treacherous even as to the most important events of the past. Thus I do not recall the reason for our rupture. It is very likely that it was solely about some argument. I wanted her to agree about something to which she would not agree, perhaps the threat that the surrender of a woman always depended upon the wooing faculties of the man, or something like that. When she failed to grasp my argument, I sent my ultimatum that all was over, and that she, please! would return my letters. I wrote this on the same day she sent me a box of roses for my birthday, and the communications crossed each other. I buried my face in the half-faded roses and mourned the death of my first love. She the next day brought back my letters, a parting of alarming dimensions.

So, with his romantic life crashing around him, he decided to pull up stakes. He was probably further impelled to make a move by Clara's mother's practical advice that he should settle down and do something, like get a job. "So I made up my mind to try Boston. I had no particular or clear idea of what I was going to do if once there. I wanted to become internationally famous, that was the principle motive."

In Boston, Sadakichi begins his serious plunge to make himself known in the world of creative arts. He commences writing free-lance articles on a variety of cultural topics, gave his first of soon-to-be many lectures on art, and before too long, his extroverted and bold social approach caused him to became a well-known individual in cultural circles. In late 1887 he prepared for his third voyage.

"When I parted again for Europe the next year, I called at her home, (but) the mother and sister at first would not admit me, (declaring) I had acted like a scoundrel and I had never returned Clara's letters, etc. But Clara intervened, and there we were once more in the parlor. She was dressed in black and deliciously pale and looked to me exceedingly beautiful. She said that she always expected that I would come back. Did she believe that I still intended to marry her? I was only too willing. I assured her that everything was as before. But then the mother appeared like a huntress from the forest. She had no hunting horn, but her voice was sufficient to tell me that I had to leave.

"This is the last time I saw her, excepting one time, many years later from a train on an errand to Philadelphia. She was well in the thirties then, but still under the winged protection of her mother, and as the three women scaled a

rocky slope over the park entrance, the sisters very much resembled chickens running aside a clucking patriarchal hen.

"No doubt, it could not be otherwise. The union was impossible from the start. Not on account of the difference of age, this was fatal only because I was walking with seven league boots while she stayed at the little dry goods store in Philadelphia. Her mental development proceeded as far as becoming an ardent admirer of social theorist Harriet Martineau, and then came to a standstill. I later heard that she had become bigoted and religious, and finally when near fifty married a widower with several children. I hope she did not wait for me. It would be too sad to waste a life of might have been large and sympathetic, and of much usefulness and beauty to marry a man in her own sphere, in such an act of identity to the past.

"I never had talent for a Chevalier Bayard, or Sir Phillip Sidney.[59] Still, she always presented to me a dear and pleasant memory, of my first sweetheart, to whom I gave everything I had to give, little as that may have been. Hers was a simple loving heart, a nature strangely tranquil and sincere, and I owe much to her friendship. Deplorable indeed that persons that have meant so much to each other never meet again. I would like to hear from her own lips that she did not regret anything, and that she had found some haven of rest and comparative happiness. I am certain she would not have found it with me.

"She still continued to pay visits to Walt Whitman during the last years of his life. No doubt he cherished her earnestness and frankness. Our one time admiration of that grand old man—now slightly fingered, earmarked and dust worn—is a bond that will always unite us, and I stretch forth my hand to you in greeting over his grave, and the residing giant. So long."

10

While in Boston Sadakichi's time was well served, for he knuckled down and seriously begin writing articles which were published in various outlets. He also continued the lecture circuit and gave art lessons, and as he wished, he was becoming highly noticed in art circles. Late that year, in October 1887, the 18-year-old departed for his third trip abroad, to England, Paris and Holland. During his travels his essays were published in Boston newspapers.

After about eight months, his last stop before returning to Boston was Charleroi, Belgium, where he planned to visit his father and to recuperate, "being all run down," most probably from traveling about and burning the candle at both ends. With his father was his stepmother, Helen, her three daughters, a governess and a servant girl.

It seems Hartmann pere had lost quite a lot of money on various financial speculations, and also (Sadakichi was later informed by relatives), some of the youth's trust fund. The trust had been set up for him years before by his uncle Ernst, which in time had been entrusted to his father. He also learned that when his father had given him money for his initial "immigration" to the States, he had dipped into his son's trust to pay for his journey-without his knowledge, of course. It appears Sadakichi took this bit of grim news in silence.[60]

At this time his father was the head bookkeeper at one of the largest glass factories in town, Charleroi being the center of Belgian's glass industry. But Sadakichi hardly got to see him, for he would leave for work early in the morning and never return until late in the evening; they were more like ships passing in the night, possibly as his father desired. As a result the youth had little to do, for there were no theaters, galleries or a decent library. His only associates were several clerks of his father's company, and with them he would travel to several outlaying towns for sightseeing jaunts.

In his solitary peregrinations he would often pass far into the country where for miles around there was nothing but scraggy villages and coal mines, and it gave him a depressing view as to how the poor lived. Workers with their dinner pails would be shuffling to and fro to the shafts at all hours, the children in rags. Before long he was exposed to the miners' wrath over their working conditions and occasional strikes, and he could not understand how the mine owners could remain so coldly unconcerned about the hardship and suffering of their employees. Sadakichi's dark fury at their plight opened a vein or two in his idealistic nature, where he was tempted to make a rallying speech to the workers, encouraging them to rise up against brutal capitalism, to make a move against wage-cuts and starvation. From his balcony one day he witnessed a march of miners from several villages, all dressed in dark, drab colors and accompanied by their wives and children, singing the *Marseillaise* and other revolutionary hymns. From the wreathes scrawled with the names of dead miners he realized it was actually a funeral procession. Aflame at the indignation of their treatment he wrote a "glowing article" in German, "Charleroi Mining Strike," which was published in 1888.[61]

He was interrupted at this time by an invitation from Uncle Ernst to come visit him, possibly at his father's "timely" suggestion, and did so, soon forgetting about the miners plight. But when he returned to Charleroi, he was reawakened again to their labor difficulties and poverty-stricken condition, and desired to do something more concrete for their cause. But his father quickly noticed what his son's young brain was up to, so swiftly shipped him out to the port of Antwerp and the States, their personal history repeating itself once again.

"On the train to Antwerp," he wrote, "the car was shared by three unusual traveling companions: a general of the Belgium army, a priest, and a business man, and they discussed the mining situation. There was much pro and con, and all voiced their opinions in such a forceful manner that when our journey came to an end, I was almost cured. I argued, if there are so many varied opinions, and each one sounds logical and may be right, how can my own be any more valuable? Better do what you can do best, and not worry too much about the destiny of other folks. My belief in brotherhood was largely youthful enthusiasm, and not built on deep foundations. I was primarily an aristocrat and have remained one all my life. Yes, if I had been given the chance to function differently I might have done much, because I believe in the fundamentals of honesty, discrimination and

good will. I am a purist after all, and not particularly interested in the swinishness constantly perpetuated by men and women who should know better."[62]

And so, shrugging his shoulders philosophically, he continued his journey back to the U.S.A.

On an August evening of 1887 in Philadelphia, Sadakichi was strolling about the deck of a ferry on the Fall River Line, and while peering through the windows into a dining room, mentally salivated at the large lumps of butter served with supper. By chance at that moment he met the Philadelphia millionaire J. G. Rosengarten who was on his way to Newport.[63] He was accompanied by a pair of German-American girls, governesses of rich families. After a short discussion, Rosengarten felt Sadakichi was making a good move, moving to Boston, and gave him kind advice, money, and letters of introduction, after which he retired early.

Arriving in Boston, Sadakichi got a newspaper and checked the "rooms for rent" columns, then took a cab where he found a pleasant front parlor and adjoining alcove in West Chester Park for eight dollars a week. He felt it was rather steep, but then one had to keep up appearances, he argued to himself. He felt he was rich with still a few dollars in his pocket.

One of Rosengarten's letters was to a young architect which worked wonders. He was received by the architect in noble style, invited to dine at his home, and then made him a guest for five weeks at the St. Botolph Club. But the dinners at the architect's home proved a failure, for his sister's raved about Lillie Lehmann, an actress visiting from Germany. Bluntly, Hartmann remarked that they did not think too much of her in Berlin. Their reply of, "Well, she is good enough for us," gave him a chill, and he realized he would have to guard his tongue a little closer as to his critical opinions if he wanted to get along in Boston.

But at the St. Botolph Club he made much better headway, and it was a wonderful opportunity, for him. In a fortnight he met many notables of Boston, and through them many others. The range of people he gained introductions to were numerous. But the downside was they were all professional men, doctors, artists, music teachers, actors and literati by the dozen, and he considered them "sympathizers," for rarely could they afford to be patrons, which he sought.[64]

"I made many calls in the North End and Back Bay, and also met the one lady at the Hamilton Apartments who had sponsored the Browning readings

by Ordway Partridge. He had been the rage the season before, had lectured all winter at two dollars per, and finally married a lady of some resources which, as he wanted to become a sculptor, was sure to help him in his career. The Partridges were sailing for Europe, so the former hostess kindly suggested, 'They will dine here next Friday, you better come and meet him, he could tell you just what you want to know.'

"I did not show up. What I heard of him was unsympathetic. I now believe that he could have given me valuable hints, i.e., valuable if I had followed them. But I was headstrong, contrary, obstinate.[65] I insisted on going my own way, and yet I realized even then what I needed most was some guidance, gentle but firm; I was absolutely alone and although many were interested they were not near enough to influence me. Partridge had been a lion; I wanted to become one. He could have told me how he did it, but I really didn't know what I wanted to do. It was never in my mind to become lionized, that came later, only not in such a shrewd and systemized manner.

"I was a true visionary living in a world of dreams, but of course could not subsist that way, and had to turn to some way of getting a few dollars. Boston society life had a distinctly intellectual flavor on the surface, and it was just this which made certain things possible. I took a young lady to the art museum and was paid three dollars for each of those explanatory trips. I gave lessons in German for two dollars, and arranged readings in German for which tickets were sold and generally netted eighteen to thirty-five dollars.

"There was an extremely quixotic idea in my head of starting a Whitman Society, and I dreamt of having a huge sign in gold lettering across my bay window announcing, The Walt Whitman Society. Of course, I would also rent the lower floor—we would have a reading room, a Whitmannea department, lectures, classes and many other wonderful things. And I of course would be the curator of this self-created establishment.

"Mr. Rosengarten gave me some money to get started, but gave me at the same time the advice that a man who could not get along himself had no right to try and help others. And then John Boyle O'Reilly, who was somewhat touched by my foolish enthusiasm, gave me a rough awakening by explaining in a truly fatherly fashion, that Boston was the last place on earth for a Whitman Society, and if I hoped to get enough paying members to promote such a scheme that I was wasting time. The idea was alright but was hopelessly impractical. Alas, the Whitman Society died a natural death.

"I continued to make acquaintances and calls to studios and local celebrities. I contributed articles to the *Evening Transcript, Record* and the *Advertiser,* farfetched but fairly well written stuff about Russian painters, modern Greek art, Bastien LePage, etc., and several articles on German literature, Munich and Paul Hesye. W. F. Fullerton thought some of them good enough to be published in a little book, but I protested violently as I could do so much better in the near future. Very modest and praiseworthy, but unbelievably stupid! To break into publication at such an early date would have meant much. But I strove for mightier accomplishments. I was busy with poems in the Whitman vein, erotic verses, and even a drama of four acts on Lincoln. A review of the ms can still be found in the files of the *Advertiser.* I began to feel my strength, my Pegasus was prancing about, but I was not yet used to all its antics and might have become unseated in some soaring flight.

"Just for fun I passed a public school examination for teaching German and French. I had to kite my age as I had to do on all occasions. The examination was *kinderspiel* (childs play) for me. It consisted on writing a short essay on Goethe's *Faust,* Corneille's *Le Cid,* and a statement on how I would teach grammar. Well, I assumed that I had a special way of my own, some Berlitz fashion. I passed easily and was offered a night school, but after some deliberation refused the job, as I wanted my evenings free. Evenings are the time when society lions prowl about, so I could not sacrifice the precious hours. Besides, I hated routine. Hadn't I left Germany for that reason?

"I gave a lecture on Paul Heyse in Chickering Hall, which if my memory serves me right was my first appearance as a lecturer, except I would give this distinction to an art talk in Alexander's former studio to a small gathering. I also arranged two concerts of chamber music devoted entirely to Edvard Grieg's works—a biographical introduction, short but in my best manner, the two violin sonatas in C major and G major (the first time in this country); some songs and piano solos in the parlors of one of the most fashionable hotels, the Vendome, and the large rooms were crowded. It went off with a fine snap to it. They were standing even in the corridors. I showed great skill in papering a house. Too, the three talented and advanced music students as accompanists, and soloists, from a symphony orchestra, worked out for the good. Still, after I had paid rent and stationary, there was little left over for the youthful impresario.

"Although I could have well afforded to wear a dress suit, I affected a

Byronic-Whitman style of no vest, a plain shirt front with flowing tie. This was registered as a point against me, as so many others afterwards. Still, the ladies young and old were fond of me. I owed the little success to them even if they looked at me more as a curiosity than as a desirable companion. I never made any advances to them, and in fact I did not know how and frequently assumed a dry Sunday school attitude.

"I was now in the swim, and swam lustily without any special aim. I just gamboled in the water, paddled and splashed up a lot of spray in all directions, and then floated not caring about anybody. It could not last long, for as soon as the novelty of my personality wore off I would be shelved as a back number.

"I had classes and gave any amount of private readings, and every father's son attended my round of social duties which consisted of showing myself at recitals, teas and receptions at the rate of at least four or five daily. To be invited to supper or dinner was a rarity; my activity was strictly perfunctory, just to pop in at an entertainment or social meeting. The acme of foolishness was my giving lectures in German, as nobody in the audience could speak the language, but my only serious competitor, Count Panin went me one better by giving a course in Russian literature in Russian when not a soul in his audiences could understand a word he was saying. We were like two show lions in different circuses. We hardly met, but when we did at evening parties, we were too diplomatic to growl at each other.

"Most of my evenings were devoted to making calls to keep up necessary prestige. I donned my Prince Albert and drove about in cabs, generally accompanied by one of my musical protégés, most frequently Froken Berg, a splendid Swedish pianist, still a young woman although easily ten years older than I. And so it came to pass that I also became a caller at Miss Vivian's, an ex-governor's daughter at their fine mansion on Commonwealth Avenue.

"How well I remember my first call. Since Miss Vivian was known as one of the best amateur pianists in town, I brought with me 'my pianist' to entertain the fair lady. Miss Vivian was a lively chatterer who probably considered me the most curious bird that ever flew to her 'at homes,' but always looked a trifle tired, not as the result of a too busy season for she hated that sort of thing, but from some less easily defined reason. She seemed weary of the pleasures that wealth and society offered. Perhaps she felt a void as she was going on in years and her younger sisters had already attained domestic felicity. She was a charming dame,

interesting and refined, and in a way expressed the restless American type of esthetic inclinations. She had made several trips alone to Europe. Ah, how I wished I could accompany her on the next. Her knowledge of art however, I discovered to be less than remarkable. One morning Vivian showed me her father's collection of paintings. Standing before a large canvas, hanging high, representing peasant women at work in the fields, she remarked with a wise mein, 'Isn't that a fine Bastien Lepage? You remember, the one who painted the Joan of Arc in the museum?' For a moment I was dumbfounded. I knew she was wrong, and then with my precocious though infallible acquaintanceship in art matters, I bluntly corrected her. 'Are you not mistaken? This is not a Lepage, Miss Vivian, it is a Leroiles.' 'Of course,' she blushed somewhat indignantly, likewise the writer of these lines, who found Miss Vivian a most charming creature. But I was simply incorrigible that way, not to show my knowledge, but simply to have things right.

"And thereupon as things went on all smoothly, I made another *faux pas* for which I could have kicked myself all over the Back Bay, yea, into the very Charles River.

"Those days I took no heed of time. So one morning when I awoke as the sun shone joyously into my room, I said to myself, 'Fine day to call on Vivian,' and dressed with amazing rapidity. Leisurely I strolled to their palatial residence. I did not know what time it was as I had pawned my watch. On the steps I tied my shoestrings that had become unfastened, and just as I was tying them, the door opened and the millionaire father stepped out. 'What on earth do you want?' 'I would like to see your daughter, Miss Vivian.' He laughed, 'Go and try,' and he looked at me like I was crazy, shook his head and went his way. I rang the bell once, twice. At last a servant appeared. I asked for Miss Vivian. The servant grinned, 'Going to see her in bed?' 'Why? What time is it?' 'Ten minutes of eight.' Then I collapsed, reeled away like a drunken man, and felt so ashamed I never called again.

"Glad that it did not get into the papers. I received so many press notices that I was a really a much-talked of personality. My readings and my contributions to the local press had established a certain intellectual standing for me, for an eighteen-year-old boy in Boston. Oh, shades of Thoreau and Emerson! I led a sort of devil-may-care-existence. I took my meals in the swellest restaurants, and had developed into a regular first-nighter. I was seen at all concerts, theatrical shows and exhibitions. I called at studios and dined preferably with artists. As

I hardly made enough to live in this semi-opulent fashion, I was chronically hard-up, but had a great knack for borrowing money. Everybody seemed to like me, and nobody I asked in those days (always men) refused to help me along.

"Thus the first season (of Boston) came to an end, and I felt with the strange confidence of youth that I would conquer the modern Athens completely next season. 'I'll go once more to Europe,' I concluded. 'And during the next season of '88 and '89 I'll try something on a larger scale!' And so I did.

"A lady in Paris had presented me with two hundred francs, my grandmother has sent me an allowance to provide me for three months, and my venerable father (a rare occurrence indeed), also had added a small amount which helped to swell my funds to about eight hundred francs. Comparative riches! And if I had proceeded straight to London as was my intention, I could have managed for quite a while. But I decreed otherwise. Why not make a trip through Holland?! The famous Saxon-Meininger Company was playing in Rotterdam, and I was anxious to see the art galleries of the Hague and Amsterdam.

"So, light-hearted, I bid goodbye to my father and Charleroi, and via Brussels started for Rotterdam. The town made no particular impression upon me. The Maas was too much like the Elbe to tempt me to any special exploration. I felt but a vague regard for the picturesqueness of bowsprit avenues and warehouses with occasional glimpses of masts and spars over the housetops, still some of the street vistas gratified my taste in the direction of good composition.

"There was an art museum in town but it did not prove interesting. In the hotel I heard nothing but English—some tourist party with a clergyman as guide which I was glad to escape. The only event was the performance of *The Merchant of Venice,* unforgettable in values of stagecraft. The same company was to give *Wilhelm Tell* two days later, yet tired of Rotterdam I decide to take a train to the Hague.

"Surely, one of the most handsome, idyllic towns I ever visited! By this time I had found my bearings, that is, I imagined I possessed infinite wealth, or rather I gave no thought to my finances and considered it indispensable to my momentary welfare to hire a guide and a fiacre for a day. I spent nearly a whole day in the museum, told the guide not to bother me, and gave my fullest attention to the treasures of that wonderful gallery. I intoxicated my vision with *The Anatomy Lesson,* Potter's *Bull* and the splendid Rubens canvasses. *The*

Steerage failed to register, and the collection of Chinese things I did not notice at all.

"After a visit to marine painter Mesdag's studio we took a drive through the park. The guide told me about Voltaire who had frequently roamed about this park, 'ruminating in thought.' Such remarks never fail to make a deep impression upon me, incorrigible hero-worshiper that I am. The natural scenery of the park is superb. It had rained in the morning, and when the sun had glided over the moist foliage the effect was quite enchanting.

"As a matter of course we paid a visit to the Huis Ten Bosh,[66] the beautiful summer residence of the Queen of the Woods with the octagonal wall covered from floor to dome with allegorical murals by Jordaens and other Rubens pupils.[67] More gorgeous wall decorations can hardly be imagined; it is just a laughing riot of color. It gave me a finer idea of the splendor and verve of the Rubens school than any museum. I also imagined what I imagined huge relief work in marble, but with closer inspection proved to be painted. Perfect imitation is rarely art, yet in this case it resembles perfect illusion, and one cannot help wondering at the patience and dexterity (of the artist).

"The entire chateau, the tapestry, the furniture, the view of the park from the windows, is a fairyland, a retreat such as a wealthy poet should inhabit, and I expressed my astonishment that the caretakers permitted people to tramp over the marble with dirty shoes. On the terrace opening on flower beds, I fancied the possibility of some princess appearing and—yes, my ideal of woman fell nothing short of princesses, and to think that my first sweetheart happened to be a West Philadelphia shopkeeper. No doubt the old ashes and elms saw me standing there lost in my day dreams like thousands of visitors before me. I found it difficult to part.

"Thereupon we drove through an avenue lined with the most beautiful villas, but my eyes were tired, and as nothing could supersede the splendor of what I had seen, I kept my eyes half-closed until we arrived in Sheveningen. The season had not yet opened, everything seemed deserted, just the time of the year when I like these shore resorts best. Just the sandy shore, grey skies and the North Sea rolling in. Ah, these days in Holland were worth all the privations that were to follow.

"The next day saw me in Amsterdam. I went to the best hotel which had a wonderful specimen of a uniformed porter standing at the entrance. I concluded

to engage no guide but to get all information from this living Baedeker. But I could not manage without a fiacre by the day. To my great regret the museum was officially closed. I bribed my way in anyway but was not allowed to stay any length of time. What else was there to see? I marched through the Royal Palace, looked at some diamond cutlery, drove about the canals, dined, visited some art stores, and then told the coachman that I would like to go to some theater, by saying in the German pronunciation, *theater!* He did not understand. He pointed with his whip in all directions and profusely shook his head. I pronounced the word in different ways; theatre, theater, teatro. Still he grew more vehement in his negative pantomime. Finally I made him drive on, and when we came to a place that looked like a theater I made him halt. "Shrouvburg!" he exclaimed in wonder. Nor was his astonishment more greater than mine. Who would have guessed that theater in Dutch was called shrouvburg. And there I saw *The Mikado* in Dutch. It disgusted me. Had I come to Amsterdam to see *The Mikado?!*

"I decided to leave the next day. Well, it was really a necessity, as my funds had dwindled to an alarmingly small heap of gold coins. The last day I strolled about listlessly, secured a first class passage to London via Flushing, and as I had nothing else to do—although I was not hungry at all having dined a few hours before—I ordered an opulent farewell supper: a huge steak, green peas, creamed potatoes and a bottle of wine, the last real dinner I was going to enjoy for months to come, for counting over my cash I realized that by the time I arrived at Pancreas Station I would have only seventeen shillings to my name.

"It still amazes me how I managed to spend all my funds in less than a week. Of course a millionaire's son can spend as much as that in one day, but my wants were after all limited; railroad fares, hotel bills, meals, fiacre, guide and incidentals as theater tickets and tips. Nothing else, yet money slipped through my fingers as it always has done, and I accepted the fact of having nothing to live on with the indifference of a gambler. Surely my childhood had spoiled me, and days of starvation had not cured me. Nor would they ever. Well, there was no regret. I had seen Holland. The sum total of experiences was small; a theatrical performance, a few paintings, the sunny palace in the woods, a glimpse of Scheveningen, and a short sojourn in Amsterdam. But I would never have seen these places otherwise. When one is young one must take advantage of opportunities, or rather create opportunities."

Let us interrupt our hero's text a moment to speak briefly of his "amazement"

at how swiftly he is able to exhaust his funds in record time. This is the one constant he appears to have maintained all his life, to expertly deplete whatever finances he had on hand as quickly as possible with no thought whatsoever of the consequences, except to end up starving. He probably went through more periods of hunger than any dozens of struggling artists in the world. His text is replete with descriptions of times when he had not a dime for a week or so, then suddenly he is flush from a "patron," or a loan, of maybe ten or twenty dollars, which he immediately disperses before the day is up. First of course is a Roman-type banquet at a restaurant, then a play or two, etc., etc., until in the morning he awakes to find himself penniless. He seems at times an Arab trundling through the lean desert from oasis to oasis, or a modern Ulysses on a perpetual odyssey of feast and famine. He even includes an interesting but stomach-gnawing five-page chapter in his autobiography of his experiment on starvation, *Hebdonas Magna* (Great Week), with a noir-like three-page introduction, *Hunger*. Whatever periodic starvation meant to him, it was a ritual which haunted him all his life. Perhaps it was in his DNA and designated, spent love.

Briefly, Great Week begins with Sunday: "When I awoke I felt that it would be a hot day, ninety in the shade at least. Monday: Felt hungry all day long. The pain never ceased, not for a minute. Tuesday: Felt no pain at all, only strangely weak and lightheaded, the blood rushing to my head whenever I stooped for something. Wednesday: Woke up feeling no pain. I wondered at it. Only at noon I suffered for an hour or so. Thursday: Six o'clock found me in a deep brown study. How people can fast for the sake of experiment is beyond me-I mused chewing on a lead pencil... Friday: It would be difficult to describe how the day passed. The wisest was not to leave the room all day. I opened a book. I felt so dull and drowsy that I merely saw letters without grasping their meaning. Saturday: Money by mail! Huzzah- how wonderful is life! I rushed to the nearest restaurant and partook of a hearty meal. My stomach, no longer used to digestion, rebelled at such crude treatment, and the meal was on the sidewalk... At lunch I was more careful. In the meanwhile I had purchased a book on art anatomy and a zither—why, of all things? Well, just because I wanted to own a zither. After that, on the way to a matinee, visits to several second-hand bookstores on ninth Street. Dinner after the performance, then off to Offenbach's *Orpheus and Eurydice* at the old Chestnut Street Opera House. The fast was over." (Each day's entry, of course, contained long paragraphs detailing his wrenching agonies).

83

Now, let us return to the text.

"I had seventeen shillings left. I took a cab to a boarding house on City Road which had been recommended at the reasonable rate of twenty-one shillings a week. There was no vacancy, but I was told to go to a house a few doors below where I might be accommodated. I confronted a little lady of French extraction not taller than four and a half foot who lived with her brother and kept roomers and boarders. It was a dingy establishment but I was glad to settle anywhere. So I made arrangements for a room with breakfast and late evening dinners, paying ten shillings in advance—and that was all the lady got from me for many weary months. How she ever allowed me to stay for ten weeks or more without paying amounts to a miracle.

"Over the next days I wrote letters for money. After paying the cabman I had only four shillings left and thought it wisest to invest them in postage stamps and provide for the future. But excepting one pound or so, nothing came, for I had temporarily exhausted my resources. Well, I had two meals a day until my promises would be no longer effective. Meanwhile I divided my time between visiting the few people to whom I had letters of introduction, and seeing the principal points of attraction as the Tower, Westminster Abbey, the Kensington Museum, the National Gallery, St. Paul's Cathedral and the British Museum Library.

"I called on Beerbohm Tree[68] with that ill-fated translation of Paul Heyse's *Don Juan*—nothing came of it. Tree looked to me like a not overly-intelligent clerk when I met him at the stage door, and we had quite a conversation. I cannot complain about his kindness and interest. Introductions to persons in the ordinary walks of life proved futile, except for courteous interviews and perchance an invitation to lunch, and that was the end of it. Of special interest was only my acquaintanceship with William Michael Rossetti.[69] I called several times at his home in Endsleigh Garden and had delightful chats on literary matters. The parlor was crowded with all sorts of pre-Raphael mementos, and had a strange stuffy and gloomy atmosphere. It seemed to me like everything else in London grey, interminably grey. The sun shone only seven times while I was in London, and although there was not much fog, there seemed to be a haze over things at all times.

"Rossetti was exceedingly amiable, willing to help me get introduced. He sent me to some society actress who happened to be the fashion and had just

arranged a high-priced matinee in upper circles. I was present and was more impressed by the audience than the play. She was a vivacious person, handsome and kind, and asked me, 'What can I do for you? To whom do you want to be introduced?' I replied that I did not care to be introduced to anybody. 'Not care to be introduced!' she exclaimed, throwing her arms into space. 'What then did you come here for?' 'To study,' I answered gloomily. This was supposed to be diplomacy on my part, for I had not the courage to confess that at the very moment I had not a shilling, and also lacked the one indispensable article to go about in London: a dress suit. I had *only* the toothbrush. How I would have liked to visit studios and get acquainted with artists. But there was no way out of it, I had to be satisfied with my own company.

"At City Road things were in bad shape. I often met the landlady on the stairs. She invariably had a satchel-like purse attached to her belt, and she would say to me, 'I love you as if you were my own son, but you have to pay soon. It can't go on in this way.' And her loving me like a son did not prevent her from telling me that she could no longer afford to give me dinner. This reduced my rations to one meal. An egg, two slices of bacon, a few pieces of bread and a cup of thin coffee at about nine o'clock, hardly sufficient to keep me physically in trim for the rest of the day. Oh, those London days! How unreasonably long they seemed!

"I dragged my weary body to Rotten Row to watch the equestriennes, to the bookshelves of the British Museum, or the paintings of the National Gallery just to kill time. I could not stand staying in my room. Oh, those dreary marches passing the Angel of Islington without being able to enter, down St. John Road, and then branching off to get to Russell Square, the Strand or Piccadilly. I was hungry and bored to death. In the evenings I had to stay home, there was nothing else to do. Weird evenings they were! I could have screamed, I did not know what to do with myself. I generally sat on the roof overlooking the dusty back yards, even more dismal than those in New York. I watched the decline of the day, and listened to the rattle of dishes below and the nightly concert of some mysterious visitor who drummed on the piano, always the same tune with the same discords and halts. It was enough to drive one frantic. And so I climbed out of my room to the roof and back again a dozen times.

"There was a storage room next to mine with stacks of dusty French books. To read French books on an empty stomach is a hard task, so I found a better use for them. I tried to put them in circulation again. So at every available

opportunity, once or twice a day, when everything was quiet in the house, I put a few under my coat and sneaked to a second hand bookstore. They began to disappear so rapidly that the landlady became suspicious. She came and said,' I love you like a son and would do anything for you. But the stacks of books seem to grow smaller. I do not accuse you. But I better lock the door,' and so she did.

"With the proceeds thus acquired, a shilling or half a shilling, I had bought food. I generally went to some coffee house and had some citron pound cake and coffee. One day when I had only three pence left I came across an advertisement: Tripes for three pence. I had always disliked tripe, but on that day I was cured from all prejudices. It tasted heavenly.

"Prompted by hunger I ventured as far as Hempstead one Sunday evening, a good five miles where I knew a casual acquaintance who was boarding there. I was rewarded for my extreme effort, for I arrived just in time for supper. Ye gods, that roast beef, and the tapioca pudding afterwards! Those generous portions, how they revived my declining spirit. Alas, two Sundays later I made the same weary march full of hope and expectation, but got there too late. Supper was over. I had made the trip in vain, and it is strange that I did not collapse from sheer exhaustion on the way home.

"And thus the days passed wearily. One day on the Strand I was called by name. I wondered who could know me in London? It was a young Jewish lawyer from Philadelphia who once upon a time had given me lessons in English without charge. He looked seedy. He asked where I lived. I said City Road. Ha, ha, said he, and invited me to take dinner with him at his boarding house somewhere in the suburbs. I accepted cheerfully and managed to get there. A good old English couple. And a good dinner, too. Afterwards in the parlor the lawyer helped himself to some of the old man's tobacco from a jar on the mantlepiece, and handed me a handful. He said, 'You know, the fact is, I am awfully hard up.'

"'Just my case,' I said. I had wondered whether he had any money to spare.

"As we looked at each other he added, 'When you said City Road, I thought that must be a swell place.'

"'Well, come and see it and take dinner with me.'

"I told my landlady the same story as he had done, that I had met an American friend who might prove of assistance, that it was necessary to show him some courtesies first lest he might flatly refuse me. The plan worked. He came to visit, and for the first time the landlady put on a clean tablecloth. The lawyer played his

part well, even flirting with the servant girl. The next day the landlady appeared full of expectancy. Well, I explained, I had not yet had the courage to ask him. I know him to be kind and generous, but I have to cultivate his good will a little. He did likewise, and there was another dinner at his place, then another at mine.

"Well, the day of deliverance was near. There was money due from various sources and I counted the days on the fingers of one hand. I foolishly promised the lawyer to pay his passage to New York, but avoided his companionship as I wanted to see something of London before I left. There was not enough money for two, and besides we had a little too much in common in regard to taste and predilections.

"When the money finally came I indulged in a carnival of intellectual amusement. There was an Italian exposition with an excellent representation of modern Italian paintings, and Venitian glass blowing to which I went several times. Also an Irish exhibition attracted me. I went to every picture exhibition in town and saw some excellent Normans and Marises. I made various excursions to historical sites; the Crystal Palace, the East India docks, and evenings went regularly to the theater and saw Irving in *Robert Macaire;* the Kendalls, Wilson Barrett, Toole, Beerbohm Tree in a specular *Narcissus,* an Alhambra show, and the Gaiety Co. with Leslie and Letty Lind. I also went home with a woman of the slums. She brought me to a horrible den, too horrible for anything to happen. We just talked and took a few drinks together.

"And before I forget let me assure you that I dined again. St. James and the Holbein Tavern were not a bit too good for me. The landlady begged me to board with them again. I disdainfully refused and told her how much money she could have made if she had trusted me. I love you like a son!' she whimpered. 'I wish you would stay with us, toujors, toujors!' I could not exactly agree with her. 'But you must not forget to tip the servant girl when you leave,' she implored. I had the best of intentions but somehow forgot. The servant never did anything for me anyway. She could just as well have tipped me.

"I proposed to my Philadelphia attaché that we would travel steerage in order to save money. He refused to go that way. This made me raving mad. I wish my fury had lasted and had told him to go to hell, where he belonged judging from events that followed. I argued with myself: I have promised him, he had once given me service, and we have been companions in recent days of suffering, so let it go! I secured two so-called first class tickets for eighty dollars, and bought

a stovepipe hat for him as well as myself. He swore by all that is holy that the money would be returned by relatives as soon as we landed. If I had known what would happen, I surely would not have given up my trip to Stratford-on-Avon for his sake.

"Thus, stovepiped, we rode to Liverpool, heard the big organ play, paid the habitual visit to the art museum (Hagar and Ishmael seemed to me a most fascinating picture), and then boarded the steamer Queen. The food was mediocre, the weather unpleasant and the passengers undecidedly uninteresting. There was a Negro colonel on board; he was cultured and I sympathized with what he had to say about the little chance Negroes had in the U.S.A. He was a well-bred gentleman, yet he was bent on teasing me. I gave him fair warning, but when he persisted I slapped his face, ready to push him into the ocean if it would come to a fight. I was in the right, and I never regret what I do when I am right. After that incident I kept pretty much to myself, except mildly courting a young lady from Kansas City, while my traveling companion made friends with everybody.

"We arrived in New York and again put on our stovepipes. The ten dollars I still had when we left Liverpool had dwindled down to twenty-five cents. He asked me for some change, so I gave it to him, saying this is my last quarter. He had given me an address of New York relatives and promised to meet me at four in the afternoon at the Hotel Astor. I was there but he did not show up. After several hours waiting, I walked to the address he had given me, all the way to somewhere in the seventies, only to find the house boarded up. I still must have had a few cents left, as I managed to write special delivery letters to my Polish friend in Boston, and one to Clara, whom I had not communicated with while I was stranded in London. I thought she would understand. But she did not, sending me merely a note of reprimand. And my Boston friends made the usual excuse that they were hard up themselves. It was the third morning when the letters arrived. All three days since my arrival I had not eaten a morsel. I could have gone into the hotel dining room and signed the checks, but as I had no money for the tips I felt too shy to venture.

"It was a gruesome experience. I suddenly recalled the name of a business friend of my father, so I called and succeeded in raising twenty-five bucks. Huzza! Every hardship was forgotten. I purchased a big bunch of flowers and called on the Kansas City girl, whose name was Jeanette, who stayed with Rose Eytinge, the actress on Union Square. I invited her to dinner at Picadonna's (lost

track of her after that), and towards midnight lay in a sleeper, once more on the way to Boston."

11

"Here I was back to give a series of Ibsen performances. How I ever came to think that I could do it with any chance of success is difficult to state. I was simply vexed, besieged with the idea.

"I was in my old quarters, but not in the sumptuous front parlor. An ordinary back room had to do, as I was going to rent a regular office. I gave a reading at Chickering Hall just as an announcement that I was back. I concocted a curious program: of my appreciation of Marie Bashkirtsew, my Paris sketches and all the poems the muses had granted me so far, some of them dangerously erotic, for Boston at least. The sap was rising and needed an outlet. What happened is best told by a clipping:

"'Sadakichi had in some way won the ever fitful favor of some of the women well up in the social-literary set. A large audience, mostly of the feminine element, assembled, and things looked very bright for S. H.

"'The reading proceeded, but as one verse followed another, a little air of uneasiness was perceived as a poem of love was recited. Young girls cheeks began to crimson, and matron's faces became set. More and more passionate grew the expressions, until at last phrases were reached which started a general exodus from the hall. There was a mad scramble to get out, but Sadakichi read vigorously on, unmoved by the sudden flight of his audience. The feelings of the few men present may be imagined. After that, young S. H. dropped from the regions of the upper ten with a thud that was not dull, but sickening—for him.'

"It was not a stampede, still I admit a goodly portion put on their wraps and left. I bravely read on to the end. An old actress, a society pet, opined that one did not mention anatomical details, no matter how symbolic, in the presence of ladies. The stage manager of the Boston Museum remarked that, 'the whole thing had been rather sad, and what on earth had possessed me to include my Paris sketches? Dismal stuff, at best.' I laughed, can't a man read what he wants to read? My attempt at entering the Back Bay society had not been overly successful.

Now, many doors closed with a bang. Thus, by mutual consent I did not bother them, and they did not bother me. The strictly literary clan also put a ban on me. Only the Westenders and the limited foreign element, that really care little about literature, were still friendly.

"What did I care? My mind was bent on grander schemes. To introduce Ibsen in Boston in 1888 was a foolhardy proposition. It would have been at any time. Certain things cannot be done in certain places. Boston had the literary tradition, but its strength lay in classic dignity, straitened and homespun. Ibsen was much played in Germany, and the topic of heated discussion in France. He was sixty, and had arrived at the stage of symbolism in *The Lady From the Sea*. Not a soul in Boston knew of such arrival, they did not even know his name. The subject was always on the tip of my tongue; I must have mentioned him to hundreds but not a single individual had ever heard of Ibsen. This should have discouraged me. No, on the contrary, I felt it the more my duty to do something for the great modern dramatist. What I wanted to launch were the three plays translated into English: *Pillars of Society, Nora* and *Ghosts,* and I was anxious to play Oswald—which I did thirty years later.

"If ever a castle was built in the air it was this venture. I had not the slightest inkling where I would get the actors, how I would mount, or stage manage it. I called on some charming actresses of real talent, and while they graciously offered me their autographed photos, I could not arouse their enthusiasm. They thought Ibsen was just an ordinary playwright, 'and a Scandinavian, you say? How could he be of any import over here?'

"Undaunted, I set to work and advertised the fact that I, C. Sadakichi Hartmann, would give a series of performances of three dramas by the great Henrik Ibsen, etc. I advertised for weeks, not only in the leading weeklies and dailies, but also in suburban sheets with liberal notices. It amounted to an unholy sum, over two thousand I believe. I filled a whole scrapbook with reading notices that informed the public, that I, since my successful tour in England, was sporting a stovepipe; that I was a second cousin to the Duke of Ctrante,[70] the grandson of Foucher; that I had known Rachel; that I was a wonderful actor, etc., all half-truths, excepting the stovepipe, which was in realistic evidence when I promenaded up and down Tremont Street. And in the meantime, large displays offered the rare information about the Ibsen cycles, and invited the public to subscribe to the rare enterprise.

"A few staunch admirers of mine promised to assist me as the venture was taking shape, but nobody from the outside world responded—absolute silence—not one. Of course, subscriptions of this kind are not gotten in that manner, only by house-to-house canvases among the elite, carried on by respectful dames endorsed by a committee of several ladies of influence. I had put my foot in it and was regarded as a free lance, not to say nuisance.

"Also, my lack of executive ability, used to the precise methods of endorsed theaters in Europe, was in my way. I worked under the illusion that I, a mere youngster, could introduce an unknown author with new material in a place used to certain dramatic tradition, and could overcome these difficulties as soon as I secured the necessary financial support, while it was more likely that I could not have swung it with even a few thousand at my disposal. It is astonishing that no one came to my rescue financially, artistically or professionally. Even a splendid failure may give one a reputation in a European town, while here—well, the whole thing was an impossibility from the start, a huge joke at my expense. The only talent I was allowed to show was my knack to get advertisements free for a month or so without paying anything in advance or after. I was never bothered about those debts. Perhaps I had an angel who preferred to remain incognito.

"After this enterprise had fallen asleep I advertised (cash) for pupils in elocution and Delsarte.[71] A Miss Call of Newton Center, an excellent Delsartean, had honored me with a demonstration of her methods, and I had caught on. Reading up a bit I was not worse or better than many teachers. As Goethe said, 'In the beginning teachers always learn more than their pupils, and later when the teaching has become stereotyped, neither pupil nor teacher learn much.' I had off and on quite a number of girl pupils (even one male) all remarkable for the rawness of art conception and absence of talent, either stupid and meek or frivolous and boisterous, with the one exception of a girl of French Swiss descent who was serious and remained loyal to me to the very end.

"I had written a play ala Lord Fauntleroy entitled *Mademoiselle Bebe,* in which the leading part was a child actress. It had the endorsement of being 'a comedy well worth performing' from various New York 'readers,' including the versatile R. Cazauran, Palmer's right-hand man. I met Olive Homans, a whimsical creature, but a remarkably clever child elocutionist who was working in clubs and church affairs. Her parents became interested in my play. I read it to them in their suburban homestead, the whole family, sisters, aunts and grandams,

assembled in conclave. Their interest was so intense that they sat motionless. Nobody dared to laugh or applaud, but thought the play was wonderful, just the thing for Olive.

"It was decided to perform it. I was to get a company together. Well, this time I succeeded as far as hiring a hall and organizing a company, a strange conglomeration of amateurs and stranded professionals. To show what talent I had on hand I arranged a most peculiar reception. I rented the entire lower floor of the Hotel Vendome, and sent out thousands of invitations that I would receive on such and such evening dressed in Japanese costume, and that the guests would be entertained by two child prodigies that I had discovered, and that the music would be furnished by the West Concord Guitar and Mandolin Club. As I had no real Japanese array in my possession, I hired a Mikado's costume, black silk patterned with golden cranes, and thus dressed in the robe of state of an Eastern emperor of operatic cut and slightly shopworn, assisted by a barnstorming actress in an amazingly loud outfit, I *received*. They came in thick throngs by the hundreds and, not exaggerating a bit, crowded all rooms at my disposal, the corridors, the steps of the hotel, and stood in groups on the sidewalk. I smiled and bowed, introduced and shook hands until my arm hung limp, and I felt like the President. The crowd surged in and out. The tinkle of the stringed instruments was drowned in the general shuffle and jabber, and the prodigies both at the same time, unheard except by a few, performed on tables, at least to be seen.

"And the aim and purpose of all this? There was none. The flame of ambition burns brightly when one is young, so put it down as an extravaganza of my youth, one of the incidents of my erratic Boston career, when I had several years to go before I was of age.

"The rehearsal had begun when the Manager of the Boston Museum made Olive's parent's an offer to have her join his company to play Lord Fauntleroy. The parents almost fell over each other to accept. Mister Field courteously asked, 'Are you obliged in any way to Mister Hartmann?' Both chimed together, 'Not in the least!' I had no contract, and had served merely as a stepping stone. (The last time I saw Olive Homans was many years later with Tyrone Powers (sic) in that ill-fated performance of *Ulysses*.[72]

"There was nothing else to do but to utilize the other prodigy, a boy to play the part of the girl, and I coached him until he was acceptable as Olive proved to be. But now came the difficulty of raising sufficient funds to make the first

performance possible. It could not be raised. The loyal Swiss girl persuaded her father to pawn his golden heirloom watch; I borrowed right and left; but it was of no avail—the company disbanded, the hall rent was wasted, and the lithograph posters all drawn were not printed.

"And poor me, who had resided the year before in the front parlor, gradually lived in every room of the house, always moving up higher to a cheaper abode, until I landed finally in a hall room under the roof."

Thus, Sadakichi's Second Boston Season was nearing its close with the familiar thundering inauspiciousness of the First.

12

"Towards the end of my would-be impresario days in Boston, I found myself one evening in the studio of a violin teacher on Tremont Street surrounded by a bevy of young girls in Zouave uniforms going through a rifle drill.

"'Carry arms! Present arms! Parade arms! Parade rest!'

"I had translated Toepfer's *Seven Girls in Uniform* with the idea that my pupils might perform it on some occasion, and here they were all gaitered and knickerbockered obeying the same orders over and over again, as I had just realized to my dismay that my knowledge of the manual of arms was peculiarly defective.

"When they had re-donned their usual garb and were clattering down the stairs, the violinist said, 'Nice girls, these.'

"I elatedly nodded. The command of a bodyguard of female Zouaves was just what appealed to me.

"'And they left no bad odor behind, which is very unusual,' he added, worldly-wise. 'But if you want to know some real nice girls—.'

"'Also odorless, I suppose,' I interpolated.

"He ignored my cynicism. 'Some young ladies in Westchester Park are very anxious to meet you. Ruth—and Hildegard.'

"'I'll call tomorrow!' I almost yelled, jubilantly."

Sadakichi's entanglement with Ruth and Hildegard would have dramatic, if not traumatic consequences.

"My enthusiasm was genuine. For nothing during my stay in Boston had made a deeper impression upon me than a certain type of young girls, who no matter at what time of the day, especially at twilight and Sundays, I had observed again and again—one could not help noticing them—were leaning with one shoulder against the window frames, looking from the parlor out on the street

with pale wistful faces. I at least in those days of 'romantic tendencies' never walked along the more quiet residential streets without discovering half a dozen of these tall languid girls of Puritan descent, veritable Priscillas ala Boughton, occupied with the naught but this described mood of indolence. They had a strange fascination for me, aside from all physical desire, and to this type Ruth and Hildegard belonged.

"They were West Enders untouched by literary folly and pretense. Their devotion was more towards art. They had a lady friend, a figure painter of considerable charm, who was also one of the first 'pictorial photographers,' and they had posed for her and other artists in costume, and even been photographed in the nude. They swore by Alexander's and Dewing's paintings, and preferred Swinburne to New England classics as every civilized person should have done. Here at last I met some ladies of taste and culture living in comfortable surroundings. I naturally felt at home with them, and dully became enamored with Ruth.

"Ruth was kind of an indolent creature of temperament so calm, as if the length of her limbs prevented her from making any quick or unnecessary movements. She was more stately than graceful, and to have called her a beauty would have met with many objections. Yet her long erect neck, dull blonde hair, prominent nose and well-modeled lips made me think of Burne Jones.

"I could sit with her the whole evening through without indulging in any lively conversation, just lapsing into silence when we felt like it, and talking when words came to our lips without effort. If you ever come across the female statue that sculpture Kitson made after the measurements of females students at the Harvard gymnasium, you will get an idea of her figure. And her charm of pose, well in one of Dewing's earlier paintings, entitled *In the Garden,* you will see her standing in a bluish gown with the back three-quarter toward you, throwing the weight of her body on one foot. I believe she posed for all three figures, or at least suggested them.

"This all appealed to me very strongly after meeting William Michael Rossetti the preceding summer. She (Ruth) embodied to me the Americanized pre-Raphealite type, and I composed a sort of rhapsodical description of her in my essay of Thomas W. Dewling, which was dragged all over the country, printed numerous times, and finally embedded in the (my) History of American Art.[75]

"Hildegard was a more virile and at the same time limpid type, a neurotic

with a subdued passion that found its expression in unfulfilled yearnings rather then the actual practices of love. I only visited her occasionally. I preferred to go to Ruth, late in the evenings when she received me in the long parlor (it must have been a half a block long), and we sat in some nook sparingly lit while the remainder of the room seemed to crowd towards us in mysterious shapes. New Year's Eve I called after twelve. I tried to kiss her but she would not permit it. She had always been very careful in granting favors of this sort.

"The next time I called she had arrived in a more lenient mood. She showed me a negative of herself, nude while attempting some allegorical interpretation. I went to another part of the room where the gas flame was lit and examined it closely for a long time. I wondered at her undeveloped breasts in contrast with the maturity of her hips, and the strange formation of her pteryla, which resembled an hourglass.

"'Haven't you looked at it long enough?' she asked.

"I came back reluctantly, smiling, anxious to say something critical.

"She interceded, 'I was rather harsh to you the other evening, not allowing you to kiss me–' and she held up her face. I kissed her decorously on the forehead, and seeing her lips below, it occurred to me that it would do no harm to kiss her also on the mouth, and so followed the impulse without hesitation or any objection on her part. I still at all times was keenly conscious of my solitary existence, and so I proposed, not losing a moment, there and then, that we should get married.

"Ruth shook her head and delivered this sane answer: 'Think how many years it would take before you could support us, and then I am so much older.' She was twenty-three. I was still hankering after ladies several years older than I. Her reply staggered me. Ye gods, had one to think of such things if one wants to marry? That she might prove awkward in the performance of domestic duties, afraid of childbirth and an invalid after the first offspring, such thoughts did not yet find shelter and were strangers to my mind. Well, anyway we could be friends, to which she agreed. I thought this the proper moment for another kiss. 'But now it is enough for awhile,' she said.

"I continued to call after theater. She made tea or we drank sweet wine together, and talked about art and literature, where we would go if we ever would get married, about the stage, local society events and prevailing fashions. I read to her my latest effusions and made designs for her dresses which would not cost

more than two hundred dollars each, at which we had a good laugh, and thus with all sorts of foolish schemes we whiled away the hours. I never saw any of her relatives although the house was full of them, except a married sister, a trifle simple-minded who also seemed to be fond of me.

"In the meanwhile I did not neglect Hildegard. To her sensuous nature I was an object of wild excitement. She had probably never met such an asinine Joseph. I endorsed Bjornson's view that men should be as pure as women until marriage, and that the play of passion should be permissible only when children sanctified indulgences. I had heard of a German student fraternity that believed in chastity until the nuptial night, and that was the ideal I espoused for my conduct.

"Alas, Hildegard thought differently. One afternoon she came into the parlor where I sat waiting with a pair of shoes in her hands. She was dressed to go out, and excused herself that she had to go, and then proceeded to put on her shoes right before me. Then she bent over me and whispered, 'I can't help myself, I have to kiss you.' Which she did. May it be said that at that time my teeth were snow white and my lips as red as a postage stamp. So, I concluded, she loves me. And when at the next occasion, when she kissed me more persistently and vehemently, accompanied with the words, 'You don't think this wrong, do you, dear boy?' No, of course not, I thought, as she loved me. But did I love her? Or did I not just allow myself to be kissed? Strange, I like to kiss Ruth, and she accepts my caresses with a forlorn look in her eyes, while Hildegard lavishly bestows favors upon me and I do not know exactly how to accept them. Well, she loves me, that settles it. What could I do but love her in return. Why make a woman unhappy? I argued with myself back and forth in this imbecilic manner, honestly curious, while nothing was farther from her mind.

"Until now everything had moved in harmonious harmlessness, but a catastrophe caused by my inexperience and peculiar trend of mind was not far off. Things had gone steadily downhill with me. I had moved into a flat in a room overlooking the railroad tracks. I was once more famished and helpless. I could not stay any longer in Boston. But how could I get away? What was the use anyway? I would never be understood. My aspirations were of the noblest, my efforts sincere, but all so lugubriously impractical. The best would be to make an end of it all. The idea of suicide loomed before me and fascinated me. Yes, that was the way out of all the trouble, but it has to be done beautifully.

"By some sublime effort I scrapped up twenty dollars. I bought a fancy vest

and tie, handkerchiefs, perfume and silk socks. After a Turkish bath I proceeded to the Adams House for my farewell dinner. I ordered a sumptuous repast with old Bordeaux at six dollars a bottle, and dined lost in gloomy meditations, sipped the wine red as blood like a connoisseur, smacked my lips after the last drop, paid the check, tipped the waiter like a *grand seigneur,* and thereupon went to the writing room to pen my farewell letters. To whom, and what was there to say? I had not yet decided on a particular mode of exit, nor had I any pistol or poison. I had not given it a thought how I would go about it. Better postpone it until the next day. The shards of a smashed glass would do, just cut a vein. It has to be thought over. In the meanwhile I wrote a wild epistle to Hildegard to come and see me before it was too late, to come to my room, 'although directly over the railroad tracks, an unusually cozy room.' I thought I would have the temerity to ask her to stay overnight.

"The next afternoon Hildegard was ushered into my room. She was excited and all tears at first. Then we discussed matters. I was stubborn in the belief that nothing could be done. I pointed towards the setting sun, meaning when the sun has set—she misunderstood and argued that I shouldn't be frivolous at such a moment, that she would do everything for me in her power. Then I pointed towards the bed meaning, be mine, marry me as you should. You have kissed me as one can kiss only a man she loves. But I did not design to explain. She of course could not understand, and thought it was all a whim of mine brought on by desperation. "I cannot do that," she said, and then as it grew late she kissed me again and again, assuring me that she would think of some way out of it, that she would pray for me.

"When she had left I was stunned for a while, then I growled with rage, jumped up like a madman, smashed a glass, and made a few slashes on my left forearm. Not very deep wounds, I managed to stop the flow of blood, and somewhat calmed by this process of bleeding, made an effort to do what I thought was 'reasoning.'

"I had a certain ideal in regard to sex relations. To offer my body unpolluted to the woman who would marry me. Hildegard had shattered this ideal by gratifying her sensuous whims, the jade! She had just played with me, humiliated me. You see, I assumed the attitude of an injured female. I was the male Swava. Swava is Bjomson's heroine in his drama, *The Glove,* who slaps the face of her suitor with a glove when she finds he has not led a life as conventionally pure as

she has. In this case, the offender, Hildegard, had unloaded her impurities upon me and sullied my chastity. But perhaps she did see how I felt about it, that I had not been sufficiently explicit.

"And so I rushed to her house, but it was late and all was dark. I counted the houses from the corner and made my way to the back alley. There was one lighted room way up. Perhaps it was hers. She was praying for me. A cheap way of getting out of it. And perhaps it was not her room at all—so I made my way back, and as I emerged from the alley a policeman pounced upon me, "Hey, young fellow, what are you doing prowling about here this time of night?'

"I stammered something.

"'It looks rather suspicious to me. What are you up to?'

"'Oh,' I said, with a sudden inspiration. 'I have a sweetheart there, a servant girl, I did not feel comfortable telling you.'

"'Why did you not say so in the first place? You better be more careful about the time when you pay your visits.'

"The next day the landlady asked me to lunch and talked about how bad luck comes to all, and not take it (my situation) to heart too much.

"She was an ordinary good soul who had not the slightest comprehension about the entangled condition of my mind. But her talk, or the coffee, soothed me. Then came a letter from Hildegard. She had prayed half the night (after all!), that she had grown calm and in the morning found a solution to my troubles. I should go to Ruth the next day. By that time she, Hildegard, would have raised enough money for me to go to New York. Getting rid of me, I grunted. Still, the prospect of going to New York put new courage into me. I paid a few farewell visits, denounced Hildegard in a veiled way to my heart's content, whenever there was a chance, and appeared punctually at Ruth's, ready to start the same evening.

"Ruth with joy beaming in her large grey eyes handed me an envelope containing some fifty or sixty dollars, remarking that Hildegard had contributed the largest part of it. She was also curious at what happened between us. I hinted at the situation. She confessed that she failed to understand. 'I know too little about your Ibsen, but perhaps if you had given your performances—

"I was invited to stay for supper and was introduced to the parents, more sisters, equally tall but less languid. I entrusted Ruth with some valuables, books, and my family album which in recent months had enjoyed a considerable

addition of photographs of Ruth and Hildegard in different poses, costumes and compromising decollates. I spoke of my future plans, how I could become somebody in the art world, which idea was always uppermost in my mind. I deplored the fact that the U.S.A., unlike European countries, had no Minister of Fine Arts. I advanced the idea that to bring about such a condition to make one necessary would be a task worth fighting for. The girls thought it wonderfully clever, and I kissed Ruth and her married sister goodbye in the most cheerful of moods. Hildegard had not shown up.

"But the feeling that I had been wronged, that I had been bought for a trifling sum rankled in my breast. The idea obsessed me, and I brooded over it for hours on the train and gave vent to what I considered my outraged feelings by scrawling down an atrocious valedictory to Hildegard, venomous as an irate female would have expressed herself, that *she* had robbed me of the mainstay of my precious existence, my sexual honor (whoever heard of such a definition of a few hysterical kisses), that I would appear at her threshold (going away from it!), and avenge myself, and I gloried in making the threat as crude as possible. A kitchen knife would prove sufficient, and that it would be a warning to wanton women not to molest the purity of youth, and more such melodramatic balderdash. It was written in a paroxysm of rage, and naturally I have forgotten the exact wording.

"After I had finished the letter (I was then in New York), I felt relieved and considered the advisability of mailing it. Why not? The only way to get rid of the grievance once and for all. That was, and is up to this day, my *opus operandi* for a cure. Hildegard did not exist for me any more. Of course the people in Boston would neither understand nor endorse this peculiar fit of insanity.

"About two weeks later, a harmless but sturdy looking man with a black moustache appeared at my lodgings and introduced himself as a Pinkerton. He talked to me in a suave, sort of personal fashion. I told him of my grievance as I would to a father confessor. He nodded, 'I understand. Of course you did not mean any harm. But it is a serious offense, my boy, and they went to a lot of expense, and you can't blame them. We all do foolish things when we are young. I understand it all. *But* you have to write an apology, making a statement that you were crazed at the moment, and did not know what you were doing. And you must promise never to come back to Boston, or bother the girl, or write to her again. I have put it down, so all you have to do is sign it.'

"I signed the document and that ended the affair, this weird conflict of Norse asceticism and New England pre-Raphealism. Although it seemed to me for months that I was watched it may have been only an imaginary feeling of discomfort.

"After forty years have passed the picture of Ruth is still thumbtacked on the wall in the room where I do my writing."

Sadakichi's incessant search for love never left him, the obsession adhering to him as a second skin. When losing himself wholeheartedly in his turbulent affairs, it released him for a small space of time from the pain of isolation and the infection of emotional hunger. During those intoxicating periods it was as if he were on an ecstatic holiday—until it ended. Then the same merry-go-round would repeat itself, of another desperate search. From gloomy darkness to brief sunrise, there seemed no emancipation from his embedded, repetitive fix. His intensity grew. And sometimes the darkness grew dangerous.

13

"And so at last the day had come to make a conquest of New York, the only city that counts! Somehow I drifted to 5 University Place, liking to live in the vicinity of universities. The northeast corner of Washington Square, which even without the toy arch (a later addition), was the accepted landmark of Greenwich Village, and was destined to play such an important part in my literature career.

"I had a back hall room on the fourth floor next to an old spinster which I rescued and carried to the adjoining roof during a fire.

"One night after coming home from a performance of the *Valkyrie,* still thinking of Wotan's magic fire ring around Brunhilde, I heard an explosion and saw flames shooting up the rear of the house up to my window. As I opened the door heavy smoke curled in. Well, I am in for it, I thought. And so I opened my neighbor's door and told the old lady, 'Quick, come along!' and we went through some strange gymnastic antics before we reached a point of safety. The fire did considerable damage but was subdued in time, and the owner and servants, Italians, Jugoslavs or Greek, ran up and downstairs with bottles and cordials to give us tenants as many drinks as we needed to regain our equilibrium.

"This adventure greatly amused my literary friends whose acquaintance I had made soon after my arrival. Something interesting always happens to Hartmann. And they belonged to the genuine brand of literati; bitter-sweet Stuart Merrill,[74] a true poet who wrote in French, and so masterly, that he would have become an academician if he had lived long enough (I met him again in Paris); Jonathon Sturgis, son of wealthy folks, somewhat of a cripple physically, who had made the first translations of Maupassant's stories; and McLivaine, a youth with aspirations of becoming a publisher. We spent the day at the studio on Fourth Avenue, a cozy place with real paintings (no modernists) on the walls, more frequently towards noon than later hours. There, I astonished my comrades with my capacity of drinking sherry, and the profusion of ideas about what I was going

to write in the near future, a series of 'pastels in prose', each depicting a female character, entitled 'Consolations'.

"'Constellations' would be better, suggested Stuart Merrill.

"They were stillborn, but the ms all finished were utilized in writing my drama, "Christ."

"Another member of the coterie was Pellew, a university and club man. He took a liking to me and dragged me to all the various clubs, 'for one more drink.' He had the habit of getting beastly drunk and falling asleep in any old place. Then I had my hands full. More than once I had the opportunity of taking his gold watch and fat wallet, surely a temptation for a poor student as I was, but it never occurred to me.

"I believe it was Tuesday evenings when we all went to the soirees of Edgar Fawcett, the novelist, at 26 West 27th Street. They were delightful gatherings, and there I met Gunther[75], author of a phenomenally successful novel, 'Mr. Barnes of New York'; selling by the tons, he claimed. And our great stylist (at least in his early works), Edgar Saltus, a strange, restless individual, always in dress suit with genius written all over him. Also his brother, the poet, dropped in. The entertainment, excepting a few drinks, consisted mainly of conversation, and we discussed about all belles lettres subjects under the sun. Oh, it meant so much to me to meet these men-their animated faces, their gestures, even how they were dressed, and then of course what they had to say, drowsy wisdom and sparkling wit; Saltus' cynicism and Merrill's good-natured persiflage. There was also the salon of the Misses Lockwood, some sort of four o' clock tea which I attended various times with Pellew. But bluestockings were not to my taste, I had met too many in Boston.

"The great sensation of the day was William Dean Howells, champion of realism and American localism. He had rooms at the Everett House on Union Square and we formed regular delegations to call on him and ask for his opinion on *Looking Backward,* or Hoyt, the farce writer, or the histrionism of Richard Mansfield, or the art of St. Gaudens. He had a good share of commonsense judgement, and believed even as I did then in genuine U.S.A. expression. At that period I also met for the first time St. Gaudens working on his *Lincoln.* Brander Matthews, whom I always admired as a causeur, and Lawrence Hutton with his collection of death masks.

"Through my Whitman interests I met some German Author who in

conjunction with somebody had translated considerable parts of *Leaves of Grass*. I enjoyed talks with him and frugal meals, but never got near to him. All nationally foreign efforts in literature (even to Conrad Niess), registering to my sensibilities as something out of place. I rather enjoyed the old virgin Jeanette Guilder[76] whom I met so often without really meeting her, and who always had an intellectual wink and smile for me, a haggard youth, trying to beat all her tribe on their own ground and territories.

"I did an awful lot of writing and thinking during those glorious golden days of my youth, and I did not worry much about material things. I had been evicted from my university abode and moved to 219 second Avenue into a front fourth story hall which I fixed up like a miniature studio, and in evenings I hung a candle lit Japanese lantern from the window sill.

"Money still came from (?). It is too long to recall the exact sources, but whenever something substantial came I was sure to indulge in a cheap dish of chicken liver stew, scrambled eggs and a bottle of sherry and *café noir* (twenty-five cents), at the Everett House. And then of course I needed my cocktails late in the afternoon, and if my purse could stand it, an Italian course dinner with wine at Ricadonna's for one buck and ten cents tip. When I was short of cash I would ask my literary associates for a lift, but they did not particularly fancy the idea. 'Why do you drink so much sherry?' Well, one has to drink something, was my repartee. Howells invited me to several home dinners when nobody was present but his wife and daughter. We got along excellently, and he told me that he would always be glad to see me in the afternoon or evening, only not in the morning. Fate willed it so that I called one day at 11 a.m. He came from his study rather grouchy. 'Did I not tell you not to come in the mornings?'

"'I do not want to talk to you, exactly,' I replied.

"'What then?'

"'I wish you would let me have five dollars.'

"'For sherry?'

"He handed me the five in a most gentleman-like manner, but somehow our relationship became strained thereafter. So I concluded then and there, in 1889, that I would never ask people for a loan, but simply to contribute something if they could spare it, and I perchance could do something for them. (I had at the time no books to offer in exchange.) A most wise policy which I learned from

Paul Heyse. Stuart Merrill went to Europe giving me his blessings, and so the literary circle lost some charm for me. I tried to expand in other directions.

"On Second Avenue was the Café Manhatten with foreign newspapers and magazines. I made the Café my headquarters for nearly a year and owed the waiter the astonishing sum of 150 dollars or more, yet still able to sign my check for a real sirloin or *Wiener Schnitzel*. I believe finally I managed to pay the waiter a part of my indebtedness; it was extra for him anyway. The Café was also headquarters for chess champions, so I at least saw the great Steinitz who had Tchigorin as the greatest opponent at some congress in a well-known Hungarian restaurant in Union Square. Also Burns and old Blackburn I can recall from the past, and others whom I talked to and drank with about this most intriguing game of all games.

"There I got acquainted with Strindberg's Red Room, and Hansum's Hunger, and Maeterlinck, through a critique by Octave Mirbeau. They were real events! It seemed to me then, and still does, that in his early writings he showed us a new way of saying things, and if he had continued to express the eurhythmic of soul action by repetition, dreamlike incoherency, and scenery of mist, he would have become the great exponent of a new poetry. Alas, he drifted back to accepted classic ways, just at a time when the arts, quite suddenly, turned a 'right about' in an entirely different direction. What strange visions I entertained how I would stage his *L'Intruse* and *Les Aveugles* in a theater of my own!

"At my home of the Japanese lantern I worked hard but also dispensed hospitality to a motley crew of derelicts such as only New York can produce.

"Notably, a racetrack fan, Ferling, by name, who painted racehorses in the most amateurish fashion, but somehow got money for them which he lost again in the poolrooms as readily as he got it. And a Jewish man journalist who lived for awhile with me who tried to write poetry and whom I remember for his uncleanliness. Also three musician brothers, violinists and cellist, with whom I talked about the 'great wonderful art.' My landlady, wife of a doctor, was so physically radiant with beauty that she took my breathe away. But then, as later, eroticism meant little to me except expressed in writing. And I surely was a young erotic poet as Saltso pronounced me to be at a much later date. Yes, I was writing *Christ,* or rather thinking of it, dreaming of it. My thoughts I put down as 'Forbidden Fruit', all about sex but as maxims of a younger man which did not have any particular literary merit. I never made any effort at publishing them.

I only published in those days my 'Naked Ghosts' on one sheet in 1,000 copies, poems which I have never surpassed in sheer ebulliency.

"And then came the great experience. I had conceived *Christ* as a young man and his possible love affairs, such as a man of his superior personality and gifts he must have had. Thus when my mentality and constitution were ready I sat down one day at eleven in the morning and wrote without eating or stopping until 6 a.m. the next morning. When dawn came and some clothes in my room moved by the wind as if some other person was in the room, and I shivered as if meeting a sub-conscious mirage, my drama *Christ* was finished.[77]

"It took several years more to get it ready for the printer, but the bulk of action and thought, in fact the whole drama as it was published a few years later, was written in those eighteen hours, and even today I am aghast at the beauty of it all. Certainly, some things happen only once. Wonderful when they do.

"Hard times made me move from Second Avenue to some room on East 31st street..."

Later, in 1915, Sadakichi would be crowned the "King of Bohemia" by Guido Bruno, a Village character and local historian, sometimes referred to as "the Barnum of Bohemia."[78]

14

Sadakichi's romantic involvements perpetually ended as hardly more than a series of vacuous *cul de sacs,* frustrating catch-22s of the heart, and it was not an unusual occurrence for him in his urgent search for emotional tranquility since fourteen. As he entered his twenties his luckless connections with the female set continued, leaving him with a feeling of mounting frustration and distress. At the same time he complained of his over-idealization of women, the pedestal he placed them upon, how he vowed to remain pure for the ideal woman he would marry, one as pure as he. It seemed he was living in a moral strait jacket, trying to adjust to his fantasies of the pure, virtuous damsel he sought while fighting his natural sexual demands. An example is his interlude with Mlle. Bebe.

"Once more, without a penny in my pocket, I was waiting for a message of relief. Dull hours those, and I could find no better occupation than to stare from my third story back room over the brickyards to the house opposite. Straight across, in a private house, I discovered a young buxom servant girl armed with a big duster cleaning the back parlor. I put on my glasses and watched her. She manipulated her duster with all sorts of flourishes, like a drum major before a grandstand. I thought a nod or two would do no harm, and she in reply smiled and whirled her feathers in a few extra, most fanciful gyrations. Our acquaintance was made, although with at least thirty yards between us.

"In the evening I felt desperately hungry, the natural result of not eating anything all day. An ingenious idea struck me. It had something to do with a bake shop. On the way passing the house where the servant girl lived, I recognized her standing at the railing of the basement entrance, but I did not greet her, although she looked at me with more than ordinary curiosity. I was always shy in such matters, besides my mind was occupied with getting something to eat. I went into the bake shop and asked for five cents of crullers. As the nasty, greasy things were slipped into a bag, I fumbled through my pockets and acted as if I suddenly

discovered I had no money with me. 'I have forgotten my money at home,' I said. 'I suppose I have to run back for it.' I expected that the fat, dowdy lady of the establishment would tell me to take them anyway and pay next time. But she gave me a queer look and said, with no sympathy, 'I suppose so.' My shame was one of utter embarrassment.

"Again, I strolled down the street where the girl was prancing about on the sidewalk. I passed, apparently without noticing her, then turned back and ventured, 'Good evening.' She returned with a laughing, 'Hello.' I stopped and walked up to her, remarking, 'Isn't this a nice evening?' Then, we were as far as shaking hands. I found out she was Norwegian. We gossiped for awhile, and when I left I had not failed to make an appointment with her for the next evening. She would prepare supper for us, as the Mister and Missus were in the country, after which we would walk up to Central Park. I then crawled hungry to bed.

"The next day with a two-day appetite I appeared at supper, doing full justice to a most delicious meal. Then we walked up to Central Park and sat next to the Shakespeare monument. For a long time I sat in doubt whether I should make an attempt to kiss her. I had always such a confounded, exalted idea about women. At last I summoned up my courage and succeeded beautifully. There was no opposition. 'Let me put up my veil,' she said. Then, when I thought we had indulged sufficiently in osculatory motion—I refrained as early as the tenth or eleventh—I saw her leaning back and gazing at the murmuring treetops and starlit sky.

"'I wonder what all those old trees could tell me?' she mused, putting her head against my shoulder.

"Strange, I contemplated, this transmigration of thought, what the Scandinavian philosopher Soren Kierkegaard thought years ago now finds an echo in a haphazard remark of a plain Norwegian servant girl. This made a deep impression upon me. I was foolishly susceptible at the time and considered at once the possibility of marrying her. In the beginning of an infatuation I discovered one good trait after the other, to be followed in an amazingly short time by inevitable disenchantment. Walking home, she complained her shoes hurt her. Dismay on my part. I had just scraped enough during the day for two ice cream sodas, and had no carfare left. Well, she was accommodating, and accepted the soda, and said on her own accord that she preferred to walk. She ordered a Calisaya, an

Italian liqueur. This was at the time a new drink to me, and once again made another impression. She was not so countryfied as I thought. She was so round and pink, I decided to call her 'Babie.'

"After this prelude we saw each other quite often. We beckoned to each other across the yard in the morning, and in the evening I went to see her, generally for supper. After returning to my room I watched her enter her own. She would throw kisses at me, and then the blind went down. For a while we were occupied with the preparations for the night, whereupon the blind went up once more, and we could see each other tucked away in bed. A harmless little comedy, indeed, that we enacted for our benefit.

"She was an interesting type, clean, healthy, twenty-three, vivacious and not exactly bad looking. She was plump without being stout; at any rate there was no need for padding. 'This is all real,' she would say, patting her hips. She was always cheerful and smiling, and a good companion as long as one did not expect any intellectual support. On one occasion she helped me out with five dollars. She simply handed it to me without any ado and never mentioned it again.

"I took her one afternoon to the art museum. She had nothing to say except that the picture gallery at the Christiana was much larger. Only a church interior, very normal except in its perspective, interested her. She wanted to know how they managed to make it look so deep. Thus our conversations were not over-brilliant. What interested her did not particularly interest me, and vice versa. Besides. We had to caress each other and that took considerable time. Her pursed-up lips were of the kissable kind, and then those protuberances—they were most tempting to further exploration. Alas, that I was too timid to obey 'the wild longings of my heart.' I sought vain satisfaction in pinching her legs. 'Stop that, nobody likes to have their legs pinched in that way! Why don't you give me a real kiss?' She was ever eager for lip service, and her sex life was often expressed in naive phrases like, 'When I am alone, I sometimes wish I had a man with me.' Or, 'When I clean the windows I wear closed panties so that the passing men can't see anything. They always look up.' And I puckered my lips and shook my head over the wicked numbers of men.

"During my frequent visits I met a countryman and relative of hers, a sailor who now and then came to port. She treated him rather shabbily, and the more disdainfully she behaved the more he sheepishly clung to her. He looked a picture of woe each time I met him. I tried to say a good word for him: 'Why

don't you marry him, he is a nice fellow.' 'But stupid,' she replied. Her ambition was for a some well-dressed clerk earning a weekly income.

"I became most favorably acquainted with the cook, a wise and necessary move—a lean, toothless Wagner-struck old maid, who knew every opera, lieder and singer by name, and who talked about them in the most lavish superlatives—'Simply remarkably wonderful and entrancing,' and the like. As I had met Seidl I was a god to her, the more so as I was patient enough to listen to her harangues, and always expressed my regrets that such an intelligent person should be obliged to cook. About Babie, she said, 'She knows nothing but she is a good girl. She lent somebody five dollars. But what do you want with her? She is no girl for you.'

"Well, for the time she was, and I have never regretted the time I spent with her. I have often wondered since whether she would have shown to better advantage against her native backgrounds of fjords, dotted with gaily colored houses and dark pine bluffs. Was it not just the foreign flavor that attracted me? If I had met her on the Karl Johanns-glade, she would not have been different than any other girl about town.

"I also met a number of Babie's servant girl friends, duennas from Switzerland, Sweden, Pomerania and Austria, and as their Masters and Mistresses were recuperating at the seashore or in the mountains, they took advantage of their absence by arranging secret house parties in the closed-up Fifth and Madison Avenue mansions. The dinners were served in the regular dining rooms, and we representatives of the life below stairs aped the doings of the rich in jolly fashion, eating their food and drinking their wine, and with me the sole male and master carver sitting at the head of the table surrounded by these delightful, hospitable creatures, who sang and danced for me. If it had not been for Mlle. Babie, I could have kissed to my heart's content.

"Babie and I made another trip to Central Park under a moonlit night. Quite naturally seclusion is desirable when one wants to kiss one's dosie in the grass. So we climbed a hill which overlooked the lake, where the swan boats plied the muddy flood. It was a warm July night, and we soon assumed strictly dangerous positions. Who knows what might have happened if the mosquitos had not mercilessly invaded her legs and my ankles, and if she had not eaten onions for supper? This disturbed the illusion of perfect bliss, and after a while when two shadowy male figures passed in the distance, she said, 'I'm afraid.'

So we left, and I took pleasure in presenting her the next day with a speaking Japanese doll which we baptized, 'The Babie that was Born on the Hill,' at which she fell into a fit of laughter that lasted at least half an hour.

"Then dawned the day of departure. I had lived all these days from hand to mouth, and planned a resurrection trip to Philadelphia. Early in the morning with valise in hand I went to the basement door, although we had already said good bye a dozen times. She was surprised and somewhat frightened that somebody might see us. Still, she pressed a kiss upon my lips which belongs to the most exceptional sensation in that particular activity I have experienced. Also, a special kiss needs its special cause and environment, the ordinary practice being merely habitual. This kiss was so pure and fresh and moist, as if her whole body, still deliciously warm from the bed from which she had just risen, was bent upon revealing its fragrance.

"After a week I was back, but left again the same day for a lecture trip in the Adirondacks. On my return was renewed our acquaintance, but it held ho longer the same charm. I found out she had indulged in quite a number of male visitors. She knew now how to attract them by giving them liberal allowance to play with her, but also managed to get rid of them as soon as they became too bold or familiar. Perhaps this was the cause with me. Anyhow, I pinched her legs too much. She showed me the discolored marks which I kissed with true penitence and new resolves. But the real cause was a series of rather unpleasant occurrences.

"One evening the gentleman of the house came down to the kitchen quite unexpectedly and I had to hide in the closet, which humiliated me greatly. Furthermore, a new cook had entered the services, a sour Irish woman with whom I did not manage to get on friendly terms. One day waiting for Babie, I went upstairs and took a stroll through the parlor to see how it looked, when she appeared on the scene. She said nothing, but made eyes as big as saucers. Babie was awfully upset, being afraid the cook would tell. This put a definite end to my visits. Besides, I annoyed her by giving moral advice, as I thought it was about her many suitors. She defended herself bravely: 'I like to kiss. Why should I not kiss men if I like, if I do nothing else? All girls do it before they get married.'

"There was no gainsay to such common sense philosophy.'

"'And how about the Mister?' I queried. 'You say he always gives you extra money?'

"'Yes, what of it?'

"'And you?' I insinuated, with a decided blush of jealousy.

"'Nixie,' she laughed. 'He is too old. Why should he not give me money? Am I not a pretty girl?'

"Our ardor had cooled considerably. Nevertheless, she visited me twice in my boarding house. I induced her to lay down on the bed with me. She consented (as she was running no risk at the time), but spoiled everything by being afraid the house might hear the bed squeak. The next time she sat on my lap mistaking me for a horse on a merry-go-round. Did she know that I was the most awkward of all men? After a while she got up laughing.

"'Well,' I remarked naively. 'Are you happy now?'

"She answered, 'Was it anywhere near the night flap of Venus Calisaya? Pardon me.'

"And that was the end of this affair.

"I called once more at her place, but it was a decidedly chilly evening. She had in the other room a young man who took her out driving on Sundays, and she tried to get rid of me as quickly as she could.

"I never saw her again. Many years later I met the Wagnerian cook who told me Babie had gone back to the old country, and that she returned a short while ago and got married.

"She was a good girl for the right man. I am heartily glad I was not foolish enough to propose to her—there was every danger—and that we did not get farther than we did. It would have meant disaster for me. Why, she could hardly read. But I suppose our union would not have lasted long, except my confounded sense of duty in such matters would have kept me fettered to a state of affairs which would have resulted in utter misery for me.

"Passing and looking into the open window one day I caught a glimpse of her, smiling and ironing with her manic movements. I did not stop but walked on. She was a mightily good girl for the right man, I mused. May the matrimonial couch be easy to her!"

15

"Just about time when I bid farewell to Babie, I met Genevieve..."

Genevieve was to prove a trial for young Sadakichi's impatience in his persistent search for love, and he was now teetering on the edge of rage. Rationalizing away Babie failed to put a satisfactory shine on his long, dark, emotional dead-ends. They all spelled personal failure no matter what justification he gave for the females he left behind, or had left him, and the latter seemed more the case, a fact he could not escape. He began to feel more spurned than abandoned, and he was quite familiar with abandonment. This was a new pain in the family of rejection, an embarrassment that cut deep. For too long now he had been feeding on the lean side of romance, and always left hungry.

"...I had advertised in the papers for pupils in dramatic instruction. All morning I sat waiting in my big parlor (the adjoining middle room, which served as a bedroom, was decorously curtained off.) Everything in this room looked so dull and dreary that it was impossible to lend it even the faintest touch of individuality. The furniture was so frayed and worn out by its innumerable occupants, and so ingrained with the dust of years, any attempt to make it look more cheerful was a hopeless task. It was a typical New York boarding house room. As nobody came, I was in a despondent mood and thought of going to the Café Manhattan, my main resort those days, when I heard a knock at the door. A middle-aged woman and a slip of a girl entered.

"The mother looked exceedingly careworn, and seemed to be obsessed with a fantastic devotion to her offspring. The daughter was about sixteen and apparently most anxious to go on the stage. As a child she had given performances in roller skating. She was tall, slender and rather underdeveloped, all wrapped and muffled up so that I could not see much of her. She made no particular impression upon me on this occasion. We agreed upon some price. The lessons should begin at once, the next day. The mother made the confidential remark that the father was against his daughter going on the stage, but that she would do anything in

her power to manage it somehow. They were just ordinary wage-earning people.

"Genevieve took a few lessons, studied several small parts, and I found her fairly intelligent. In a short while I got so used to her company and so interested in her that I offered—ye, gods, I had no other income at the time—to instruct her gratuitously. Wasn't that customary among celebrated teachers? Why should I not do the same!

"After continuing in this fashion for a week or more, I fell in love and considered it necessary for my welfare to propose to her at once. I talked for about an hour about everything under the sun, and at last managed to tell her with faltering voice that I loved her, and wanted to marry her. I kissed her on the forehead, and bending over noticed on her thin, tapering neck a dirt mark from the black velvet neckband she wore. This absorbed my attention for quite a while. She, in the meanwhile, sat very astonished, and said that she would speak to her mother. Thereupon, without caressing her any further, I let her go home and awaited further developments.

"The next day the mother came. She was delighted, overjoyed almost, but she did not believe her husband would ever give his consent. Still, she would speak to him,

"'You know,' she said, 'Genevieve hasn't had her sickness yet.'

"'That will come out all right,' I answered, being rather perturbed she had not brought Genevieve with her.

"The next day I called at her fourth floor flat on Fifty First Street near Tenth Avenue. The mother received me and then left me alone into the parlor. There I stood in the dinky little parlor, studying the environment in which the person had grown up, who might possibly become my wife. Everything was in bad taste, particularly to me the two china dogs on the mantlepiece. But it was not only merely this which put me in a strangely despondent mood, rather a kind of hallucination that made all objects around me look too small, stunted, under life-size, as it were, as if I had strayed into some Lilliputian habitat and found myself too large for the dimensions of the room.

"The father came shuffling in, a short, heavy-built, common place sort of man with a black moustache. He sat down awkwardly and told me frankly that Genevieve was entirely too young to marry, that he could not think of such a thing. Besides, there were other reasons. But as far as the teaching was concerned, that could continue. Then he excused himself. As he was night-watchman in some

Patterson silk mill, he was obliged to leave at a certain time. Then Genevieve and her mother arrived on the scene, I took the refusal phlegmatically, and we were all jubilant that he seemed to entertain no further objection to her studying.

"After that memorable event, Genevieve came for her lessons nearly every day, and stayed the whole afternoon and evening. We would take supper together in some restaurant, and after that go to the theater—Ernst Possart was playing at the time at the German Theater, and we saw him in all his leading roles. Also Clara Morris, Janauscheck and many other interesting performances. After the theater I accompanied her home. We parted with a kiss, and the next day the same thing happened over again. I had no way of getting money, but borrowed right and left.

"From two to six is a long time, and of course we did not devote all that time 'to tear passions to tatters,' in a manner of speaking, but we also made, at first very feeble attempts, at accomplishing this in the world of actual sensations. Towards the end of the afternoon, frail Genevieve would recline on my couch and I would sit on a chair nearby, smoking cigarettes.

"There she lay, nonchalantly enough, but not quite as comfortably as she might have done at home, realizing that she was in her teacher's room, and therefore not at liberty to allow herself to rest on the worn out springs in perfect abandon.

"She was tired, only half-awake, and no doubt strange half-sensuous pictures, such as a child may imagine, moved lazily through her waking dreams, visions bright and irritating as those suggested by approaching puberty, or wrapped in veils of mystery, vague and drowsy, like the rising of warm air that rose from the register and mingled with the cigarette smoke and faint odors of boarding house cooking around the flickering gas flame.

"My fingers caressed her ankles. We looked at each other in short intervals, she with the smiling curiosity of an unstained life, I tremulous with fierce sexual impulses, subdued as usual by the grotesque self-denial which was characteristic of my youth. The curious roamer, my hand, glided up her thigh. She almost fainted, and all evening lay as if in a trance. I went to the window, wiped my face with a silk handkerchief, and lit a cigarette.

"The next evening my hand behaved even less platonically. Again she was near swooning, but roused herself more quickly, and we proceeded to some French restaurant. There, her face still flushed, bending across the table, she

prattled confidentially, 'Now, that doesn't hurt, tell me—it makes me afraid. Particularly yesterday.'

"'How did it feel?' I encouraged her, taking another sip of wine.

"'Oh God, will he go further yet—when will he stop? Just like that—felt it all over. It went right up my back. It was as if, well, as if one longs for one point, and if one gets there—it makes me crazy. I never knew I had such a liking for it. How will it be when I am twenty? I will always feel like hugging something between my legs. I am getting awfully bad. Oh, it made me so tired. I can hardly keep my eyes open.'

"I, her twenty-two-old teacher, smiled in Mephistophelian fashion. Assuredly, these were the most peculiar lessons I had ever given. A pousse cafe after this will do no harm. 'Your health, Genevieve!' and I whispered something into her ear which made her blush furiously.

"After this prelude I permitted myself even greater liberty of action. And yet, despite my making her obedient to my amatory whims, of scrupulous examinations, of making her undress partly whenever caprice prompted it, and inventing all sorts of methods and attitudes, we never went beyond immaculate dissipation. In fact, technically she remained a virgin, although I knew her over a year. I at the time did not only believe that a man had no right to seduce a girl, but entertained the curious notion that also a man should remain pure until their marriage. It was the influence of Tolstoy and Bjornson which had made a sort of male demi-virgin of me.

"Genevieve had become quite beautiful in the last few months; her hair had grown luxuriant, not only on her temples. Her hips had rounded out and her breasts gave promise of becoming more decided and self-assertive. So I was not astonished when her mother told me that the long expected event had finally occurred during a visit to a department store.

"For more than three months everything had run delightfully smooth, then I heard again of the father whose existence I had almost forgotten, that he wanted to end the whole affair. The brute. And true enough one day Genevieve announced that she had to go for a week's vacation to Paterson. This came to me like a thunderbolt from a clear sky. There was really nothing extraordinary in her making a visit to her relatives, but I was absolutely unreasonable. I objected, I grew furious, I imagined I might never see her again. I visited the mother and argued so persistently and persuasively that somehow Genevieve postpone the

trip. But a few weeks later she came with the same news. I fumed with rage.

"'This time I have to go,' she said.

"I shouted at her she had to stay, that everything would be over if she went. She replied that she could not help it, that she had to obey orders. Before leaving me I made her promise to try her best not to go. The next day I anxiously awaited her arrival. She did not come. I waited and waited, and gradually got into a desperate state. At last when I was certain she would not come, I rushed to her home. I did not yet believe she had really vanished. Perhaps she was sick. But nobody was home except her grandmother. She told me they had left for Paterson. I did not answer. As if pursued by the furies, I flew down the stairs and ran along the street with such amazing rapidity (as I was afterwards told), by the time the exceedingly stout and gouty grandmother could manage to place her ponderous form at the window sill to look after me, I was out of sight, as of the earth had swallowed me.

"I covered the distance from Fifty First Street and Tenth Avenue to Twelfth Street and Third Avenue within fifteen minutes.

"Returning to my room, I did not know what to do. I tore off my coat, pushed up my shirt sleeves, smashed a few glasses, then began to cut myself with their shards in the left arm. Once, twice, a half dozen times, always deeper and deeper, and at last I succeeded in piercing a vein. This somewhat calmed me. The wound bled profusely but soon clogged. For a moment I may have had the desire to kill myself. It seems my ignorance of my anatomy hindered me of making anything but a very poor job of my intentions. Still, I assumed the air of a would-be suicide. I staggered about the room, posed as if I were dying, and at last called in the landlord. The old grey-bearded gentleman felt exceedingly friendly towards me since I accidently discovered him with a servant girl on his lap and had kept silent about it, brought me a glass of wine, tried to calm me, and took me to a doctor.

"The doctor looked at the cuts, and remarked if they were a trifle deeper the experiment might have proved more dangerous, that no vein was cut clear through. Still, two of the wounds had to be stitched.

"'Does it hurt?' the landlord asked.

"I shook my head; I rather enjoyed it. The doctor advised me to live regularly and particularly to eat regularly. 'An expensive diet is not necessary,' he added. 'Beans and milk will do.'

"In the boarding house the matter was hushed up. I had to wear my arm in a sling but no one asked me about it. The landlady called my action absurd. She did not believe I intended to commit suicide. At any rate I should have had some consideration for her, as such things were apt to cause considerable inconvenience for her. The same evening, I wrote to Paterson that I had an accident and was laid up for a few days.

"The next morning I went to the Café Manhattan, where for the time being I had unlimited credit, my bill having climbed beyond the hundred-dollar mark. My arm attracted attention. I was obliged to make explanations. The pose of a man to whom an accident had happened pleased me, and I wore my arm in a sling several days longer than was necessary.

"In the afternoon Genevieve and her mother came, both extremely excited. Numerous kisses and caresses followed. The naughty boy had to be pacified. The servant girl whom I had seen sitting on the landlord's lap brought in my dinner on a tray. She looked at us with a quizzical mein and made some remark about love running smoothly, which made me highly indignant.

"Genevieve returned to Paterson and I no longer cared what happened. I refused to give lessons to my other pupils. I believe I had two. This in turn roused the temper of my landlady. Surely my arm was not so severely hurt that it would keep me from giving lessons. But young ladies in knickerbockers had no more charm for me, and a few days later I found the room of my door locked. I asked for an explanation.

"'Well,' the landlord said, 'it can't go any further in this way.'

"They could rent my room, so I had to leave. He personally was very sorry.

"'Where shall I go?' I asked. 'I have not a cent to my name.' Then happened the unforseen, something that stands unparalleled in the chronicles of boarding house transactions.

"The landlord said, 'Here's ten dollars for another room. You owe us altogether one hundred and thirty. I trust you will pay it back some day when you can.'

"'Are you going to keep my things?'

"'No. You can take them with you.'

"I was moved to tears ... Bless the old rogue!

"'But return the Shakespeare you borrowed,' chimed the landlady. 'It was given to my daughter, and it is a very old edition.'

"I must have looked most guilty and dejected, for the book in question I had sold in dire need to a second-hand bookdealer for seventy-five cents. I made a clean breast of it; I had the virtue of frankness those days. I ran to the bookstore to purchase it back, if possible, but it was gone.

"So I took my valise, which contained all my possessions, and wandered to Eighth Street, where I took a garret over a costumer's establishment. My room, if such it could be called, adjoined to that of a young musician I knew. What I did in those days I do not remember. I was utterly reckless, and after staying two weeks or more, I found myself one night almost mad with bad luck, and may I say, sorrow, over the lost Genevieve.

"The young musician had a peculiar friend, a waiter who went out on special jobs and generally returned with weird collection of silverware. This worthy Ganymede of some education and worldly experiences instructed the young violinist. They went to concerts and picture galleries together, and he also initiated him into the rites of sexual indulgences.

"'Why, there is nothing to it, just a momentary satisfaction.'

"Well, he did not know all at the time, and neither did I.

"This evening I raved about disappointed love, murder, of committing suicide and the like. The young man did his best to calm me. He offered me money to go to some theater, restaurant or sporting house, to do whatever I liked, but it was all in vain. I threatened to set the whole blooming house on fire. I made one scene after the other, knocked my head against the walls, upset the furniture, cursed fate and the entire world with all its inhabitants, and made actual preparations, such as balling up newspapers, to set the old building on fire. He finally got frightened. I heard him go to the waiter and hold council with him. Then the waiter locked himself up in his room and the young man went downstairs. I slipped into my bed undressed and wept.

"A few minutes later I heard voices and people coming upstairs. Then I saw the musician, the landlord in a dressing gown with his wife holding a candle, and a policeman standing at the door of my room. I feigned sleep and delirium as the policeman came and shook me. He said, 'He's all right, but if anything happens, call me.' Then they went.

"I was furious, and determined to leave the place the next morning. I got up early, told the musician my opinion about his calling a policeman when a doctor would have been the proper thing, advised the landlady—snippish old hen—that I would leave my baggage and left.

"I did not know where to go. I had an appointment with Genevieve's mother in the afternoon, who had just returned to town, but what was there to do until then? Look for a room. Without money and baggage? I studied a newspaper and saw a room advertised for two dollars, somewhere near where Genevieve lived. I went there—I liked the room—it was in a flat overlooking the elevated—and asked the really ladylike looking landlady if she would trust me until Monday. It was Saturday. She sized me up in a motherly sort of way and answered she had no objection, but that I had to pay on Monday.

"There I sat in the little room, at least warm and with a roof over my head, but I was desperately hungry. I met Genevieve's mother before a bakeshop. I was in a deplorable condition, unshaven and unkempt, with no overcoat, unsteady on my legs from shear weakness and continually starving. She told me that everything was all right again, that Genevieve was back, that she would resume her studies, that I was welcome at the flat, but not before Monday morning, as they had visitors from out of town. Perhaps she would be able to bring me something to eat in the evening. Still it was doubtful if she could get away. I better had let her buy some bakery for me. With some inconceivable pride, or rather stubbornness, as I wanted money, I refused. In consequence, I suffered all night and the next day and the following night. I tried to sleep most of the time.

"On Monday I went to Genevieve's flat; a lavish breakfast was fed to me in the parlor, and my immediate needs were provided for. Then I took up the interrupted thread of instruction. I stayed the whole day for dinner and supper and then went home. The same the next day, and on. The father was at no time in evidence. My teaching I took very seriously, and Genevieve made wonderful progress. I made her study dozens of parts from the classic repertory, played the opposite part to hers, each time absolutely different. For instance, the scene between Hamlet and Ophelia I would play one time like Mounet Sully and another time ala Irving, etc. Nor was I satisfied with letting her make mere Delsartean movements. I initiated her into the study of painting and sculpture, and she had to imitate striking poses of well-known figures in marble and on canvas. She had to read at least one drama every day, and I made her familiar with all the great names in the world of art. All I knew—and I was a veritable storehouse of art and book knowledge—I tried to teach her, not by any pedantic, systematic method, but rather by suggestion, continually keeping her interest alive with something new. I was really an excellent coach, as young as I was, indefatigable,

enthusiastic, equipped with Teutonic thoroughness, and it was not my fault if she never amounted to anything behind the footlights. Alas, the brain cells of a pupil cannot be increased, no matter how successful the pruning processes may turn out.

"Only now and then we interrupted our studies for an hour devoted to love, when she would assume a lying position on the sofa, not unlike that of the young, sleeping hermaphrodite in the Louvre, and I endeavored to spell out the alphabet of passion, by all sorts of foolish attempts at solving the problem of voluptuousness without disturbing virginity.

"One day we were discovered by Genevieve's sister-in-law (a damsel with a head so ridiculously small, that as in Greek statues it occupied but one/ninth of the entire length of her body). Her eyes, however, were all right, and although I quietly got up and walked to the window as Genevieve managed to pull her dress down, she had seen enough to at once proceed to tell her mother she had seen Genevieve lying on the sofa in an absolutely inexcusable position. Genevieve had to defend herself, and she did this by simply turning on her heels with a jeer, and stating that people had no right to draw at once wrong conclusions.

"After that nobody could have convinced the mother that anything was wrong. Neither the grandmother, who of late wondered why so many buttons were torn off her granddaughter's underwear. Genevieve still wore closed drawers, and they demanded at times special energetic treatment on my part.

"Like all young girls, Genevieve had her moods and occasionally took it in her head to object to our peculiar pastimes. No wonder, for they were getting rather monotonous and disquieting.

"'As long as it is not the real thing,' I would argue, 'it can't do any harm.'

"'But it isn't right.'

"'Well, I should have done the real thing long ago, then you wouldn't object.'

"'I would kill myself.'

"'No, you wouldn't, you would like it too well.'

"'Surely, I would.' And then like a young martyress she would assume her position on the sofa.

"In the meanwhile, being there all day from nine in the morning to eight in the evening, I had grown so tyrannical and despotic I grew furious when anybody else ventured into the parlor, or when Genevieve had to go on an errand. Then

a big quarrel ensued, and by my brutality and obstinacy I generally had my way. On an evening walk through lower Central Park, Genevieve wanted to take a swing. I objected, for her dresses would fly up and I wanted nobody to have the privilege of seeing it. She took her swing anyhow, and the mother admiringly, and I in a most sinister mood, looked on. She did it most gracefully, wrapping her skirts tightly around her legs so that nobody could have seen even a flutter of lace. Besides, it was night. Nevertheless, I lashed myself into a fury, picked a quarrel, and struck her straight in the face. No pleasant lover, I. She screamed and ran away with her mother, I after them, offering apologies. In the beginning she would not listen, but gradually yielded to my entreaties, and we were good friends again by the time we got home.

"As a rule we managed things more peacefully. We had all sorts of little adventures. One afternoon we made up our minds to climb the hill where I had once been with Babie. Halfway up a park policeman shouted, 'Come down from there, they are not the Alps.'

"A few hours later we managed to sneak up anyhow. There was no moonlight and the mosquitos were again in evidence. Still, we went through our exercises with special glee that evening. No doubt the danger of being discovered added to the pleasure. When we came down she had to go to a place 'For Ladies' but there was none to be found. So I advised her to sit in the grass, and I did sentinel duty so nobody would surprise her.

"Afterwards I made a drawing of the incident and showed it to the mother. She was deeply moved, to tears, about my cavalier-like behavior. She was about the most foolish woman in such matters I ever met. She told me confidentially that she knew nothing even when she was married, and when she expected her first child she did not know where it would come from; she thought somewhere out of her navel. Also, that once when she went to the theater carrying Genevieve, she was greatly shocked seeing in some spectacular performance a red devil jumping about on the stage, and that this was the reason Genevieve had a tiny indication of a tail at the end of her back. On the contrary, it was a slight cavity.

"I derived a special pleasure from dressing her up in her Delsarte costume. Of course, she made a fuss at first, but rather enjoyed having somebody play the part of dressing the maid. She had the costume especially made and when she came home from the tailor, she told me while blushing profusely that the tailor had put his hand right up *there*. It turned out to be not a gymnasium suit as I

expected, but a blouse with a very tight fitting pair of pants, hardly reaching to the knee. In this makeup, which revealed all her form, she looked like a boy, and it was with rare aesthetic gratification that I watched her moving about me. She was no beauty, her nose was pudgy, and her eyes although suave lacked strength. Her mouth was exquisite in shape though, and her complexion almost transparent. Still, her greatest charm was she had just entered, upon that adorable period of transition when a young girl turns into a woman. She had the refinement of a woman of good breed, and I could never account for it. Her relatives gave me a shiver they were so crude, while she was like a hothouse plant reared under special care.

"How well I remember on one occasion when she was dressed this way and her father came to the door. She would not show herself, merely called goodbye, hiding in a corner. But her timidity was like a bathing nymph surprised by some intruder, and was beautiful to look at. If her father had seen her in that costume everything would have come to an end then and there, but he merely took it as shyness. She was always shy in his presence.

"But there was no trace of shyness when she paid me a long expected visit to my room. I read my drama *Christ* to her. The atmosphere in the little room was stifling, so she opened her waist. The landlady came in and asked a question. Genevieve did not seem to mind that her waist was wide open and looked defiantly at the old lady. Then I locked the door and induced her to undress. She disrobed completely, except for her shoes and stockings. Then I lay on the bed and drew her body upon me. This was to be another experiment. I had promised she would be absolutely safe, that I merely wanted to prove I could lie in bed with a naked girl without any serious happenings. She yielded to the peculiar situation with the best grace in the world, and no doubt was excited to the last degree of amatory expectation, while I, poor simpleton, almost lost consciousness, and only my ignorance saved the day. When we arose from this couch of tantalizing sensations, I tried to smooth the impress of our two bodies upon the bed. Still, it was badly tossed up and our shoes had dirtied the white counterpane which had been put on fresh that very morning. The landlady remarked afterwards in her gentlest manner, 'You better not bring her here again. If she is a good girl as you say she is, it wouldn't be right'

"I bitterly assailed myself for not having shown better control. Some time later I induced her once more to undress completely, and I did the same. I was

determined to show that it could be done. She naturally gave way to her feelings and she was wet and limp, but I refused myself to return her intoxication with the ardor which would have been the only sane and normal thing to do under the circumstances.

"When all the danger was over, I bragged, 'See, it can be done.'

"And she, gosling, answered, 'I wouldn't respect you much if you couldn't have done it'

"A poor reward, I thought, for so much self-sacrifice. Darn you, old cobbler philosopher of Tula, the joke was on me, as you did not follow out your own theories. You first took your fill of everything, then began to preach what people call conversion and the awakening to larger visions.

"In this period also our various theatrical ventures took place; the initial performance of *My Japanese Romance,* and our appearance as Richard III and Queen Anne. There was only one dressing room available—oh, if her father had known it! And how my armor rattled when I began, 'Now is the winter of our discontent.'

"When our short season had come to an end, the father began once more to fume and fret. There had to be an end to all this nonsense. He accused his wife of the vilest things in reference to me. We were all upset and continually on the warpath, and Genevieve—I do not recall anymore how it came about—once more disappeared into the wilds of New Jersey. I made a trip to Philadelphia, returned within a week and stopped at a hotel over a saloon. A nice large room though, and there I lay on the leather couch building air castles. I was again negotiating with Genevieve's mother when my landlady came to see me, informing me with kindhearted anxiety that the letter carrier had called with a registered letter with a foreign stamp on it, and that I should go at once to the post office. She was indeed a loyal soul and I always remembered her, although I never managed to pay her the few dollars I owed her.

"The letter was from my father and contained a hundred dollars for the publication of *Christ* Well, it was not enough for that purpose and I was reduced to desperate shifts. So I invested a part of it in a new suit and other necessities of bodily comfort. Then there was a family council, a heated debate, which ended with my offering to take a forty dollar flat and have Genevieve, father, mother and grandmother live with me. I was to occupy the parlor, which however the family could make use of, and sleep in the adjoining hall room. Genevieve went

with me to buy some furniture on the installment plan, and I principally bought a big couch. She smiled and whispered that she knew to what purpose I bought it. Then I invited her to go to the Café Manhattan for dinner. She excused herself, that they had company at home and she had to go back. I would allow no excuse and a fierce quarrel ensued in the street, on the stairs to the elevated, in the waiting room. I would not buy the tickets. She said she would walk. At last I paid the fare, and as soon as we were in the car, I with malicious intent, began a long discussion and talked so persistently that we paid no attention to the stations and passed our stop. We had to walk back, and of course came too late for any company.

"These quarrels became more frequent and more violent with each day. I slapped her, and she threatened she would never speak to me again. Then I gave her a black eye. The mother hushed it up somehow by saying Genevieve had hurt herself, I pleaded pardon, she granted it, but said she could not forget such things and that it must not happen again.

"But it happened again, the next day, when we moved into our new home, I did not strike her this time but threw something at her. She complained to her mother. I said I had done it merely for fun. I took her in my arms and put her down by force on a heap of things. I fondled her legs which were quite exposed, and although the janitress and moving men were passing through the room we did not change our position.

"Then I took possession of my new quarters on 42nd Street. I was now the great Panjandrum, king of the realm, but it was not to last any length of time. It seemed as if the father had given consent to this crazy arrangement only to render me checkmate. He gave no money to his wife, and I had to pay all expenses. Genevieve was all the time with me. There were no more lessons. Early in the morning before the father came I sat on the edge of the bed and played with her, and in the evening she slept in the same bed with her mother, I made a habit of undressing her, and then I would enter in my nightgown and lay by her side, 'my darling, my bride.' Once I even succeeded in reaching the very gates of paradise while holding across her body a conversation with her mother,

"But the quarrels which became more and more difficult to avoid was our undoing. One afternoon she objected to immaculate dissipation, so I threw her off the couch. In the meanwhile her father declared war by insisting on taking her to Paterson. The fiend, and the first month's rent not yet paid. It was very

soon after the quarrel, and we had not yet quite made up. She said she would not oppose his wishes, although that this time it would be more than a mere visit, that her father intended to keep her with his relatives in Paterson. Thereupon this typical and most absurd dialogue took place:

"'So you are going to leave?'

"'Yes, this afternoon.'

"'And I may never see you again?'

"'Not if it can be avoided.'

"'Have you taken everything into consideration?'

"'I told you so before. It is all over between us.'

"'If it is all over,' I sneered, 'why is it necessary for you to go?'

"She nodded her head in a diagonal direction, saying, 'Yes, it is the best that can happen. We would never agree.' She added with strong vehemence, 'It is all your fault.'

"'You know I have a temper. I mean nothing by it.'

"'But I can't stand it any longer.'

"'You forget we have lived together as husband and wife.'

"'I give in, it is the fault of both of us, but a respectable girl can't act that way. Neither does a respectable young man strike the lady to whom he is engaged.'

"'I am sorry those things have happened, but it is no reason to leave. Other men, no doubt, act more hypocritically while they are engaged, and only show their true colors after marriage.'

"'I am grateful to you for it, but I did not know we were exactly engaged.'

"'Because I gave you no ring, eh? But don't you see it would be wrong for you to leave me in this way?'

"'You will soon find somebody else.'

"'Don't get frivolous.'

"'Men are alike.'

"'You know that I am different, or you would not have liked me. You know that I had the ambition to remain as pure as the girl I marry. I expected you to become my wife, so I thought a little dissipation would do no harm. But if you break with me, I have lost the chance, and through you—'

"'Why did you not wait?'

"'I wish I had been less careful. You would speak differently if I had acted like the rest.'

"'I would never have allowed you to touch me.'

"'Ha, ha, you are a woman.'

"'And you are a man.'

"'True enough (although I had not acted like one), but you would have yielded under the circumstances. You know you would!' I screamed.

"'Perhaps.'

"'Perhaps? What would you do with a man who would leave you as soon as there were any results?'

"'Let him go.'

"'No, you would marry him.'

"'I would hate the man who could do such a thing.'

"'No, you would be sure to marry him. Some women even go to the law to force the man to marry them. Why? Because they have lost their cherished chastity. In a sense I have lost mine. So I have the same right to demand from you—'

"'With men it is something entirely different, don't talk foolish. Men cannot bear children.'

"'A strange world in which men are not allowed to have any moral pride.'

"'Men do not lose their honor before the world.'

"'But women do, eh? That is why you want to stay. Genevieve, give me a kiss.'

"'No. What is the use of kissing you?'

"'Well, a last kiss won't do any harm.'

"'No, I won't. I will follow your advice and not sully my reputation any further,'

"'Only one more!'

"'No, I'll scream.'

"'I'll get it anyhow.'

"'Let me go! What are you doing?'

"(Kissing her). 'See, you are a woman all right.'

"'And you are a beast of a man!'

"'Let the beast embrace you for the last time—'

"'No, I dare not trust you any more, I told you, it is all over.'

"'Here we are, at the point from which we started.'

"'Then let us stop talking. It is time to get ready.'

"'Then you really mean to leave?'

"Genevieve managed to leave that afternoon. I was absolutely beside myself, and wrote to the father the same afternoon that his daughter belonged to me as we had lived together like husband and wife. A charming situation, indeed, to sit there moping with two old women in a flat for which I had to pay, and the little pet bird flown away from its gilded cage. I went out to get a large sirloin steak and a dozen ears of corn. I had to have something to eat at least. The mother, with a wet towel around her head, whined and wailed for her daughter without cessation. The grandmother sat at the window and wondered at the many cars that passed. She had never seen so many cars before.

"One of Genevieve's brothers, a druggist and husband to a Greek woman, came in on the pleasant errand of sending a bullet through my anatomy. The father had written to him, and he posthaste got in a shooting mood and approached me with embarrassing questions, 'Is it true, have you had connections with her?'

"'Yes,' I replied.

"'Then you will suffer for it,' and he pulled his revolver and aimed at me.

"The mother and grandmother intervened screaming and fell upon him, holding his arms

"'Did not the same thing happen to you and your wife?' the mother boldly addressed him, at which he collapsed weeping,

"'You have no right to mention that now,' he replied.

"He then grew more enraged and aimed at me again. Once more the women clung to his body and arms. I remained strangely calm. I brushed aside his revolver-clasped hand and merely said, 'I don't believe it's loaded.'

"He afterwards told me he had never expected to see a man act so calmly in such a situation, that apparently nothing could ruffle me. Nevertheless, I considered it wise to get out of the house and have him arrested. At police headquarters I told my story. The sergeant said, 'We better have him arrested, he has threatened to shoot him and who knows if he might not do it.'

"But an older officer said, 'It is your fault. You have done something to the only daughter. They have a right to be mad. You better stay out of their way.'

"Then I returned. It was a sad evening. I did not want to talk to the brother, but he had become quite sensible, even promising that if it were true what I said, he would see to it she would marry me.

"I went to bed, over-fatigued, to find upon awakening alone with the grandmother. The mother had followed her daughter. She had left a note that she could not stand it any longer, she had to see her daughter, and that she had kissed me goodbye while I was asleep. I jumped out of bed like a demon and tore up everything I had ever given to Genevieve. All day I sat with the grandmother, making plans and wondering what else was in store for us. In the evening the bell rang. It was two men, an elderly lawyer-friend of Genevieve's, and another brother, a bartender. The lawyer wanted to have a talk with me to settle matters. The brother could hardly restrain himself and angrily said, 'If you talk truthfully everything may yet be straightened out. But if you give us an insolence, I'll knock you down.'

"'Hush,' warned the lawyer.

"I smiled vaguely. I was perfectly calm. Then began a most curious conversation. The lawyer questioned me about my intercourse with Genevieve, if the hymen was broken. No. Well, then, it was legally not intercourse. I contended this decision and expressed the opinion that a girl who exposed her body to amorous pursuits, no matter of what severity, was no longer a virgin. I asked the brother what he thought about it. He replied bluntly, 'I don't know much about such matters, but I believe if a man has entered a woman's privates, no matter how deep, they have had intercourse.'

"We could not agree on this point. I ventured to say I loved her, and she loved me, and that matters would come to a friendly issue despite this interference. The lawyer said, 'She loved you once, but no longer. You struck her too often.'

"At this the brother, who sat there most of the time in a dull stupor, looked at me wildly and grunted, 'To think that you have struck my sister and I sit here calmly—'

"I held a discourse on temper in my defense, claiming it was largely due to unsatisfied desire, and she had profited by it. Returning to the old argument, we repeated the principal points at least a dozen times. Tired at these endless variations, I finally said they could do whatever they liked. The excitement of the debate subsided, and the barkeeper got a growler of beer, then another, then many more, and we sat drinking beer and still talking on the same topic until midnight. Finally, they left.

"As soon as they were gone, I shed my mask of indifference and furiously

set to work to destroy everything I could lay my hands on. I made a Supreme effort to cut the wires of their piano, but could find no instrument sharp enough.'

"The next day I simply packed my things, then got an express man and moved to a basement room on Twenty-Eighth Street. The druggist brother had agreed to buy my furniture. Out of mere curiosity I returned to the flat in the afternoon. The grandmother just went through a fainting spell. The barkeeper tore his hair and exclaimed in despair, 'Ah, that this should all happen at once and to me, my mother sick, my sister—and now my grandmother!' And he got another growler of beer to drown his sorrow.

"Thus ended this affair. I never heard of them again. I once wrote to the grandmother. She answered, asking, 'What is the use if it can't be changed?' She, at any rate, was powerless. I do not believe that Genevieve went on the stage. I got a glimpse of her, however, three times in later years. The first time was at an actors' matinee. I was in the balcony and she in the orchestra. I got up from my seat several times to attract her attention, and I believe she recognized me. I recognized her by the tiny diamond earrings, which I had so often fastened and unfastened in the days gone by. I had two young ladies with me and could not leave them between the acts. At the end of the performance I managed to lose them for a while and struggled through the parting crowd in eager search, but could find no trace of her.

"Several years later passing the flat where we lived together, I looked up and saw in the apartment next to it, a young girl sitting on the sill cleaning the windows. This position, which unfolds the lines and roundness of a feminine back to exquisite advantage, made me reflect. The form looked so familiar to me, I thought at once it might be Genevieve. Had I not once upon a time been most familiar with that part of her anatomy? But I was on a car and so passed on. The third time I passed I looked up again. I saw two female figures at the window. Yes, it was Genevieve, She stepped back when she saw me and spoke to her mother, but the mother was festooned with a towel, and merely wiggled her head. This is the last I saw of them.

"In this love affair that flowed freely the passion of my youth, it may perhaps be seen as a misdirected, stunted and grotesque exercise. Yet it was all fervor, an enthusiasm of unadulterated idealism which guided my actions and so strangely perturbed my temperament, in which an overdeveloped mentality tried to control all physical outbreaks."

16

Sometime in 1890 Sadakichi spent an evening over dinner with his father at a Hungarian Restaurant in New York. This was after he received his father's one-hundred dollar check while still enmeshed with Genevieve, near the end of their deteriorating romance. When the affair ended, Sadakichi got in touch with his father, who was working for a firm in New York, to thank him for the check. Even though neither were on the best of terms with the other, the son may have felt that pere's company might help pull him out of his emotional doldrums following his last inane debacle. He may have been on the edge of a breakdown. They seemed to have at least a good intellectual association, both being intelligent and well read—the only plateau upon which they could communicate without descending to sarcasm or verbal dueling. And too, since the stipend from his father was not enough for the publishing of his play, *Christ*, he undoubtedly toyed there might be a possibility for further funds. Yet, whatever hope he held for further financial aid stood in the looming shadow of his father's lean fiscal sympathy, and growing bitter conclusion that, "I knew Jean Valjean much better than my venerable father, who seldom honored my childhood with his presence."

"My venerable father at no time seemed to me much more than a casual acquaintance with whom one could while away an hour pleasantly in conversation. He had considerable charm that way, the *savior faire* of a man of the world, and I recall with special gratification a dinner we had together at the Hungarian restaurant on Union Square, New York, at which occasion we indulged in a *causerie* that was delightfully intellectual. He had traveled so extensively and was conversant on so many topics that there was never a lapse of embarrassment. He could have informed me as easily about different modes of salutations customary with various nations as the ways of ornamentation and conceits of female beauty

in multifarious lands, although he himself was rather of a sober, ascetic bend of mind.

"Over black coffee the conversation drifted to my plans and hopes for the future. In the most nonchalant manner he remarked, 'What you probably need is a thousand dollars. Less would be of no use.'

"Never was a greater truth more calmly uttered. If I had ever been the recipient of that sum, I no doubt could have molded my early career a trifle more successfully (although at that date it was rather early to handle carefully such an accumulation of change). And to think that with all my rich relatives and millionaires I met, such a gift was never offered to me. By him least of all. He in fact among occasional patrons, less than any.

"And this explains my inability of arousing within me the slightest feeling of filial consideration for my venerable father. The truth is that no opportunity ever offered itself to grow somewhat intimate with him. I do not believe we have spent more than six months under the same roof together, and often I lost track of him for years. He sailed the seas with all the ardor of a buccaneer. Like the Japanese he did not believe in the ceremony of kissing, and during my childhood I never wrote to him, nor did he write to me.

"He was a roving spirit, uncontrollable in his wanderlust, a globe trotter par excellence. In this respect I have never seen his equal. As the Germans say, *der reiesteufel war in him,* the travel-devil was in him. He somehow managed to occupy important positions, always as superintendent, or director of large firms and enterprises on all five continents. But he refused to stay long in one place. He worked hard, performed even more than his duty, and then some fair morning packed his grips and numerous trunks and set out for some new land of opportunities, never minding what opportunities he left behind.

"He never was rich. He may have reached the hundred-thousand mark point at various times, but his investments were of a volatile, quixotic order, and as quickly dispersed as earned. He told me of an investment in perishable cargo that went astray in some mysterious fashion. It tramped the Indian Ocean for an incredible length of time, but when it finally reached port, it proved valueless.

"When I first became acquainted with the remarkable intelligent countenance of my venerable father—his clean-cut features, high forehead and the keen glance of his eyes—previous to this I had not the slightest idea how he looked. I was eight or nine years old, and he came back with a complexion well-browned

from a tropical sun from the Fiji Islands, where he had been busy with some sugar plantation. He soon disappeared again. I know he had been in Canada, in the States, in Panama, Rio, Buenos Aires, Montevideo, Valparaiso, Sidney, Melbourne, Hong Kong, East India, Europe. He boasted of knowing them thoroughly, excepting (with a deep sigh of regret), Russia and Scandinavia. For several years he was in business with my uncle, his brother, in La Havre. The name of the millionaire firm of Hartmann, White and Goldenberg, dealing largely in coffee and rice from Haiti, enjoyed an enviable reputation in the commercial world.

"The next time I beheld his lean, gaunt figure was at the age of eleven when I lived with him in some suburb near Hamburg, and spent the summer in Kreuznach. He however was absent most of the time. After that, largely due to my insistence of following in his footsteps as a *wanderbursche* (happy wanderer), we were reunited for a few weeks at my various visits to Charleroi, Belgium, where he occupied a position as chief clerk of foreign correspondence at one of the largest glass export firms. The meeting in New York in 1880 (actually 1890) was the last time I saw him. Many years later I heard reports he was in Johannesburg and other out-of-the-way places. So he apparently kept up with his wanderings.

"What I admired about him was his gentlemanly nonchalance and unusual knowledge. He was an exceptional linguist, being able to talk, read and write business letters in at least ten languages, and this no doubt was the reason he could at all times command a good job. His interests however went far beyond mercantile limitations, and even in literature he was quite at home. He astounded me one day when speaking of Lermontov's *A Hero of Our Time,* and comparing him as to style with Gogol, Turgenev and other writers. He knew my preference for Hesse, Zola and Rossetti, etc., and made the caustic remark, 'I fear none of your fetishes will live as long as Victor Hugo. He was a truly great writer, and if you by chance (smiling), should ever get near to such accomplishment, I should feel very proud of it.'

"I could not help but agree.

"He also shared my love for the ocean, and once wrote to me from Charleroi, that his only recreation was to take a trip to Osteade, just to gaze once more at the sea. And there our sympathies ended. He never showed a trace of affection, or any sense of duty such as venerable fathers are supposed to have.

"Certain things he has done, I have found difficult to condone. It was surely not an act of kindness to send me as a boy of fourteen with three dollars

in my pocket to America to shift for myself, and he did not even pay passage, as he took the money out of my little savings bank hidden in some secret stocks to be looked at occasionally which I had had as long as I could remember, and which contained some three-hundred marks.[79] Nor was it excusable that when I was starving in Philadelphia, and he for half a year or more held some kind of position in New York, he never informed me of his presence. Events like these are not apt to foster filial piety.

"He apparently was unconscious of any neglect, and this cold indifference which by the by he showed to everybody of his kin, was also the cause of our final rupture. A casual remark in regard to my half-Japanese parentage opened up a chasm which steadily widened until it became impossible to overbridge in this lifetime.[80]

"I have but little information about his sojourn to Japan, beyond that he went as a young man in the sixties, that he resided in Nagasaki in the Foreign Settlement, the Island of Dejima, that he was attached to the consulate in some capacity, and did some importing business on his own account. I've heard him comment on the imitative ingenuity of his Japanese customers. Once, he sold two little passenger steamers, like those that ply the Alster in Hamburg, to some client. When the crew manned them they lost control of the steering gear and the steamers gamboled about in a circle. Anticipating a second order, his clients were already building a steamer after the pattern they had purchased.

"Of the domestic relations of my parents I am completely ignorant. Trustworthy persons (if there are such in delicate matters as this), have told me they did not get along very well, that he had maltreated my mother and even struck her. Well, that is nothing unusual in the skirmishes of matrimonial warfare. No doubt, they were racially too different to reach any close approximation to happiness. He made her, however, the promise that in case of her death, he would send my brother and I to Europe to be educated. This promise he kept. Quite exceptional when one considers how unscrupulously foreigners behave with native women. So he prided himself that he had not acted like so many others. This aroused my ire. It had been fermenting for some time. I had just arrived at the age to give it some serious thought. So one afternoon in Charleroi I expressed my opinion he could have left us just as well in Japan, that I could not see any particular advantage I had gained by his magnanimity, and that I would have gotten along as well over there. This put my venerable father into a furious temper. He fairly

shouted, 'Never say this again if you want to enjoy the hospitality of my home!' Then followed a long tirade. 'Children of alien fathers had but little chance in Japan. Your relatives in Japan (with a sneer) would have done nothing for you!'

"'Nor have my European relatives over-exerted themselves in that respect.'

"'Have they not given you a European education and brought you up in decent surroundings?'

"'By far too much so, if they did not mean to keep it up.'

"'They made you a German, a member of the most illustrious nation on earth!'

"'To serve in the army? It does not mean anything to me to be a German—in America.'

Came another outbreak of indignation toward my ingratitude that, 'I was a German, that I should be proud of being one, that I owed everything to his generosity, that he at least had not shirked his duty as many other fathers would have done.'

"I responded that I, 'Thanked him for his kindness, but that in my opinion he had only done what any decent father would have,' and thus the heated discussion went on, each of us repeating the same arguments over again. Well, we made up again, but it resembled a thunderstorm that had not cleared the atmosphere. The subject was not broached again until many years later, and then a single letter brought about our complete alienation. I was in New York, poverty-stricken and half-crazy by ill luck. He had sent me some money, a very rare performance for him; I needed more, asked, and he refused.[81] By this time I was really distressed, not only by one hardship I had gone through and showed at the very moment, but my logical reasoning arrived at the conviction a great injustice had been done to me, and largely through his cold-blooded devil-may-care methods which had deprived me of advantages enjoyed by the children of his second wife. They could ride to college horseback, but I had to starve. I was wild with rage, and so it came to pass that in some desperate mood, no doubt prompted by hunger, I wrote a foolish, threatening letter, referring to my stepmother as the 'Beautiful Helena,' upbraiding him for all he had made me suffer—no, it was not an attempt at blackmail. I had sense enough to realize that such an epistle as I penned would end matters for good, still I asked, no, commanded him to send money, the money he had purloined, even if it were to hurl it back at him, or I would not know what I might be capable of doing if our paths crossed again.

"He answered me from Port au Prince he would notify authorities if I would address him again in such scurrilous terms. Well, I have never regretted I wrote that letter.[82] (The main theory in my life is not to regret.) I had to tell him at one time or another what I thought of him as a father. I could have done it in a more dignified manner, no doubt, but the state of my mind in those dismal days prevented it, and so he heard all the bitterness that had accumulated for years, deep down in the recesses of my consciousness in all its crass and ghastly vehemence.

"As a father he no longer existed for me, yet as the years passed I would have not minded meeting him again, if for nothing else but half an hour's conversation about foreign lands, some demigod of literature, or the everlasting charm of the sea.

"I owe to my venerable father nothing but my German education and my transplantation to American soil, and they are indirect though important factors in the understructure of my career. My education, interrupted at the early age of thirteen, served merely as a basis for further conquest. If I had not been of a studious nature, although most of the time a lazy good-for-nothing at school, I would not have amounted to much. It gave me however the advantage of mental precociousness among the people I was destined to associate with. As for my coming to America, for my father a convenience and to me a degree of fate such as may happen to any of us. We cannot pronounce judgment upon events which condition and determine our life, whether they be beneficial or detrimental to our welfare, as we can only surmise what might have happened if such and such a particular event had not taken place. And thus I am thankful to fate for the racial combination of my parentage, as it made me acquainted with a part of social life which I was never able to inhabit again, for any approach to an existence of comfort without worry over the necessities of life came to me in later years only like an occasional oasis in a desert of poverty."

17

Events appeared to be emotionally pressing and draining for young Sadakichi about this time, so much so that he voluntarily entered the German Hospital for help and treatment. It was 1890 and he was in his twenty-fourth year. Various reasons are stated. One is that he attempted suicide. Another is that an infected wrist from an earlier attempt became infected. A third claims his growing depression over continued failures in his multitudinous efforts toward success in the creative world. In his autobiography he wrote he was suffering from insomnia. The following pages, "A Hospital Romance," are from the final chapter of his unfinished, unpublished work, written in 1892.

"Oh, I was so weary of everything, the world, my surroundings, even the plaster casts I had just purchased, beautiful specimens of remote periods of artistic endeavor (even as there may be today!).

"'I am deathly sick,' I persuaded myself. 'I can't sleep, what is the matter with me? Better go to some hospital, die or take a long rest.'

"My relatives at one time or another had endowed the German Hospital,[83] so it was merely necessary to say that I was so-and-so and I would be admitted free.

"The superintendent voiced the opinion that my case did not seem quite severe enough—yet I was a Hartmann—and if I thought I really needed treatment he would admit me. But what ailment or disease shall I register?

"'Insomnia,' I suggested.

"'We will cure you of that.' And they did, but had a devilish time of it. I would not go to sleep for days.

"I was ushered into a large ward—there must have been at least thirty-six beds, in two rows of eighteen each with a wide aisle between. Put to bed, I collapsed. I became violent, shouted at the top of my voice, had weeping spells, tossed about and threw myself half out of bed. It was genuine enough, it was a

nervous breakdown. I was completely exhausted. One of the young house doctors came—a friendly figure in white—he told me to behave or he would have to put me in a strait-jacket. This somehow quieted me. I did not long for any experience as in Strindberg's *The Father.*

"Then a voice uttered the simple words, 'Is this the new patient?' The words seemed to me like a melodious lightray coming from some cloud-heaven above. It electrified me, I cannot explain. Some sleeping potion was administered. I slightly relaxed, but did not go to sleep, but continued to rave about my bad luck and Genevieve. I probably revealed my entire history of life that evening to the nurse who hovered about me with kind attention.

"The next day I felt more normal. The visiting doctors walked like movie actors through the scene. They merely shrugged their shoulders at my dilemma, recommended all sorts of drugs, and I swallowed any amount of nasty tasting stuff. But sleep, 'the brother of death', refused to come.

"I was allowed to sit on the edge of the bed, and as there was nothing to occupy me, I soon helped the nurses in performing their more or less strenuous duties. Several TB cases came in, and they seemed remarkably quiet. One asked for a glass of water, and I sat with him for half an hour talking over vast stretches, and two hours later he shook off his mortal coil. He was carried away, bed and all, and a few moments later there was another bed with another occupant suffering from (blank) and kept alive artificially by (blank). Thus, life runs on its weary way. What for? Whereto?

"The nurse who had made such an impression on me served as night nurse, and we had wonderful conversations. She seemed to be a discriminating reader, and I found on her desk Byron's *Don Juan,* a volume of *Les Miserables,* Poe's poems and Dr. Billroth's clinical studies. This made me enthusiastic. At last, the right woman for you! And she seemed inclined to feel that I might possibly be the right man for her. I did all the persuading I could do in the dim light, *sotto voce,* and hurrying back to my couch whenever a doctor or orderly passed.

"Finally, after a week, my system permitted Morpheus to enter, but as I could not miss our nocturnal conferences, I slept most of the day and was keenly awake at night. At the time, Dr. Koch's cure for consumption had startled the world,[84] and there were a dozen or more patients on whom the effects of the lymph were tested. Being considered 'a young intelligent fellow,' the doctors entrusted me with the duty of taking the temperature of the consumptives twice

a day and marking the results on a chart. This fascinated me and I did the best I could, although I cannot guarantee the temperature in each case was correctly taken. I had too much imagination for that sort of thing, and a beautiful zigzag line was a temptation to make, which I could not always resist.[85]

"Well, it proved a brave failure anyway, so it did not matter much whether the temperature was a trifle higher or lower than it actually was.

"And the nights—they were surely topics of the greatest poets, even if the *mise en scene* was not idyllic—it was difficult to say anything in the unheated washroom. But the lady in question was so warm, that at least in the points of casual contact, one believed that there is a superior warmth in this futile existence which condones for many disappointments. She confided that the young doctor who had threatened me with a strait-jacket was in love with her, also the night watchman. To hell with him! During my silent rage at the doctor he lent me a silver watch to time the temperatures, so I threw it into the toilet during a love tryst in the chilly washroom, and it gurgled away as so much excrement.[86] As for the young, handsome doctor, I asked her, 'Do you love him?'

"'No!' she replied.

"'Then, after I get out of the hospital tomorrow come to see me and we will talk. Oh, the watch? I have lost it, and what can I do about it?'

"And so I took my leave. 'Everything all right?' asked the superintendent.

"'Yes. Only that the washroom should be heated. People catch cold there.'

"The super thought this a very irreverent remark for a non-paying patient.

"Then she came and saw me among all these plaster casts, then petting-party exercises, yes and no. She said, like most females, she didn't care for that sort of thing. 'Well, will you come and live with me? We don't have to do anything—'

"She left the hospital and the first evening, before she had come to stay with me for good, we had a pair of undesirable visitors, the superintendent and a lawyer-friend of her father's from Philadelphia. They were called post-haste when she told the hospital she would not finish her training course. It was even in the papers.

"She very benignly told them she would do as she pleased (why did she think that was so easy?) Since she was of age there was no trouble.

"The next day the lady arrived in the anteroom in full armor, I mean with all her baggage. We went to the Fleishman Café and had some dripped coffee

and fluffy cream things which she did not think so wonderful after all. After a dinner I escorted her to my temporary home, then excused myself, explaining I had to say goodbye to my bachelor days at the Café Manhattan, and treat my nondescript friends to a last coffee farewell.

"When I came in at two in the morning she was asleep in my double bed, and on the chair near the bed was decorously displayed a most bewildering array: a corset, black stockings, garters, starched skirts and other nameless things of apparel, as nameless as emotions are in those supreme moments of our flight across the few years Father Time grants us to find out where we are and why we are here at all. I sat for a long time, contemplating. Surely this was the beginning of a new life. And thus closes the first volume of my auto-biography."

18

It may be a stretch, but Sadakichi's fortuitous meeting with Elizabeth Blanche Walsh may have saved his life. And stretching it a bit further, he may have sensed this intuitively. But when it comes to raw, urgent survival, who knows what powers are at work on the same road? The two were thrown together, drawn to each other, and within a week she quit her job and moved into his one-room flat with nary a qualm. She was nineteen, he in his twenty-fourth year. They would marry the following year, in 1891. He would become the father of five children. He would at last have the symbolic family assemblage he for so long had sought.[87]

If not the beginning of a new life, as he optimistically weighed thoughtfully on the last page of part one of his uncompleted memoirs, at the very least it was a time-out from his old one, a rest and reprieve from the emotional chaos and psyche-draining series of soap operas of his continuous tumultuous "affairs" since sixteen, and not actually consummated either, but ideal-fantasies of an overheated imagination which fed on unrealistic romantic expectations, most ending on the altar of disappointment. His last adventure with Genevieve left him beyond crushed, near the edge of a breakdown. Shaken, his nerve-ends dangling like broken wires, he went to have dinner with his father, probably with the desire of some sort of surcease from despair, maybe even basking in the fanciful hope of a filial resuscitation which would finally bring the two together, melting away their estrangement and alienation which hung over them for years.[88] Yes, to bury the hatchet, to finally be accepted as his son. His back was to the wall, and he desperately sought release from emotional pain.

But it was not to be. His anticipated supper with his father turned out to be black disaster. Pere's casual remark at the end of their meal, perhaps purposefully rehearsed, was a knife in his son's heart. There was to be no resuscitation, only meaner devastation. Off-handedly his father, while casually buttering a piece of a roll, spoke of his time in Japan, of living several years with a young harlot with

whom he had borne a pair of illegitimate boys *(not* sons). Sadakichi sat stunned as he listened to the cold, aloof, distant monotone of a jaded wanderer relating a weary tale of cohabiting with a whore. They birthed a pair of half-breeds. Illegitimate. Bastards. Finishing his roll and washing it down with the remnants of his coffee, he took out his wallet, removed a wad of bills which he tossed on the table, and stood. "I must rush off," came his bored comment. "I have a pressing business engagement." With that he turned and departed.

His son sat crushed. He wondered if he had heard correctly, this villianous revelation. He felt light-headed and disembodied. Standing as if in a coma, he reached across the table, pocketed the bills and left. The cool night was a comfort. He made his way in a daze through the scattered night traffic of pedestrians toward his room. He would feel safer there. Yes. Safe and alone. His father's gelid words continued to echo in his pounding head. *Bastards. Whore.* He entered his room depressed. Wanting to escape those words, that voice: that mechanical voice. Face wet with tears he shattered a wine glass on the floor and retrieved a large piece and began systematically slicing his forearms, first one, then the other. He then threw himself on his bed and lay until he fell asleep, hoping never to wake. But in an hour he woke to find his arms and sheets bloodied. The cuts had coagulated and fortunately were superficial. Washing his hands and arms, he wrapped them with torn rags made from a pillow case and returned to sleep. Several days later the shallow wounds became infected and inflamed. He decided to go to the hospital, and was admitted for treatment and observation. (So much for the insomnia story.)

Of course the above two paragraphs are speculation, but enough of the stagnant relationship between the dueling pair is known, including the father's dispassionate deportment, to lead one to this invented hypothesis as a possible description of their last meeting. And although reading between the lines is not a valid historical method, at times there is nothing more solid on which to build possibilities. Sadakichi's somewhat lean account in his autobiography of their final meeting only mentions his father's "casual" remark of his "half-Japanese parentage" that opened a "chasm which steadily widened." Shadowy insinuations, but nothing concrete. Just what was his father's "casual" remark? Was he too ashamed and embarrassed to describe it any further? Possibly it was too painfully humiliating to reveal—especially in writing, for writing it down is like etching it on the bark of a tree for the world to see.

Well, he could at least thank his father for helping create the near-tragic scenario which led his son to hospital and his future wife, an uplifting event which released him from his depression and gave him second thoughts about self-destruction. Yet their initial months together was no paradise, for they experienced a "tough time in Philly and N.Y. Spent winter (of 1891-92) in Canada (probably with his wife's family)." Sometime in early 1892 he became an American citizen.

Also in 1892,[89] *McClure's Magazine,* a new publication by Samuel Sidney McClure, became a resounding success. They soon published pieces by well-known journalists and authors such as Ida Tarbell, Rudyard Kipling, Robert Louis Stevenson, Willa Cather and Upton Sinclair, as well as discovering new writers. Sadakichi got an excellent break and was hired by the magazine and sent to France as a roving reporter.[90] This was the fourth trip to Europe for him, and this time at least he had not only a steady income, but an elevated professional standing, which no doubt gave his ego a colossal boost. The Hartmanns spent the winter of 1892-1893 in Paris and its environs.

Hartmann's struggles up to now had amounted to a series of fits and starts in various phases of his creative endeavors, such as writing a series of articles and critiques on the arts, giving acting lessons, lectures, and putting on several stage presentations, while unsuccessfully seeking out an "angel" to back theatrical ideas he had. He also had three trips to Europe behind him for whatever experience he may claim, the first tour of which was the more positive, in that he spent much of it seriously studying stagecraft in Munich as an apprentice under the noted Karl Autenschlager. Before this, as described earlier, he spent the first two to three years after his arrival in the States in a fevered drive of self-education, in the end coming away with what might be compared to a degree in Liberal Arts. Having an innate intelligence he soaked up everything like a sponge and amazed those who witnessed this natural trait. Total retention of information gave him a storehouse of knowledge of anything of interest or value he came across. But it was still a struggle for him, for his youth was a handicap. Despite his voluminous intellectual capacities he was still an untried neophyte, for he lacked solid experience and a professional working history. It was difficult for his ego to accept.

In his driving ambition he at times displayed impatience, even brusqueness, in his haste to climb the ladder of success, and his growing rash behavior and sarcasm over the years would be a minus for him, no doubt in time causing

those with influence to pass him by, or avoid him altogether. But now, his France assignment gave him the feeling he was ascending a rung of that ladder.

While on assignment in Paris, Sadakichi claimed "about one hundred interviews with European celebrities." He became acquainted with the composer Claude Debussy, and the Symbolist poets Paul Verlaine and Stephen Mallarme, as he moved among a myriad of notables.[91]

But alas, after his return to New York, "he has a falling-out with McClure and goes back to Boston."[92] Possibly somewhere along the way his steed Pegasus stumbled, or threw a shoe. Or became spooked. Or he pissed someone off. Like McClure.

But what of Carl Hermann Oscar Hartmann? Why and how did he come to express and possess such an emotional distance from the two sons he brought into the world? He is referred to several times as a "Prussian," the earlier nomenclature of the territory before it was christened Germany. Prussians are usually described as cold, rigid, aloof and uncompromising. Did his father absorb the traits via genetic/cultural osmosis, or was it through parental training and social conditioning? He moves through Sadakichi's manuscript in an 8-page chapter, "My Venerable Father," less venerable than serpentine. More a specter actually, a grim wraith. But they are his son's description, bitter words of not-too-hidden anger and resentment, feeling justified after his feelings of abandonment and total alienation.

"The Hartmann's were all of a reticent, stoical nature," he wrote. "For my uncle I have always entertained the highest feeling of reverence, even admiration, not love, simply because one could not love him." Of his grandmother, "(I) loved this woman with all my soul…and yet she was in no way demonstrative of her feelings towards us."

For the next eighteen years after his marriage Sadakichi drove himself relentlessly in an effort to gain notoriety and fame, and of course recognition and acceptance, which he would crave all his life. He wrote hundreds of articles, reviews, critiques and stories, gave drama readings and lectures, founded a handful of short-lived art magazines, authored a dozen books, including volumes on American and Japanese art. He pushed the works of photographers Alfred Stieglitz, photo gallery owner, and Sergi Eisenstein, among many others, in an effort to champion photography as an art.

But over the years as his commentaries and criticisms harshened, it caused an alienation in people who gradually pulled away.[93] He and Stieglitz were close friends and enthusiastically worked together for several years, both influencing the other. Then they had a cold parting after Sadakichi sardonically labeled Stieglitz "the Torquemada of American photography" at a meeting of his organization of photographers, the Photo-Secession. In time they reunited and remained friends.

Soon his desire for fame turned toward infamous, and his personal life began to suffer. After five children he and his wife divorced. During the last years of his marriage he embarked on a brief affair with New England poetess, Anne Throop. After Throop became pregnant, he left, never to see her again. About 1911 he decided to leave New York City because of poor health. Soon he met and began living with artist Lillian Bonham at the Roycroft Art Colony in Roycroft, New York, managed by Elbert Hubbard.[94] Gradually peregrinating westward they settled briefly in San Francisco with their children, then drifted to Los Angeles, where he met Douglas Fairbanks, Sr. In 1924 he debuted as a court magician in Fairbanks' silent film, *The Thief of Bagdad,* and soon was hobnobbing with the Hollywood crowd. About 1930 he moved to the desert town of Beaumont, then Banning in 1935. In 1938 he built a clapboard shack in which to live on the Morongo Reservation next to the home of his daughter, Wisteria, who was married to Walter Linton, a sheep rancher.[95] Whether as escape, solitude, or peace of mind, he resided near Wisteria and his son-in-law while Lillian Bonham lived in Beaumont with the children. He named his shack, "Catclaw Siding."[96]

The fame and fortune Sadakichi sought avoided, evaded and ignored him completely, and to a degree, his one-time biographer, Gene Fowler, certainly read him quite closely, although some Sadakichians thought his book treated the ancient curmudgeon unfairly.[97] Sadakichi had morphed into a mixture of fiction and fact, an entertaining raconteur on the skids and no longer interested in accuracy. Most of his prevarications were merely harmless embroidery, background for his personal yarns, like colorful wallpaper used to enhance an otherwise drab room.[98] Since his thirst for success was now, in his seventies, but a dry memory, and his fading health more prominent, he became the court jester Fowler described. What was left? Maybe a few more years if he were lucky. Perhaps too, the main object of his purpose in life for recognition probably died some few years before (his father), and since he was no longer alive to try and impress and win, why the

struggle? Why knock any longer on the door of an empty room? Hell, he did enough of that while pere was still alive.

So here he was, old and worn out, grey and cere, the bitter jester on a continuous tape unreeling his oft-told tales of yesteryear. A sad jester too, cynical and sarcastic. The rustic remains of a once hopeful young genius now long forgotten, unappreciated and unsung.

The raw truth of failure ate at him, forcing him to face the fact he was just another sick and broke old man waiting to die. Actually he was too much the cynic to care either way, having faced many a hungry night in his life spaced by a handful of flush times to break the monotony of starvation. Give me liberty, or give me wine, he laughed to himself. He was worn and weary and exhausted from years of scraping and scratching for that bitch fame and fortune, and for what? He wondered why it had mattered at one time. He wondered why anything mattered now.

Of his thirteen children, does he ever recall his sixth one, Robert, whom he bred with Anne Throop? His marriage to his first wife, Elizabeth Walsh, was in its eighth year when he met New England poet, Throop, in May 1899. She was a strong advocate for women's emancipation, and had long desired to do her revolutionary bit for the cause by bearing a child by a literary man without the blessing of marriage. Swiftly, she and Sadakichi became an item, and before long she was carrying his child. But he, not being in the same state of mind, declined, and departed.

Having not only enraged her parents, but much of proper New England by what all felt was a revolting deed—which today is worn with joyous pride—she was ostracized and cast out by all. Sadakichi was also banned from lecturing in the state. Too, she had not the strength of a true rebel, only the thoughts and words, and as a result suffered greatly with unresolved guilt over her act.

Eleventh months later, in June 1900, shortly following her son Robert's birth, Elizabeth wrote her lover in the hopes he wished to visit his son. But silence was her only answer. She lived for a time with a sympathetic cousin on a small allowance from her estranged parents. She later moved to New Jersey and continued writing her absent amour.

So it went for years, she writing, pleading for him to visit, he not doing so, but dropping an indifferent line now and then. Yet, branded as a renegade, she courageously strove on, raising her son and moving, always moving, to escape

the verbal condemnation, social harassment and snubbing as she was found out. Time crawled on. Finally becoming emotionally distraught, she furiously wrote her ex-lover after incredible patience, "But I know now it never could have been love at all—because love is fire and iron." She later referred to him as, "The trashy philanderer with the hangdog look of a knave when caught...one who hovers about a cheap Bohemia..."

During the First World War their son joined the army and was sent to Europe. Anne joined the Red Cross and was eventually sent to France. Her nineteen-year-old son had one brief leave in Paris during which they visited. He was planning a second leave from the front, so she rented a small *pension,* placing a small vase of white asters by his bed, and waited. And waited. But he never showed. She received word he had been killed in action before his leave.

She described everything in a final letter to Sadakichi, and he never heard from her again.

After relating the tale to Fowler he commented, "After Robert's death the meaning of life became obscure to me. I lost interest in the pattern of it."

It had to be the understatement of the year. He certainly had to be aware of this therapeutic play he created in which he had the starring role; he the child and Throop his mother, all based on actual events.

Yet, aware or not, it was too late. Robert was dead and Anna was gone, as were so many others, but his squawking albatross which pursued him all his life still rested on his shoulder, never allowing him to erase his feeling of worthlessness and insecurity. He had an inherently gifted talent for the creative arts, some called him a genius, but he was weaponless and helpless before the dark, dank ogre of crushing paternal repudiation. He could not muster the strength to defeat, nor rise above it. Only to lash out like a frustrated punch-drunk pugilist at crippling memories.

For the final sixty-some years of existence the emotionally ruptured youth gradually morphed into an iconoclastic adult. His overly long trail of cancerous contumacy was slowly self-devouring, and he swung constantly from gifted creativity to dark discontent, vainly jousting windmills wherever and whenever he imagined them, ending a bantering stoic, his idealism turning into a cluster of sour grapes, his last days as Hollywood's court jester, and his wasted talents objects of Fowler's foil. But at least Sadakichi's prolific copulatory vigor, resulting in thirteen offspring, was proof he had been here. He pollinated liberally to give

evidence he wasn't the complete non-entity his venerable father held him out to be, fructuously leaving behind a baker's dozen living carriers of his DNA to further off-sprinkle the populace.

But he was a fatally wounded man, and it was difficult to know which and how many of the lacerations were self-inflicted. His personal rood of betrayal, guilt and abandonment all left their scars upon him as well as on those who came too close. There was little left to do in his final years of self-exile but to linger on in unsweet solitude. His life had been a time-bomb, and it ended with the soft detonation of instant, merciful death. He no doubt exhaled his final breath gratefully, leaving his stress-laden life with a sigh of relief. And like a good showman, which he certainly was in his younger years, he may have looked forward to finally uniting with his Teutonic father.

One afternoon in November 1944 Sadakichi Hartmann took a Greyhound to Florida to visit a married daughter in St. Petersburg, Dorothea Gilliland. On the twenty-first, the day after he arrived, he was resting in a backyard lawn chair in the sun and silently passed away. He was seventy-seven years and thirteen days old.[99]

Several years later the noted poet and critic, Ezra Pound, still laboring over his voluminous *Cantos,* gave Sadakichi a few lines of attention in Canto LXXX (80). The two had been frequent correspondents many years before, so he was not entirely forgotten. Both wanderers during their lives, Pound was at this time an incarcerated guest in the prison ward of St. Elizabeths Hospital in Washington, D.C., just down the road from the White House and the U.S. Capitol, for treasonous broadcasting for the Italian Government during W.W. II.

The Pisan Canto section described, "...and as for the vagaries of our friend Mr. Hartmann—Sadikichi—a few more of him, were that conceivable, would have enriched the life of Manhattan or any other town or metropolis..."

Although not quite an Oscar, or even an Obie, the ancient trooper in response would probably have removed his burned-out cigar stub, bowed left and right to an invisible audience, then turned to Pound in mock arrogance and announced in simulated triumph, "HA! In the words of noble Caesar, my dear Ezra, 'Let us have a bit more grape!'"

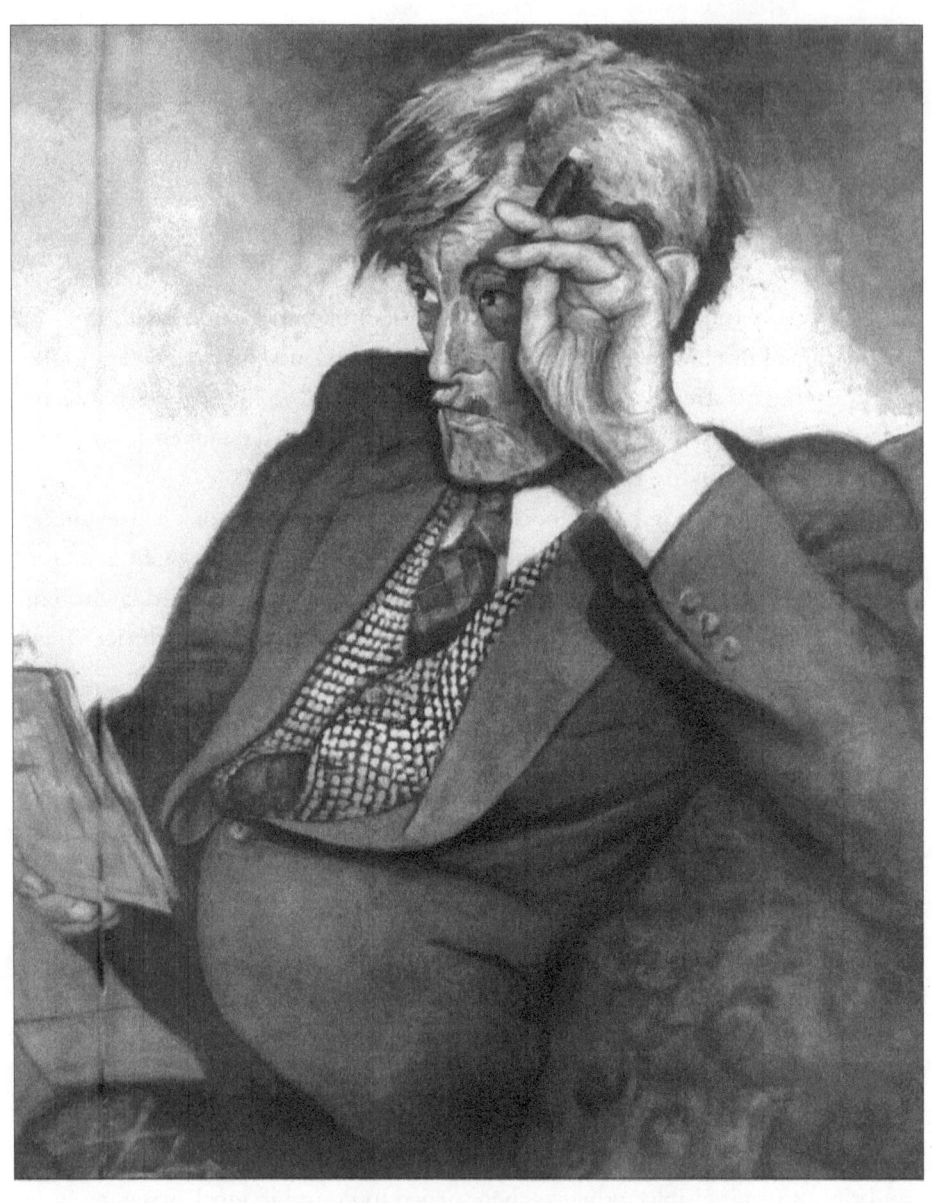

Sadakichi Hartman. Painting by John Decker.

Sadakichi Hartman, Gene Fowler and John Decker visit John Barrymore backstage.

Allen McNeill, Will Fowler, John Decker, Sadakichi Hartman, and Gene Fowler holding court at 419 Bunday Drive.

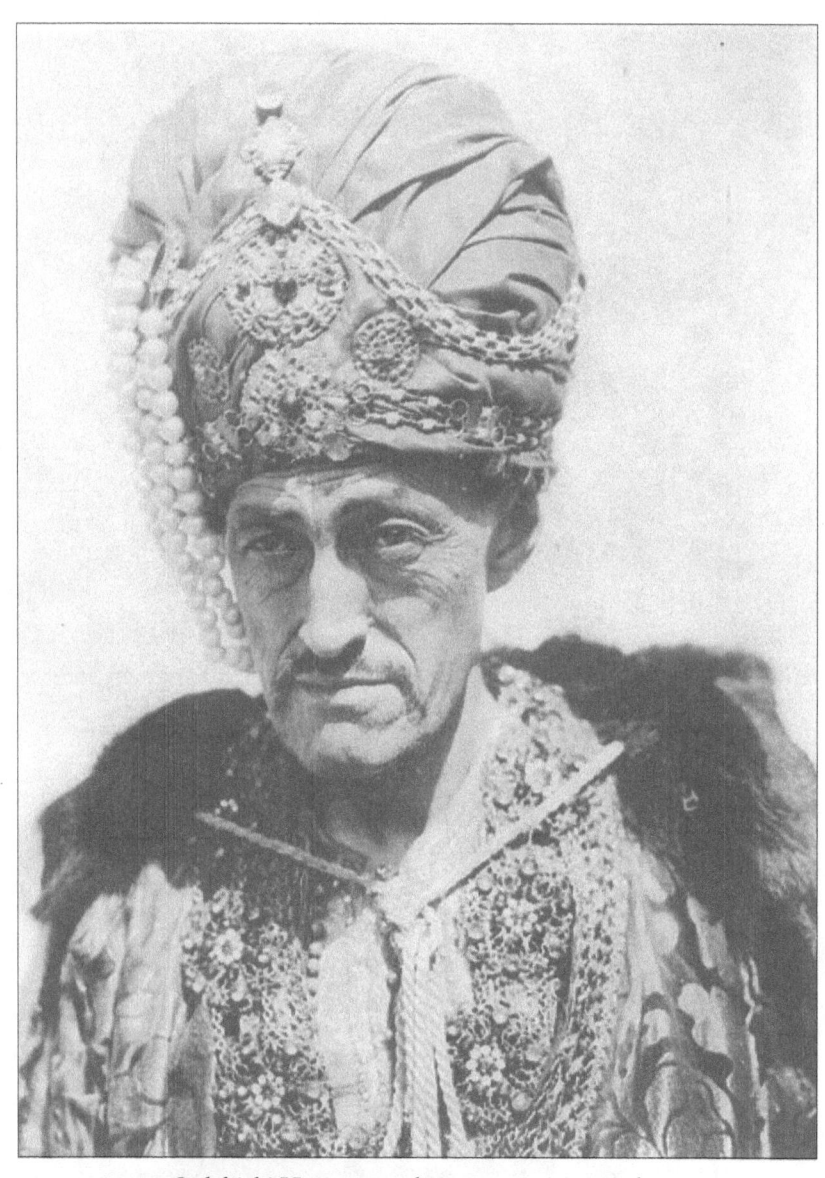
Sadakichi Hartman as the court magician in the
Douglas Fairbanks, Sr. 1924 film, "The Thief of Bagdad."

Anne Throop, New England poet, mother of Sadakichi's son, Robert.

Notes

1. George Knox. *Modern American Poetry.* "Sadakichi Hartmann's Life and Career," no date, p. 3. Sadakichi Hartmann Papers, University of California, Riverside, California.
2. Although this birth date is commonly accepted, in his unpublished autobiography Hartmann declares, "I was born in Nagasaki, but even the exact date is doubtful. Although my venerable father kept a diary, a different division of time and calendar got him mixed up, and he could not vouch whether it had happened in August or September, 1867, '68, or '69." In Fowler's work, p. 50, Hartmann claims, perhaps jocundly,"...the year of the Battle of Wilderness," U.S. Civil War, 1864.
3. Lane Earns. *The Historian.* "The Foreign Settlement in Nagasaki, 1859–1869." HTTP://www.highbeam.com/doc/lGl-17199159-html. "In 1863 the old Dutch quarters at Dejima was incorporated with the Foreign Settlement. French and *Prussian* (italics, author) merchants...joined the Dutch on Dejima." It is probable the Prussian Hartmann met Osada in 1864, and their sons Oscar Taru and Carl Sadakichi were born in 1865 and 1867, respectively. Assumedly the time line fits if Hartmann arrived and took up residence there in 1863 or 1864. Sadakichi in his autobiography claims his father "...went there as a young man in the sixties (1860s), that he resided in Nagasaki in the Foreign Settlement, the island of Dejima, and did some importing business..."
4. "OURA ARTICLES." The first German Consulate was Louis Kniffler in 1865, a German merchant headquartered at No. 4, Dejima. The six named following Kniffler through 1875 do not include any Hartmanns. It is thought Hartmann left Japan about 1871–1872.
5. Kushibo-e Kibun of Seoul, South Korea, suggests Osada may have been Korean. Kushibo@gmail.com; Fowler, p. 229.
6. Gene Fowler. *Minutes of the Last Meeting.* Viking Press, N.Y., 1954, p. 51; Sadakichi Hartmann autobiography, p.7. Hereafter referred to as CSH.
7. Fowler, p. 50.
8. Osada's "pulmonary disorder" was inherited by her two sons.
9. Fowler, p. 51.
10. Fowler, p. 50. Another reason given was, "Hartmann...had an assignment in Japan as an agent for the family's company of coffee importers."
11. Web: Benjamin Cassan. *Historia.* "William Jardine: Architect of the First Opium War."

12. The Dejima post closed in 1859 since the Dutch merchants were no longer restricted to the island and from trading in Nagasaki proper. In 1863 Dejima was incorporated as part of the Foreign Settlement.
13. The Walsh brothers, Thomas (1827–1901) and John (1829–1897), were wealthy Americans who set up a trading company in Nagasaki in 1862, and became respected in the business community. They organized the Japan Paper Making Co., Ltd., in Kobe in 1875. After John died in Kobe Thomas retired, and in 1898 he ceded the company, now the Kobe Paper Mill, to Hisaya Iwasaki, the son of a leading investor, who later renamed it the Mitsibishi Paper Mill in 1904. Exactly when Hartmann joined or left the firm is unknown.
14. Kenneth L. Richard. "Sadakichi Hartmann in America 1887–1918, The Early Works," page 7. HTTP://www.genji54.com/nagasaki%studies.
15. Web: Thomas Telkamp-Notes on Ja.
16. Liza Critchfield Dalby. *Geisha*. University of California Press, 1998. A fine and incisive history of the Geisha.
17. Kenneth L. Richard, Web: "Dejima Boy to Bundy Drive Boys," p. 11, fn 6.
18. An early demonstration of Sadakichi's rage toward his innate feelings of abandonment.
19. Fritz Reuter (1810–1874) was a popular and leading novelist of Lower German literature, born at Stavenhagen in Mecklenburg-Schwerin. He had earlier studied at Parchim.
20. Fanny Janauschek (1830–1904), aka Madame Fanny Janauscheck, was a 19th century character actress born in Prague, who came to New York in 1867. In three years she mastered English and soon became famous in many acting roles, including Shakespeare. Following a stroke in 1900, she died in Amityville, Long Island. She is buried in Woodlawn Cemetery, Bronx.
21. Was Taru trying to explain to a stubborn Sadakichi their mother was not married?
22. One of Sadakichi's strong role models appears to have been his uncle Ernst, especially in mimicking his flamboyant, c 'est la vive lifestyle–minus the wealth.
23. Datura stramonium (thorn apple, devil's apple, jimsonweed). A poisonous plant of medicinal value which offers temporary respiratory relief. Leaves are usually cut up and rolled into a cigarette, cigar, or smoked in a pipe, inhaling the smoke.
24. Captain Frederick Marryat (1792–1848), an English Royal Navy officer, novelist, and early pioneer of the sea story. The author of 26 novels, *Peter Simple* was his fourth. James Fenimore Cooper (1789–1851), American writer, whose *The Leatherstocking Tales* are five novels based on English, French and American intruders creating havoc among the Amerind Natives of Colonial America.
25. The miasmic alienation between dada and son would eventually stretch past infinity.
26. "Half-breeds and illegitimate." Were these damning epitaphs originally Sadakichi's, or were they earlier bantered about by whispering kin? Were they exchanged now and then by his father–who wished to be rid of the two—and his step-mother—who looked to insure that her daughters married well? Were the parents overheard in their not-too careful excoriations by the two offspring? The paragraph itself is a dismal picture of the Hartmann household's dank racist atmosphere, and what

the pair were insensitively exposed to. Hartmann senior appeared content to be manipulated by his wife as to what could be done to be rid of his young "wards," what he desired in the first place. It must have been a relief for him to share and dampen whatever guilt he may have experienced with his co-schemer.

27. Lessing/Nerthe. Weight, 3,496 gross tones. Length, 375.1 feet x beam 40 feet. One funnel, two masts, iron hull, single crew. Speed, 13 knots. Accommodation: 1st class, 90; 2nd, 100; 3rd, 800. Launched 20 February 1874 by A. Stephen & Sons, Glassgow, for the Alder Line, Hamburg. Maiden voyage from N.Y. on 28 May 1874. Purchased in 1875 by Hamburg America Line and continued Hamburg-Havre-N. Y. sailings. Rebuilt in 1882 with two funnels. Last voyage 22 April 1888, then sold to Messageries Maritines, Marseilles, and renamed Nerthe. Scrapped in 1897. Info: *North Atlantic Seaway,* vol. 1, by N.R.P. Bonsor.
28. CSH possibly appears in error here as to who wrote what.
29. This build-up of Sadakichi's suppressed rage at his father probably prepared him for his ricocheted fury toward the pompous tourist of fn 30.
30. A bit of therapeutic anger continued from the above note.
31. CSH later makes the false claim several times of his father shipping him off to the States at 14 with but three dollars pocket money and the philosophical adage, "The experience will give you character and resourcefulness. You must learn to shift for yourself." But he appears to have forgotten that in his earlier autobio he boasted of his self-reliance after his ship docked in Hoboken, as described here, and paid for his ticket to Philadelphia. Years later in relating his life's experiences to Fowler, he was by then in his mid-70s, and perhaps memories became fuzzy–unless he decided to paint "venerable" pere with a darker brush. Fowler, pp. 53-54.
32. Carl Webber (1850–1921), a highly successful and wonderful painter of landscapes.
33. Karl von Piloty (1826–1886) was an artist born in Munich. He gravitated toward themes of historical scenes, and was greatly influenced by the old masters after studying in England, France and Belgium.
34. Sadakichi's choice of steerage turned out to be a miserable and wretched experience, his personal *Inferno.* "Never will I forget that trip." CSH ms., "My Trip to Munich," p. 2.
35. In Fowler's account, Sadakichi more dramatically claims the exchanged money from the Bowery was counterfeit, so the ticket seller sent for the police. But he was successful in explaining "his way out, of jail, pawned his valise, and borrowed enough money from an American traveler to go third-class to Hamburg." Fowler, p. 75.
36. Sadakichi, arriving at his grandmother's door unannounced, baggage-less and in a somewhat disheveled state, naturally struck the socially conservative woman as improper, and caused her to question what the servants would think? To Fowler, CSH ends his description of his arrival in Hamburg with the half-truth, "There, his grandmother fed him, outfitted him with new clothes and luggage, and paid his railway fare to Paris (sic)." Fowler, p. 75.
37. CSH's quick visit to Kiel was quite probably for a loan to further fortify his wallet.
38. The Piloty school of Symbolists again impressed him, with Arnold Bocklin

(1827–1901), in his opinion, the greatest artist of them all. "And the mother of Wisteria agreed with me," he adds in emphasis in his autobio. A few of Bocklin's paintings served as inspirations for several composers, such as Hans Huber (1852–1921), Sergi Rachmaninoff (1873–1943), Max Reger (1873–1916), and Heinrich Schultz-Beauthen (1838–1915). Adolf Hitler (1889–1945?) owned eleven of Bocklin's oils, http://www.arnoldbocklin.com/

39. Karl Lautenschlager (1843–1906), a highly respected and imaginative technician, was the Technical Director at the Royal Theater for 22 years, and especially known for his revolving stage. Although he constructed the first one in the western world in1896 in Munich, they were earlier used in Japan in 1793, after which he fashioned his, with some modification. Sadakichi may have had some satisfaction in its history, although he strangely makes no mention of it in his autobiography.

40. Friedrich Georg Heinrich (Fritz) Brandt (1854–1895). Fritz and his father Karl (1828–1881), were both respected and formidable talents as stage engineers and directors. Lautenschlager studied under Karl in Darmstadt at the court theater, after which he went on to Munich. While Lautenschlager was the first to introduce the Kabuki revolving stage at the Residenz Theater in Munich in 1896, Fritz Brandt brought the first rolling stage at the Royal Opera House in Berlin in 1900, which moved on rollers set on tracks.

41. Ludwig II (Ludwig Otto Friedrich Wilhelm, 1845–1886) died 13 June, three days following being declared "insane" by four psychiatrists. Such dissension was there between he and his financial ministers, he announced he would fire them after they refused his order to seek funds from Europe's royalty to continue his lavish spending. To prevent this, led by Count von Holstein, the rebelling ministers in an artificial Medical Report *(Arztliches Gutachen)*, declared Otto suffered from paranoia, which four selected psychiatrists signed, who never saw or examined the "patient." It was later claimed his death was a suicide by drowning. But from newly gathered information, it was said he was murdered by two gunshots into his back, and his accompanying psychiatrist on their walk that morning was also slain, unfortunately being a witness. *Ludwig II of Bavaria,* Wikipedia; *Murder Mystery,* Independent.co.uk. Otto seemed an "unkingly" king, one who had no use or interest in the pomp and circumstance of parades or war, or the political trappings of his office, and seemed in the wrong place at the wrong time. He was probably an extremely eccentric neurotic living in a world of his own, a dreamer blissfully building castles, and producing Richard Wagner's operas around the clock (whom he fanatically idealized and financially supported for some years). Falsely accused by the ministers of using state money in his fetish of castle-building, and thus threatening the budget, he actually used his own funds, sometimes borrowing from the family.

42. Actually, Heinrich Conried (1855–1909), Manager and Director of the Metropolitan House, 1903–1908.

43. Walhalla is a vast temple in commemoration of noted Germans of history, constructed between 1830 and 1842 under supervision of architect Leo von Klenze. It was modeled after the Parthenon of Athens, and houses 191 busts and 65 plaques.

44. Architect and goldsmith Johann von Ludwig (1673–1752), was born in Hohenhart, Germany. In 1698 he moved to Italy where he worked on church altars. He married, converted to Catholicism and changed his name to Ludovice. His work was so admired by the Jesuits, he was invited to Portugal where he relocated, then adopted Portugese citizenship. Known as Joao Frederico Ludovice, he died in 1752.
45. John of Austria/Don Juan of Austria (1547–1578), turned out to be a dynamic and leading military leader of his day, and an adventurous and romantic individual. He inspired one play, two operas, a poem and one novel, plus additional varied studies of him and his campaigns. His life would have made an outstanding film, starring Tyrone Power. He died at 31.
46. American sculptor, Jo Davidson (1883–1952).
47. Befreiungshalle, "Hall of Liberation." An historical classical monument in Bavaria commemorating the victories over Napoleon from 1813 through 1815. Architect Leo von Klenze completed the structure in 1863.
48. Prolific German sculptor, Ludwig Michael Schwanthaler (1802–1848).
49. Ilka Seidl, 19, Munich stage dancer where he earlier worked. "It was only worship from afar."
50. *Manfred,* an epic poem of guilt and lost love by Lord Byron.
51. "Mortimer to her Mary." Another of Sadakichi's chronic literary allusions.
52. Paul Johann Ludwig von Heyse (1830–1914), was a highly productive and important poet, novelist and writer of short stories, and man of letters. In 1910 he was awarded the Nobel Prize for Literature.
53. CSH ms., "Paul Heyse" chapter, p. 7.
54. Fowler, p.69.
55. A tragic love story of Italian history (circa 1285), where lovers Paolo and Francesca were slain by her husband Giovanni, his brother.
56. Paris sculptor Antoine-Louis Barye (1795–1875), marvelously worked animals in bronze, and was famous for anatomical detail and tension.
57. Dante's Beatrice and Petrarch's Laura were outstanding beauties who were said to have inspired and influenced their writings.
58. A reference to Sadakichi's controversial first play, *Christ,* written in 1889.
59. Sir Philip Sidney (1554–1586), English courtier and soldier of the Elizabethan Age. Chevealier de Bayard (1473–1524), a French soldier and hero of old, considered the Last Knight in Shining Armor, and epitome of chivalry. He was fearless, faultless, beyond approach and a skillful commander, and also referred to as, "le bon chevealier."
60. This trust fund has never been explained or elaborated upon in Sadakichi's autobio, except described as a sort of "little savings bank hidden in some sort of secret stocks...which I had as long as I can remember." Was he able to draw from it at any time over the years, which allowed him some economic independence? Or was he limited to certain scheduled times and amounts? How much? Was this why his father maintained a parsimonious attitude and rarely contributed to his financial need? Perhaps he feared losing it completely if he complained of his father dipping into it. Was it finally depleted by pere's latest mentioned financial losses?

61. Report of "Charleroi Mining Strikes," *Kieler Nachrichten,* (Kiel News), 1888, Kiel Germany.
62. Although young Hartmann's concern over the miners' miserable existence on the one hand may be admirable, on the other his description of their plight in his autobiography reads more like a fleeting outline for a possible play of struggling proletarians.
63. Rosengarten was an earlier acquaintance of the Shakesperean study group Sadakichi was invited to join by Albert Henry Smyth.
64. His search for a "patron" to financially espouse his various cultural agendas appeared uppermost in his social contacts. But for a 17-year-old, what could he actually offer? His plight seemed the dilemma of an intelligent, educated and widely-read individual sans maturity and solid experience seeking an "angel" to support half-baked scenarios, a difficult undertaking, indeed.
65. This admitted comprehension of the negative side of his persona seemed a knowledgeable insight greatly ignored by his conscious self.
66. Today, eco-friendly and an environmentalist's dream, Huis Ten Bosch (House in the Forest), is a 152-hectare residential-style resort town designed with thousands of trees, shrubs and flowers, and laced with miles of canals.
67. Actually, Adam van Noort. Peter Paul Rubens (1577–1640) and Jacob Jordaens (1593–1648) both studied under van Noort. Jordaens was never a pupil of Rubens, but they worked together, with others, on several large projects.
68. Beerbohm Tree (1852–1917), English actor and stage manager with a long and noted career. His half-brother was caricaturist Max Beerbolm.
69. William Michael Rosetti (1829–1919), English writer and critic. Younger brother of the more famous Dante Gabriel Rossetti (1828–1882).
70. 1st Duke of Otranto, Joseph Fouche (1759–1820). Paternal grandson of Julien Fouche (1667–1845).
71. Francois Delsarte (1811–1871). Tenor opera singer and sometime composer, he was also a noted teacher in a new singing and declamation technique. Later, method acting in America can probably be labeled a distant cousin of "Delsarte."
72. Renowned stage thespian Frederick Tyrone Edmond Power (1869–1931) was the father of the stage and film actor Tyrone Edmond Power (1914–1944). Sadakichi probably saw the Broadway production of *Ulysses* in late 1903 (Sep-Nov) at the Garden Theater. But the supporting role was with Rose Coglan. Holmans may have been a stand-in.
73. Sadakichi Hartmann. *A History of American Art*. One Volume Edition. L. C. Page & Company, April 1934. Pp. 299-308. The first edition in two volumes was published in 1901 with the dedication, "To my Uncle Ernst Hartmann, among whose books and art treasures I spent my childhood, and whom I have to thank for my first appreciation of art." Sadakichi's pointed remembrance of his uncle may also have been a delicious touch of spite toward his father in not coupling him to the dedication, knowing he would eventually hear of the publication from Ernst.

74. Stuart Merrill (1863–1915) was an American poet who wrote his works in French. After his return to Paris, Sadakichi would again meet him there on his 4th return to Europe with his wife.
75. Archibald Clavering Gunter (1847–1907) was a prolific English-born novelist, playwright, stockbroker, mining and civil engineer. He published his own books plus *Gunter's Magazine*. Wikipedia.
76. Jeanette Leonard Gilder (1849–1916) was a journalist, editor and writer. She was the daughter of Clergyman William Henry Gilder (1812–1864) and Nancy Nutt. Her brothers were William Henry, an explorer; Richard Watson, poet and editor; and Joseph, an editor. Wikipedia.
77. *Christ* was Sadakichi's first play and first true exposure to the literary world, although not a blessed one. In 1893 he printed one thousand copies of the drama and staged it in Boston. It exhibited full-front nudity and was labeled scandalous. Besides being banned, nearly all copies of the play were burned by the New England Watch and Ward Society, and he spent Christmas week in jail where he complained of the food. It appears Boston was not yet ready for nakedness in Eden. Arrested 21 December 1893 for publishing *Christ,* he was bailed out by friends 2 January 1894. The case was tried before Judge Hardy on 4 January 1894, then sent to the grand jury. While waiting in the courtroom he was shortly after arrested a second time for selling the work. "I pleaded guilty for having violated the laws, (but) not of having written an immoral book, and paid a fine of $100." Sadakichi Hartmann. *White* Chrysanthemums. Edited by George Knox and Harry W. Lawton, Herder and Herder, New York, 1971, p. 91.
78. *White Chrysanthemums,* p. 23, fn.
79. While his three dollar pocket money lament does not hold water by now, the passage cost taken out of his trust fund by his father without his knowledge was an irksome point.
80. His father's base remarks concerning his ethnicity have never been fully disclosed.
81. During the end of his Genevieve romance.
82. It was possibly written and mailed shortly before his last arm-slashing.
83. The German Hospital/Dispensary, was founded in January 1857, and renamed Lenox Hill Hospital in July 1918. It opened its nurses training school with four young German-American women forming its first class in 1887. Before then, nurses and attendants were brought over from Germany.
84. Prussian Dr. Heinrich Hermann Robert Koch (1843–1910), Nobel Laureate, discovered the bacterium, tubercle bacilli, the cause of TB, not the cure, in 1882.
85. Patients assigned to ward duty seem a stretch.
86. "I took his watch while he was leaning over to listen to my chest, for I had nimble fingers." No loan was mentioned in Fowler, p. 180.
87. 1910 United States Federal Census. Bronx Assembly District 35, N.Y., N.Y. Carl S. Hartmann, 40. (43?); Elizabeth B. Hartmann, 38; Alma, 18; Minurva, 16; Paul W., 13; Marion M., 9; Edger A., 7. On 28 February 1918 Elizabeth would take him to court for non-support. Richard, "Sadakichi," p. 20, fn 10.

88. It is assumed that the letter and draft from his father may have informed him of his brief stay in the city and possibly a dinner invitation.
89. *Sadakichi Hartmann,* Critical Modernist. Edited by Jane Calhoun Weaver. University of California Press, Herder and Herder, New York, 1971, p. 46.
90. Ibid., p. 2,46.
91. *White Chrysanthemums,* pp. 24, 25.
92. Weaver, p. 46.
93. Weaver, pp. 5,18, examples of his brashness.
94. Elbert Hubbard and L. Ron Hubbard are thought to be related, Elbert a distant non-blooded uncle. The arts and crafts colony was directed by Elbert and his wife Alice, and soon flourished. The talented craftspeople included furniture making, metal smiths, leather smiths, and bookbinders. In 1910 they had over 500 workers—including Sadakichi and Lillian Bonham. As tastes and times changed, the Roycrofters finally closed down in 1938. Although it is thought they never met, L. Ron, impressed with his uncle's accomplishments, dedicated to him in 1956 the ninth printing of *Dianetics: The Modern Science of Mental Health.*
95. U.S. Indian Schedules, 1885–1940. Mission Morongo, California. Census date, 1 January 1937. Walter Linton, Head, 6 Oct 1904; Wife, Wisteria Linton, 1912; Son, Cedric L. Linton, 26, June 1934; Daughter, Marigold Linton, 30 Sep 1936. Walter A. Linton was the son of John Baptiste Linton. John, born in 1855 in Scotland, immigrated to San Diego in 1871. He later moved to Agua Caliente, 50 miles northeast, and was listed as a sheepherder. There, he met and married American Native Maria Guadalupe Anderson, 20, in 1884. Around the turn of the century, they and their family moved north to the Morongo Reservation in Riverside County. On the 1930 U. S. Federal Census is found Sadakichi's second wife, Lillian Hartmann, with five of their children. Lillian, 46, Head of household; Wisteria, 18, daughter; Astor, 13, son; Robert, 11, son; Tansy, 10, Daughter; and Jonquil, 4, daughter. They were residing in Beaumont, Riverside County. On the 1940 U.S. Census is found, Walter Linton, American Indian, 35, Head of household; Wisteria, 28, wife; Cedric, 5, son; Marigold, 3, daughter; Rodrick, 1, son; and Carl Hartmann (Sadakichi), 70.
96. The medicinal herb, "Catsclaw," is a woody vine with hook-like thorns resembling the claws of a cat. Found in tropical areas, indigenous peoples have used them over the centuries for a wide variety of ailments, including *asthma*. A siding is a short run of railroad tracks next to a main line where a train could pull onto in order to allow the passage of another, overtaking or oncoming. Perhaps asthmatic Hartmann felt he had been shunted off as life now passes him by. He has shot his bolt, so to speak, run the gamut of his professional endeavors to where his successes were lean and failures outstanding. All is left is a shrug of the shoulders as he shuffles off toward his sunset, and perhaps the rationale that it was a somewhat interesting run. His use of the singular "cat" in catsclaw may be a hint of his personal identification with the named herb, also that one of its many uses was for asthma. Too, as he attempted clawing his way to the top, his thorny mind set and criticisms often alienated him from potential aid and assistance.

97. Fowler at this time was a retired newspaper man, the author of some two dozen books and 18 screenplays, and not new to the scribbling or publishing world. Born in Denver in 1890, as a 10-year-old he claimed witnessing a street brawl starring William "Bat" Masterson and his ex-business partner and *Denver Post* sports editor, Otto Floto. The combatants began by kicking each other in the groin, then whaled away with windy roundhouse rights, after which the obese Floto fled the arena. Not too impressed by the pugilists' unfancy antics, Fowler later disappointedly described them as "...a pair of charcoal burners of the Black Forest..." (His son Will, in his father's biography in 1962, makes no mention of the incident, although Masterson is mentioned but once, briefly in a two-liner concerning his feud with Floto.) After serving a year at the University of Colorado, he quit and joined the *Denver Post* as a cub reporter. One of his assignments was to interview frontiersman Buffalo Bill Cody. After Cody's death in 1917 he composed the showman's obituary, describing him as "Indiscreet, prodigal, as temperamental as a diva, pompous but somehow naive, vain but generous... Cody lived with the world at his feet and died with it on his shoulders. He was subject to suspicious whims and distorted perspectives, yet the sharpers who swindled him the oftenest he trusted the most." Fowler married in 1916 and the following year moved to New York where he took a job at the *Daily Mirror*. Masterson had preceded him to the Big Apple in 1902, ending as a sports writer for the *Morning Telegraph* for 18 years, dying at his typewriter in 1921. Fowler eventually gravitated to California and Hollywood, where he worked for a number of years as a screenwriter. He soon became acquainted with the actors of stage and screen who frequently met with the Hellfire Club at artist John Decker's home and studio in Brentwood, to become one of its permanent components. He died in 1960.
98. He would sometimes open a story with, "On a day like this, there were Rodin, Whitman, myself and three beers in a cafe in Vienna..." Well, while colorful enough, Whitman was never in Vienna, let alone ever traveled beyond the limits of the United States.
99. Sadakichi Hartman's Certificate of Death states he died about 11 p.m. on 21 November 1944, on the second day after his arrival in Florida of coronary thrombosis. His age was entered as 77 years 11 months and 13 days. He was actually 77 years and 13 days old. He is also claimed to be still married to his first wife, Elizabeth Blanche Walsh. It is possible they acrimoniously fled each other, neither bothering with official rituals. His second and last marriage is sometimes described as common law coupling.
Ending on a historic note, not quite eight months later, on 9 August 1945 at 11:02 a.m. over Uragami, Nagasaki, about five miles north of Dejima, the second of two A-bombs was dropped. It slew 73,884 and injured 74,909 people over half of the population of 270,000.
Web: http://www.english.illinois.edu/maps/poets/g_l/levine/bombing.htm

Bibliography

Fowler, Gene. *Minutes of the Last Meeting.* Viking Press, New York, April 1954.

Hartmann, Sadakichi. *A History of American Art, in Two Volumes.* Tudor Publishing Company, October 1932.

Hartmann, Sadakichi. *White Chrysanthemums, Literary Fragments and Pronouncements.* Edited by George Knox and Harry W. Lawton. Foreword by Kenneth Rexroth. Herder and Herder, New York, 1971. Copyright 1971 by Wisteria Hartmann Linton.

Hartmann, Sadakichi. *Unfinished Autobiography.* University of California, Riverside, California.

Jordan, Stephen C. *Bohemian Rogue: The Life of Hollywood Artist John Decker.* Scarecrow Press, Inc., Lanham, Maryland, 2005.

Linton, Wisteria Hartmann. *The Life and times of Sadakichi Hartmann.* Copyright 1970. Presented at an exhibition at the University of California, Riverside, 1970.

Mank, Gregory William. *Hollywood's Hellfire Club.* Feral House, Los Angeles, California, 2007.

Pound, Ezra Weston Loomis. *The Cantos of Ezra Pound.* New Directions, *New York,* 1996.

Weaver, Jane Calhoun. *Sadakichi Hartmann, Critical Modernist.* University of California Press, 1991.

www.ingramcontent.com/pod-product-compliance
Lightning Source LLC
Chambersburg PA
CBHW020913180526
45163CB00007B/2717